A DESCRIPTIVE CATALOGUE

OF THE MARINE COLLECTION

AT INDIA HOUSE

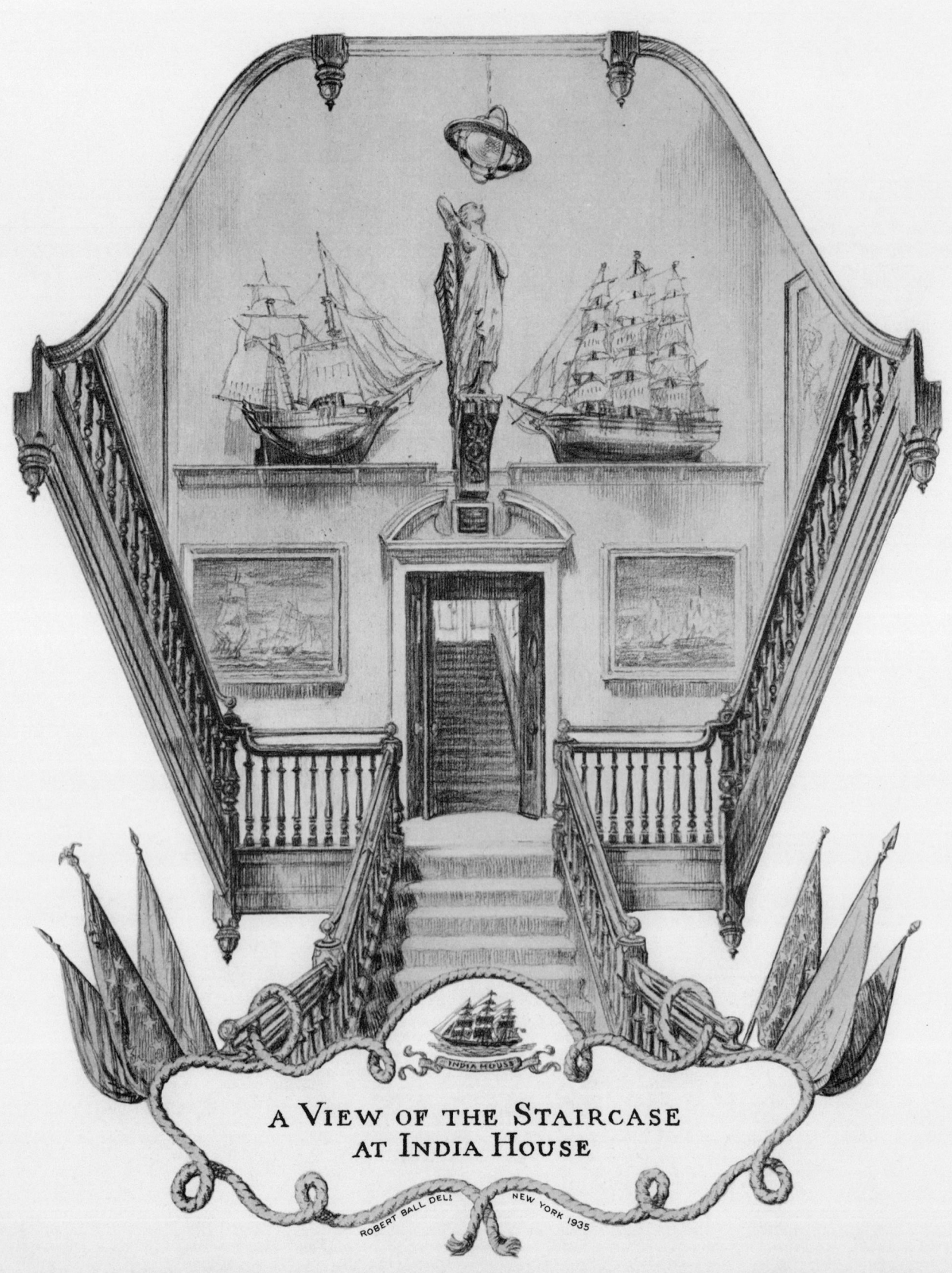

A DESCRIPTIVE CATALOGUE OF THE MARINE COLLECTION TO BE FOUND AT INDIA HOUSE

Second Edition
Wesleyan University Press
Middletown, Connecticut

Copyrighted 1935, by India House, Inc.; Copyright © 1973 by India House, Inc.

Library of Congress Catalog Card Number: 73-7088

ISBN: 0-8195-4065-x

Manufactured in the United States of America

CONTENTS

FOREWORD TO THE FIRST EDITION xi

FOREWORD TO THE SECOND EDITION xiii

BIRTH OF INDIA HOUSE xvii

INDIA HOUSE—A LANDMARK xix

THE PORT OF NEW YORK—*An Historical Sketch* xxiii

ACKNOWLEDGMENT xliii

OIL PAINTINGS, WATER-COLORS AND DRAWINGS OF SHIPS 1

OIL PAINTINGS OTHER THAN SHIP PORTRAITS 41

CATALOGUE OF SHIP MODELS—*Full and Profile* 51

LITHOGRAPHS, ETCHINGS, WOODCUTS AND DRAWINGS 61

MISCELLANEOUS OBJECTS OF IMPORTANCE 133

ACQUISITIONS SINCE 1935 139

ILLUSTRATIONS

COLOR PLATES

	FACING PAGE
ARAGO, from an oil painting by P. Tanneur	8
COURIER, from an oil painting by Evans	16
HARVEST QUEEN, from an oil painting by J. Hughes	24
THE HONGS AND WATER FRONT—CANTON, from an oil painting by Chun Ling Soo	32
HOUQUA, from an oil painting by George Chinnery	48
ISAAC WEBB, from an oil painting by J. Hughes	56
MARY GLOVER, from an oil painting by Egide Linnig	72
NATCHEZ, from a water-color by an unknown artist	80
A NIGHT ON THE HUDSON (*Isaac Newton* and *Francis Skiddy*), from a Currier & Ives lithograph	88
RESOLUTE, from an oil painting by Lai Sung	96
SOVEREIGN OF THE SEAS, from an oil painting, possibly by "F. M."	104
WILLIAM H. CONNOR, from an oil painting by an unknown artist	112

MONOCHROME PLATES

VIEW OF THE STAIRCASE AT INDIA HOUSE, from an original pencil drawing by Robert Ball	*frontispiece*
	FACING PAGE
AGNES, from an oil painting by Lai Sung	2
AGUAN, from an oil painting by A. Jacobsen	4

BALTIC, from an oil painting by W. Yorke 10

BATAVIA, from an oil painting by Antonio Jacobsen 12

BAVARIA, from an oil painting by H. Stuck 18

BLACK PRINCE, from an oil painting by an anonymous Chinese artist 20

CASA FUCA, a model 26

CHINA, from a colored lithograph by Endicott & Co. 28

DE WITT CLINTON, from an oil painting by S. Walters 34

EASTERN STAR, from an oil painting by an unknown artist 36

FLYING CLOUD, from an oil painting by Warren Sheppard 42

GANGES, from an oil painting by an unknown artist 44

GLADIATOR, a model 52

GOLDEN GATE, from a lithograph "engraved by R. Major" 54

ILLINOIS, from a lithograph by Charles Parsons 58

ISAAC WRIGHT, from an oil painting by an unknown artist 62

JAPAN, from a lithograph by Endicott & Co. 66

LIZZIE OAKFORD, from an oil painting by an unknown artist 68

MARGARET A. JOHNSON, from an oil painting by S. Walters 74

MARIA (built in 1821), from an oil painting by J. Walters 76

MONMOUTH, from an oil painting by Evans 82

NORTH AMERICAN, from an oil painting by Lai Fong 84

PARTHENIA, from an oil painting by D. McFarlane 90

QUAKER CITY, from a lithograph by J. L. Giles & Co. 92

RED JACKET, from a painting by an unknown artist 98

ROYAL SOVEREIGN, a model 100

Sonora, from a colored lithograph by Endicott & Co. 106

Union, a model 108

Wide Awake, from an oil painting by S. Walters 114

Wild Ranger, from an oil painting by J. Hughes 116

De Lesseps Medal 118

Glory of the Seas Figurehead 120

Leviathan Bell 122

Pair of Cannon 124

India House, Main Staircase 126

India House, Lounge 130

India House, Marine Room 134

India House, Library 136

FOREWORD

INDIA HOUSE dates its origin from the period, two decades ago, when the National Foreign Trade Council was organized for the promotion of our foreign trade. The time foreseen by Alexander Hamilton had arrived when production in the United States far exceeded domestic requirements, and when the country of necessity turned its eyes seaward in pursuit of foreign markets. The occasion found America unprepared. The palmy days of the clipper ship had been succeeded by our virtual eclipse as a maritime nation, and public interest in nautical matters was at a low ebb. About the time when the problems raised by this situation were most pressing, a dinner was given at the Metropolitan Club in May, 1914. Among the group present were the late Willard Straight and the writer, and others interested in commerce. The suggestion was made over the table that New York should have a place, maritime in spirit, purpose and atmosphere, where those interested in rebuilding a merchant marine worthy of America could meet. The idea met with instant approval, and largely due to the efforts of Willard Straight a suitable home for the Club was found in Hanover Square, the heart of the foreign trade district of New York, and the organization of the Club was rapidly accomplished.

Before he went to the world war, in which he died, Major Straight purchased the India House property in order to hold it until the Club might eventually buy it, which it did on February 16, 1921. To the competent and prudent hands of Joshua A. Hatfield were given the important duties of the chairmanship of the Executive Committee which he discharged with exceptional success until his death in 1930.

It happened that the founding of India House closely coincided with the beginning of a new spirit of sea-mindedness in the nation. The intervening years have witnessed a tremendous change in our attitude to foreign commerce. Our country no longer lags behind in the race for world trade, but has won its way to the front rank in international commerce. Traditions of the sea have been revived by a renewed interest in our American merchant marine, and strengthened by the establishment of a new arm of transportation. Thousands of miles of this Western Hemisphere have been charted as airways to speed our commercial undertakings. We have the confidence that we possess the means and desire to carry on with undiminished enterprise.

In this development, India House has played an interesting rather than a great part. It has an atmosphere all its own. Situated in the heart of Old New York, memories of a historic past are stirred as we look out of its windows. On its walls, reviving the associations which cluster thickly about Hanover Square, may be traced the pictured story of a maritime people, through whose efforts the port was made the gateway to a Western World of boundless wealth and resources. Organized for the encouragement and perpetuation of American foreign trade traditions, the situation of India House is calculated to impress upon its members the dramatic story of the growth of our commerce. Its site, at the close of the Revolu-

tion, was occupied by shipping firms. About it, for more than two hundred years, pressed the homes and even the ships of a majority of the great maritime interests of the past. A most interesting map of the old waterfront, prepared by Mr. Henry A. Chandler, shows the city's encroachments on the sea in the centuries which have witnessed the building up of our foreign trade.

Here in these rooms are treasured the relics of the past, symbolizing the world-wide extent of our trading interests. India House is bound by every tradition with the adventurers of all ages who went down to the sea in ships, and all now engaged or interested in foreign commerce are represented on its roll of members. Here we may plan the practical details of future growth, or dream the dreams of Robert Louis Stevenson and other inimitable story tellers of the sea, surrounded by inspiring memorials of the past, and wake to the realization of the changes which centuries of progress have brought to our country. New as years go, India House is old in the traditions it holds of pioneers who once lived around Hanover Square, and who laid so well in their day the foundations on which this greater New York has been raised.

It was never more incumbent on us than at the present juncture to encourage the foreign commerce of the United States, and its natural corollary, an adequate American merchant marine. We owe it to the settlers whose deeds are preserved in the history of New Amsterdam and early New York to maintain, as they maintained, an undaunted front to the difficulties of our times. We owe it to those who shall follow, to build, as our forefathers builded, wisely and courageously. The purpose that called India House into existence remains to be carried on by this and future generations.

<div style="text-align: right;">JAMES A. FARRELL</div>

1935

FOREWORD TO THE SECOND EDITION

IN THE NEARLY SIXTY YEARS of its existence India House has become considerably more than simply a club "maritime in spirit, purpose and atmosphere." In its historic building at 1 Hanover Square in New York, it has become a repository of paintings, etchings, lithographs, statues, models and diverse maritime memorabilia, virtually a museum of American merchant shipping throughout the world.

With the acquisition of a number of notable pieces since the publication of the first edition of this catalogue in 1935, the Directors of the Club deemed it wise to issue a new edition, which would preserve the original and add new material, both written and illustrative, on the recent acquisitions.

This new edition closely reproduces the handsome format of the first edition and retains unchanged the listings written for that edition by the noted historian Carl C. Cutler, then the Curator of the recently founded Mystic Seaport in Connecticut. It includes as well the ancillary material written in 1935: the original foreword by James A. Farrell; "Birth of India House" by Walter L. Clark, who, since the earliest days of the Club, had been the chairman of its Art Committee and who had overseen its collection; "The Port of New York—An Historical Sketch" by Mr. Cutler; and the acknowledgment by Harry T. Peters, the renowned New York collector of prints and himself a member of the Art Committee.

New listings have been written in the style of the original for the acquisitions since 1935, and new illustrations have been prepared from especially commissioned photographs. In addition there are included this foreword, which will offer a review of maritime developments in New York and in America since 1935, and an article on the recent designation of India House as a New York Landmark.

* * *

In 1935 the American Merchant Marine was on the threshold of a period of expansion made possible by the Merchant Marine Act of the following year, now known generally as the Magna Carta of the American shipping industry. The four decades since that time have been marked by the most extraordinary fluctuations, and American shipping has dramatically changed in many ways. Sailing ships, still to be seen in 1935, have become an extinct species, a fact that makes many of the paintings in the India House collection even more valuable, more significant than they were then.

Most of the art works in India House and the major part of Mr. Cutler's preface deal with ships built between the American Revolution and the Civil War. Mr. Cutler's countless historical anecdotes and ship histories tell the story of our shipping, coastal, non-contiguous and deep-sea, through the middle of the nineteenth century. The fact that there is relatively little art from the latter half of that century is evidence of the sad decline of the American Merchant Marine after the Civil War. Indeed, between the Civil War and World War I,

except for coastal shipping, there was only one major line crossing the Atlantic, and one crossing the Pacific: the American Line, whose first ship sailed in 1873 (today's United States Lines); and the Pacific Mail (ancestor of today's American President Lines).

The American coastal-cargo and passenger-ship fleets, which for a century were the backbone of the American Merchant Marine, are now gone. Gone too are the famous overnight boats that used to speed through the crowded waters of Long Island Sound, through Chesapeake Bay, between San Francisco and Los Angeles, all without benefit of radar and other equipment that make navigation today so much safer. Few even remember the names of their companies: the Colonial Line; the Fall River Line; the Lassco Line; the Old Bay Line; the Hudson River Night Line. And few remember the famous coastal lines: the Clyde Line; the Merchants & Miners Line; the Morgan Line; the Eastern Steamship Line; the Mallory Line; the Weems Line; the Savannah Line. Sadly, the only survivor of this once most important stream of domestic shipping is the oil-tanker fleet, preserved because foreign-flag ships may not operate in American coastal commerce, and because the American coast of the Gulf of Mexico remains a major center of petroleum refineries.

The passing of the era of coastal shipping was accelerated by World War II. Virtually all the ships in this once prosperous part of the Merchant Marine were used as troopships, as hospital ships or for war-supply service. The importance of moving troops and materiel during time of war can hardly be overestimated, but a proper history of these ships and their part in the defense of America and the Allies has yet to be written. It is needed. Perhaps some student of a future generation will be inspired by the Antonio Jacobsen paintings of coastal liners hanging in India House.

Still another major change in the Merchant Marine since 1935 has been the elimination of the once significant intercoastal shipping route. Although many American vessels made the dangerous passage around Cape Horn before the Panama Canal was completed in 1914, the opening of that new waterway created a new sea-lane. At one time the intercoastal route boasted the three largest passenger liners ever built for service under the American flag, the *California,* the *Virginia* and the *Pennsylvania*. Their owner was the Panama Pacific Line, the name of which still remains in large metal letters at the back entrance of 1 Broadway, though not a ship has served under its house flag since 1940. A period of enforced inactivity during World War II helped to destroy intercoastal shipping. The truck, the automobile and finally the airplane made a post-war revival economically out of the question. Today not a single vessel is regularly employed on the intercoastal route in general cargo or passenger service.

Even more dramatic, perhaps, has been the decline of the American passenger fleet as a whole. Although stimulated in 1928 by the Jones-White Act and given a firm subsidy foundation in 1936 by the Merchant Marine Act, the ships of this fleet have all but disappeared. Only two full-fledged liners serve under the American flag on the oceans of the world at the time of this writing—the *Mariposa* and the *Monterey,* both of the Pacific Far East Line. Not a single American passenger-carrying vessel sails now from New York or any other Atlantic port or from a Gulf-Coast port. The proudest flagship of them all, the *United States,* lies unused and without prospect of use near the place of her birth, Newport News, Virginia.

FOREWORD TO THE SECOND EDITION

Considered by many the safest and the most remarkable passenger ship ever built, she has been sold to the federal government and probably will be kept in lay-up status for possible emergency use as a troopship.

During this forty-year period of rapid maritime evolution and competitive failures, the American Merchant Marine has nevertheless made many dramatic achievements. The defense of freedom in World War II was made possible by the American shipbuilding and ship-operating enterprises. More than five thousand new merchant vessels were built in the world's greatest shipbuilding effort of all time. Without these American-built merchant ships Europe might well have fallen before the might of Hitler. England could not have survived without the armada of American-built, American-manned, American-operated merchant vessels created by naval architects like William Francis Gibbs and managed by many of the outstanding members of India House.

A remarkable transformation has taken place in cargo shipping since World War II, led by American inventive genius—the advent of containers. The container revolution has not only altered world shipbuilding, but has also drastically changed cargo-handling techniques in nearly every major seaport in nearly every maritime nation. Because of the container revolution and the decline of coastal shipping, virtually all the piers on Manhattan Island have become obsolete. Never before has a major port city suddenly found itself with a strip of between five hundred to one thousand feet of choice land around its perimeter available for new construction.

New York's old piers are rapidly being torn down. It is of key importance to New York that this magnificent frame around Manhattan be used to the best advantage for the general public. It must not be parcelled off to the highest bidder to block it forever with pilings and new towers of aluminum. It should not be destroyed for public use by the construction of wider and more expansive car and truck routes simply because it is available and presently unused. The tall ships have gone, but where they docked must be remembered and cherished through such efforts as that being made, for example, by the South Street Seaport Museum. The noble heritage of maritime New York, so beautifully portrayed on the walls of India House, must be preserved.

India House, as a downtown repository of the Port's and the nation's maritime glory, can help to insure that city-planners remain conscious generation after generation of the nation's maritime heritage. An expanded public awareness of the art treasures of India House can help to preserve the integrity of the collection.

FRANK O. BRAYNARD

April, 1973

BIRTH OF INDIA HOUSE

SHORTLY after the formation of the National Foreign Trade Council, Mr. James A. Farrell invited a number of his friends to dine with him at the Metropolitan Club on a certain evening in May, 1914. No mention was made of any special reason. Dinner was served in a private dining room and there were thirty-nine men present, leading manufacturers, bankers and shipping firms identified with foreign trade being represented by their chief officers. The dinner guests on this evening were as follows:

W. E. Bemis, Pres., Bemis Bag Co.
W. H. Childs, Pres., Barrett Mfg. Co.
Walter L. Clark, V.P., Niles-Bement-Pond Co.
E. A. S. Clarke, Pres., Lackawanna Steel Co.
Samuel P. Colt, Pres., United States Rubber Co.
Maurice Coster, Westinghouse Gen'l. Electric Co.
E. P. Cronkhite, Cotton Goods Merchant
H. P. Davison, J. P. Morgan & Co.
Robert Dollar, Pres., Dollar Steamship Co.
Martin Egan, American Asiatic Association
James A. Farrell, Pres., United States Steel Corp.
John Foord, Editor, Journal of Commerce
W. Cameron Forbes, Governor, Philippine Islands
P. A. S. Franklin, Pres., International Mercantile Marine
J. P. Grace, Pres., W. R. Grace & Co.
Lloyd C. Griscom, Former Minister to Japan
Fairfax Harrison, Pres., Southern Railroad
Joshua A. Hatfield, Pres., American Bridge Co.
E. N. Hurley, Pres., Chicago Pneumatic Tool Co.
Charles E. Jennings, Engineer, Norwalk, Connecticut

Alba B. Johnson, Pres., Baldwin Locomotive Co.
W. H. Marshall, Pres., American Locomotive Co.
James R. Morse, Pres., American Trading Co.
Charles M. Muchnic, American Locomotive Co.
M. A. Oudin, General Electric Co.
Robert H. Patchin, Sec'y., National Foreign Trade Council
Frank Presbrey, Advertising
Welding Ring, Pres., Mailler & Quereau
Charles H. Sabin, Guaranty Trust Co.
Charles A. Schieren, Jr., Charles A. Schieren & Co.
W. L. Saunders, Chairman, Ingersoll-Rand Co.
C. M. Schwab, Pres., Bethlehem Steel Co.
W. D. Simmons, Pres., Simmons Hardware Co.
Willard Straight, J. P. Morgan & Co.
E. P. Thomas, Pres., U. S. Steel Products Co.
F. A. Vanderlip, Pres., National City Bank
J. G. White, Pres., J. G. White & Co.
A. H. Wiggin, Pres., Chase National Bank
Elisha F. Williams, United States Rubber Co.

In looking around the table it was evident to all of us that we were brought together for some special purpose but no one knew what that purpose was. The blight of prohibition had not then come upon us and the beverages were as good as the food. When the coffee-and-cigar time arrived, Mr. Farrell announced the formation of a new club downtown—to be called India House.

A lease was taken for ten years on the old Cotton Exchange building in Hanover Square and it was being turned into a clubhouse at that time at his expense and Mr. Willard Straight's—later taken care of by the Club itself.

The purpose of the Club, Mr. Farrell explained, was to bring together all the elements in foreign trade so that they would know each other better and would work together more intimately than in the past. What he had in mind was to create in this country a relation between the bankers and the promoters of foreign enterprises that would make it possible

to handle foreign undertakings as they had long been handled in London. The Club was also to furnish offices and headquarters for the National Foreign Trade Council.

The whole proposition was so well conceived and so constructive that the Board was then and there constituted, and it is believed that nearly every one of those men has remained a governor of India House to this day, excepting those who have passed away.

The success of India House from that time to this has been a phenomenal one in every way. To all practical purposes it is a lunch club and, as is well known, the finances of such clubs are exceedingly difficult to manage. India House has, however, now run for nearly twenty years and the income every single year has been well in excess of the expenses. The handling of the affairs of the Club by the Executive Committee has been most able, a sufficient Sinking Fund having been created to enable us to take title to the building—which was done from Mr. Willard Straight's estate, he having purchased it for the express purpose of enabling the Club to purchase when the proper time arrived.

The building was of old Colonial design and the location had originally been on the actual bank of the East River. Mr. William A. Delano, the architect, changed the interior character as little as possible in making it over for club uses. The judgment and taste of Mr. Delano has helped materially to give India House its undoubted charm. Mr. Straight presented to the Club his collection of marine prints and also a collection of ship models which he purchased for that particular purpose. From time to time members of the Club have made handsome contributions to our collection of unique objects of art—all connected with the sea-going interests of the institution. One of the members of the Board has also painted and presented to India House oil portraits of five of its original officers, which hang together in the main reception room.

The Club by its unique beginning and attractive home at once established itself as one of the leading downtown clubs, and there has been from the first a spirit of interest and loyalty in the members which is hard to equal in any organization of this kind. Everyone seems to take pride in the institution. The Board of Governors meets once a month at lunchtime. These meetings are frequent for a club and yet they are well attended. The regular form of business is gone through with while a very enjoyable lunch is being served.

In conclusion, it might be said that this Club has been an unusual success from its inception, and a large share of credit for this success undoubtedly belongs to its Founders.

WALTER L. CLARK

INDIA HOUSE - A LANDMARK

IN THE FIRST EDITION of the India House catalogue scant attention was paid to the handsome building itself, one of the finest examples of the old business structures of downtown Manhattan. In this new edition it is highly appropriate to consider the history of India House, as the building and its site have since been designated landmarks by the Landmarks Preservation Commission of New York.

Since the publication of the first edition of the catalogue there have been issued two little documents of interest about India House. One entitled *Why India House?* was written by John Foord, a member of the Club. It explains why the name of the Club was chosen. Quoting the Secretary of the American Asiatic Association, this two-page pamphlet outlines how the wealth of the Indies had since Renaissance times been the keystone of Western commerce and how, consequently, the Indies became a synonym for all that is rare and precious. The author goes on to observe that the burst of American maritime energy that occurred after we freed ourselves from English domination had as its goal the linking of New York with the Indies.

The second document is a study entitled *Where Gather Those Who Bear 'The Burden of the Desert of the Sea.'* It was prepared from historical materials collected by H. W. Foster of the New York Title and Mortgage Company. Factual and well documented, this pamphlet begins with a list of the owners of the tract of land on which India House stands.

Hanover Square was originally located almost at the water's edge, and stood in view of the house of the Dutch Governor Kieft. A contemporary writer left a delightful description of the buildings of that day. "The buildings are brick, generally, in some cases of divers colors and laid in cheques, being glazed, they looked very well. The streets were paved to the width of ten feet from the front of the houses, leaving the center unpaved as a runway for water. There were no sidewalks."

The great fire of 1835, which destroyed fifteen million dollars worth of buildings in the heart of New York's business district, destroyed the little old Dutch and Colonial buildings at 1 Hanover Square, making it possible for a single building to be erected on this site. The exact date of the construction of the building that is India House and the name of the first owner are not known. It is possible that one Richard Carman, of 42 Broadway, was both builder and first owner, but his precise relationship to the property remains a challenge to historians. The first owner probably used the building for stores and rented them.

In 1851 the land and the building were owned by the Hanover Bank, which used the building as its headquarters. The Bank maintained the original townhouse quality of the building, and its appearance today is little changed from a picture owned by the Bank dated 1851.

This was the period when South Street was the headquarters for the great clipper lines to California, the Far East and the Indies, when the Port of New York and the American

Merchant Marine boasted such highly successful steamship services as the Collins Line, the Bremen Line and the Havre Line, all proudly carrying the flag of the United States and employing ships built in America. It was a period of rapid business expansion and great change in New York. It merged into the Civil War era, and, while shipping declined, the nation's whole economy moved ahead so rapidly that by 1870 the Hanover Bank had outgrown India House. In that year India House became the New York Cotton Exchange. With the Maritime Exchange, founded three years later, and the Stock Exchange, both located on Broad Street, the Cotton Exchange became a part of one of the vital centers of New York business.

All three major exchanges were in walking distance of each other and of the forest of masts that towered above South Street. The ties of all three with ships and shipping were quite direct, even visible. To get the proper perspective of India House in that day, it should be remembered that New York was rimmed along its eastern shore by the so-called street of ships, South Street. The top masts of the clippers of that day and the great sailing ships that followed the clippers were taller by far than even the tallest buildings, with the possible exception of Trinity Church's historic spire. New York's horizon from the sea was concave in those days, not convex as today's skyscrapers make it.

The physical domination of the New York scene by ships and shipping found its parallel in the world of business, for the business community of New York was dependent upon shipping. The insurance business began as marine insurance. The earliest exchanges of capital were transactions involving money owned by shipowners. Sea-lanes were our roads. Virtually all commerce came and left by ship. People realized their reliance on maritime commerce, something many have forgot or never even known. It is the preservation of this heritage of New York's past that is coming to be seen as a new and most important responsibility of India House.

After sixteen years of use as the Cotton Exchange, India House became too small for such a growing institution. The proprietors of the Exchange acquired property across the street and moved. To this day the new location has served this important phase of New York's mercantile life. The property at 1 Hanover Square was purchased by W. R. Grace & Company, a firm whose growth has matched the evolution of the port. Its origin was in shipping, though its expansion and growth have found new opportunities around the world in many different spheres of commerce. But once again India House became too small for its owner, and the Grace interests moved south to a new and larger structure.

In May of 1914 a group of business leaders headed by James A. Farrell and Willard Straight organized India House and rented the building from George Ehret, the owner at that time. In 1918 Mr. Straight bought the property, and at his death it was acquired by the Club. In 1924 the well known architect W. A. Delano renovated the interior. It is interesting to note that four of the leading figures in the first days of the Club are represented by their sons in directing the affairs of India House at this time. The four were James A. Farrell, Joseph P. Grace, P. A. S. Franklin and Clifford D. Mallory. Their sons are James A. Farrell, Jr., Peter Grace, John M. Franklin and Clifford D. Mallory, Jr.

In 1965 the Landmarks Preservation Commission of New York held a public hearing

on the proposed designation of India House as an historic landmark and the designation of the property as an historic landmark site. Three witnesses appeared, and all spoke in favor of the designation. No one was in opposition, and on December 21, 1965, the Commission officially designated India House as a "Landmark" and its ground plot as a "Landmark Site."

In announcing its designation, the Commission summed up the importance of India House as a notable New York building and as one worthy of the landmark designation:

"This brownstone building with its handsome doorway, cornice and pedimented windows illustrates Anglo-Italianate architecture to perfection.

"Above a strong base the smooth masonry walls rise to a well-detailed cornice, carried on closely-spaced brackets. The entrance is made effective with Corinthian columns and a fine railing above (balustrade). As an example of a large, free-standing symmetrical building, India House has few to equal it in architectural excellence in the City. This building is important because it was basically the prototype of the New York brownstone residence."

The Commission's summary of the site of India House is also important, and gives proof of the wisdom of the Club's founders in selecting it as their headquarters.

"The site too is important, for placed as it is, in the center of the financial district, it adds to the cityscape and gives a feeling of warmth and intimacy to the surroundings, which are of almost unrelieved concrete and steel. It is the very kind of architecture and site of India House which attracts so many visitors to our City.

"The entire area is almost completely populated on Saturdays and Sundays with tourists carrying cameras who are seeking to find some small part of New York as it once was. If India House as it now stands were to be dismantled or moved, it would be a great loss to all of us. Indeed, such short sightedness applied to this and other Seventeenth, Eighteenth and Nineteenth Century buildings in New York could wipe out all evidence of the periods of growth of our City."

Fortunately India House will not be destroyed and replaced by another tower of concrete and steel. Its importance as a club for leaders in the city's maritime world is now secure. Its recognition as a landmark building and site has given new validity to those who are determined to insure that it will carry forward to future generations the story of New York's and the nation's roots in our maritime heritage.

In its summation the Landmarks Commission ruled as follows:

"On the basis of careful consideration of the history, the architecture and other features of this building, the Landmarks Preservation Commission finds that India House has a special character, special historical and aesthetic interest and value as part of the development, heritage and cultural characteristics of New York City.

"The Commission finds further that, among its important qualities, India House is one of the few surviving New York banking houses of the mid-Nineteenth Cenutry, that it is a rare and outstanding example of a symmetrical Anglo-Italianate Brownstone and that it symbolizes the important period during which the City was achieving its first major growth.

"Accordingly, pursuant to the provisions of Chapter 8-A of the Charter of the City of New York and Chapter 8-A of the Administrative Code of the City of New York, the Landmarks Preservation Commission designates as a Landmark India House, 1 Hanover Square,

Borough of Manhattan and designates Tax Map Block 29, Lot 33, Borough of Manhattan, as its Landmark Site."

All this, and without even stepping inside to view the treasures of the India House collection, which, after all, are the chief purpose of this revised catalogue.

THE PORT OF NEW YORK
An Historical Sketch

THERE is no economic factor in modern times that has more profoundly affected the destinies of the human race than the development of ocean transportation. This is true whether the shipping industry be considered from the standpoint of its contribution to temporal welfare, or with regard to its influence on social institutions. From the first voyages of Columbus down to the middle of the nineteenth century, men engaged in the work of building, operating and sailing ships in constantly increasing numbers. In the course of time masses of population were transformed from predominantly agricultural to maritime communities, a change which was reflected not merely in business and social codes but in the more fundamental matters of practical and political philosophies and religious beliefs. On the material side, the industry not only afforded new employment for immense bodies of skilled and unskilled workers; not only furnished one of the greatest available fields for investment and profit, while supplying both physical and financial means for developing new continents, but it provided, in time, a vast experiment station in which the first great inventions and discoveries of the present era were perfected and utilized. It would, indeed, hardly seem amiss if the historian of the future were to characterize the four centuries following the early Spanish explorations as the "Shipping Age."

It was inevitable that America should profit by the expansion of sail and, of all places in America, New York City, perhaps, owes more to shipping than any other locality. Conversely, shipping owes more to New York than to any other locality, a statement which will presently be considered in some detail. It is, indeed, this debt and this contribution which make it peculiarly fitting that the people of New York should erect such memorials as India House in honor of the men who established her prosperity, and to perpetuate as living, activating principles those qualities of courage, self-reliance, vision and initiative which their sea-faring activities developed in so high a degree.

The harbor of New York was formed by nature and predestined by situation to be an important seaport. Looking backward, there is a temptation to assume a certain inevitability not merely in the direction but in the rate of its growth. The matter, however, is not so simple. In human affairs progress is a matter of character as well as of resources. Great as the city was bound to become, it by no means follows that she must have eventually attained her present relative position, or that her development should outstrip every rival with a rapidity unprecedented in history.

It would be interesting if it did not involve too great a digression, as well as the risk of unwarrantable deductions, to speculate on the situation if Holland had continued to hold New Amsterdam, or if the withdrawal of the British in 1783 had not afforded her inhabitants

an opportunity for the free exercise of those qualities they later demonstrated. It is sufficient, however, to note that Manhattan was held successively by the Dutch and British for approximately 175 years. At the close of that long period its population was 20,000 and there had, as yet, been virtually no indication of that remarkable spirit of activity and enterprise which characterized it shortly after the ratification of independence. Less than 25 years after the evacuation by the British its population had increased more than four fold, while in maritime affairs it had risen from third place to a commanding lead over all competitors in the thirteen states, outdistancing even Philadelphia, which at the close of the Revolution had possessed far greater wealth and twice its population. The lead thus gained New York never lost. On the contrary the city entered upon a period of growth and achievement surpassing anything the world had ever seen. In less than 75 years her men were to accomplish more than the greatest and richest centers of Europe had accomplished in a thousand. What is more, they achieved this result by a single hearted devotion to one object—the building of a superior and successful merchant marine.

Too much stress cannot be laid upon this point, which, it is submitted, can and should be made without reflecting in any degree on the truly admirable achievements of other American ports. Broadly speaking, New York not only built and operated better ships on the whole than other sections, but she took the lead in costly experimental work and in the design of new models and new aids to efficient water transportation. While America's contest for maritime supremacy lasted—that is to say, from 1784 to 1860—New York merchants, builders and seamen were responsible for more important improvements in ships and greater progress in seamanship than any other port in the world. In that great sea tourney they took more firsts than all the rest of the nation combined.

It was New York that opened the China Trade; that first applied steam to successful navigation; that launched the first steam warship the world had ever seen, and that put the first steamboats on the Great Lakes and the Mississippi, supplying thereby a factor to which the West owes much of its rapid development. Her steamships were the first to make ocean voyages; the first to cross the Atlantic, and the first to apply successfully the principle of twin screw propulsion. New York men founded the first packet lines; perfected that service until it became the backbone of our former maritime supremacy, and in it repeatedly broke every transatlantic sailing and passenger carrying record, and established the marks which stand today. It was a New York built pilot boat which, in 1789, decisively defeated the champion of the Chesapeake in the first recorded match of the kind; New York which first produced the new and extraordinarily efficient version of the clipper ship; her clippers which established the first unbeaten sailing records; which wrested control of the exclusive and valuable tea trade from the combined British fleets in 1850, and which gave first expression to the essential principles embodied in every subsequent fast sailing ship. Throughout the first half of the nineteenth century the city invariably led in the race to build larger merchantmen. Her yards produced the largest wooden ships of all time; her designers developed the longest, fastest and most palatial inland water craft the world has seen, and in the process trained and sent forth not a few of the greatest naval architects of America, including Samuel Hartt Pook and Donald McKay. It is neither desirable nor practical to list her achievements in full,

but enough has been said to indicate that here is something not wholly to be explained by natural resources or geographical position, any more than the possession of wealth explains Washington, or its lack, General Grant.

Even before the Revolution New York had attracted a few exceptionally able shipwrights. From John Latham, in 1701, to Thomas Cheeseman in 1770, we may reckon a dozen or more who launched ships equal in quality and design, if not in size, to those produced by the best yards in Europe. In 1774 Cheeseman built the *Maria-Wilhelmina*, a great three-decker measuring more than a thousand tons. Half the town assembled near the foot of Dover street to see her launched, and it is sufficient commentary on Cheeseman's work to note that 65 years were to elapse before another merchant ship of equal size was laid down in America. It was something for a city to have builders of the technical skill, daring and vision of the Cheesemans, the Lathams, Gilbert Pell and Totten & Crossfield. Nevertheless, in spite of occasional indications of a latent spirit of progressiveness there was little in colonial New York to foreshadow the remarkable wave of collective energy and individual initiative which later enabled her to overtake not only the larger centers of Boston and Philadelphia but the greatest seaports of Europe. Before the Revolution, in fact, America had reached a curiously static condition. Class lines were closely drawn. The restrictions of the mother country became more galling year by year. If actual repression occurred but rarely, its threat was always present and exerted a powerful influence. The entire country appears to have been waiting. Such progress as took place resembled the slow unfolding of vegetation rather than a growth conditioned by human enterprise. With the coming of peace and independence, it was as though floodgates had been thrown open, releasing the pent-up ambitions of a century past. All America seethed. The national tempo quickened overnight to a feverish pace.

* * *

For practical purposes the history of the Port of New York may be said to begin on Evacuation Day, November 25th, 1783. At one o'clock on that day the British troops drew in their outposts, marched down Queen Street and the Broad Way and out of America. A youth loitering in Hanover Square before the present site of India House, where Robert Gault was soon to establish his shipping business, would have heard the rattle of arms and tramp of feet as they passed. An hour later he might have glimpsed the Continental buff and blue as Washington's escort wound down toward Gage's and Fraunces' taverns where huge banquets were in preparation. If the same observer could have returned there at opportune moments through the approaching years, he might have beheld from that single vantage point the first appearance of more revolutionary types of ships; the beginning of more epoch making maritime adventures, and the start of more record breaking voyages than all the rest of America, if not the world, was to witness during the next seventy years. There was, of course, small thought then of such matters, but even as Washington and his staff dined that night and drank the innumerable toasts appropriate to the occasion, the repatriated merchants, ship-builders and mariners of New York were busy with plans for the resumption of a commerce interrupted by eight years' civil strife, and for its glorious extension into new fields.

The task they faced might have daunted the most courageous. They had almost no ships suitable for long voyages and little money. They had no commercial connections save in the West Indies and a few European ports. For one hundred and seventy-five years Colonial America had been virtually restricted to the North Atlantic ocean with the exception of the African slave coast. They faced the prospect of ruinous competition from former foes armed with unlimited capital and animated by ill will. They knew that they must put their ships to grave risks in unknown seas and that, lacking specie, they must gather means of barter by their wits. Nevertheless, they set about their task as valiantly and as undismayed as eight years before they had set about driving the mighty power of King George from their shores. Within ninety days from the date of Washington's triumphal entry a company of Philadelphia and New York merchants had procured a smart new ship, commended themselves to God and their six pounders, and with a sound money cargo of ginseng set out in the general direction of Canton.

The departure of the "fast sailing ship" *Empress of China*, Captain John Green, master, for Canton on the morning of Washington's birthday, 1784, was an event of major importance in the history of the Port of New York. The venture proved modestly successful. Its effects on the commerce of America were, however, far from modest. For the moment the nation's future hung in the balance. The merchants of Europe intended and confidently expected to control our carrying trade. Even our own leaders, for the most part, held and expressed pessimistic views as to America's ability to carry on a foreign trade without the support of their mother country. The cheering report brought back by the *Empress of China* changed all that, proving as it did, that our ships could compete successfully with the greatest merchantmen of Europe in the most exclusive market of the world. Thenceforth, nothing seemed impossible. Every important port along the coast hastened to send ships to the Orient, some by way of the Cape of Good Hope, others by the Oregon route. What might have happened if our merchants had delayed this first venture, awaiting reliable information, is another story. The time element was tremendously important in the early years of the Republic. Oregon was secured to the Union by a painfully narrow margin and largely through the voyages of the first China traders. We pushed into the Mississippi valley and bought Louisiana at a crucial moment, and here again we were assisted measurably, if not decisively, by the wealth gained through foreign trade.

It was a day of small things in cousin Jonathan's dominions, and ships were no exception. The average size, even of those engaged in long voyages, was less than 200 tons, or from 70 to 80 feet in length. Most of these were brig- or schooner-rigged. Some full-rigged ships measured less than 100 tons. For this there was an excellent reason; New York merchants were poor. They could afford neither to build nor load large vessels, and when it happened that a large ship was built to fill some special requirement, it was usually found convenient to divide her ownership among a number of merchants. The *Maryland*, for instance, a vessel of 465 tons, was owned jointly as late as 1805 by more than thirty residents of New York, including Nicholas Low, Roswell Colt, Archibald Gracie, Isaac Moses, Nicholas Fish, John Jacob Astor, the Ogdens, Winthrops, Gebhards and others, even then reckoned among the most substantial men of the city. For similar reasons of economy it was

the normal and salutary practice for the sons of such men to begin their career in the forecastle. As a substitute for a school of finance it had its shortcomings, but its graduates were well grounded in courage, initiative and knowledge of human nature.

Thus, before and after the Revolution, Peter Schermerhorn, later prominent in the field of marine insurance, was master of schooners and brigs in the New York-Charleston trade. Captains Mark Collins, Preserved Fish, Henry Marshall, William Chambers, James Rogers, John and Samuel Armour, William Whitlock, Pierre Depeyster, Andrew Ogden, John Palmer, James Goelet, Thomas Randall, Richard Law, Henry Kermit, George Lippincott, Maurice Murray and scores of other mariners who bore names still familiar and still for the most part represented on the street signs and in the business directories of the city, were gaining at sea the experience and financial competence which later enabled them to found substantial shipping concerns and establish the first banks and insurance companies of the little town. Others, like the Rhinelander, Roosevelt, Lenox, Constable, Low, Stewart, Ludlow, Stuyvesant, Brevoort, Pell, Livingston, Gouverneur, Varick, Kemble, Forbes, Aspinwall and Shaw families, harked back to still earlier generations of merchants and mariners. A majority of these owned and attended their own stores.

Hanover Square was, and for some years after the close of the Revolution, continued to be the center of the wholesale and retail trade. It was lined with shipping firms, dry goods houses and printing establishments. Peter Goelet's general store there displayed an astounding variety of merchandise. The Schermerhorn ship chandlery stood near by. A few doors to the North, John Roosevelt sold liquors in Maiden Lane hard by the Fly-Market. In the immediate neighborhood "Nick" Stuyvesant, Isaac Moses, the Morrises and Livingstons were active in dry goods. Warehouses for heavier merchandise—hardware, naval stores, oil, sugar, hemp, molasses, etc.,—were conveniently located a few steps from the square at Old Slip and neighboring wharves.

During the turbulent Napoleonic period which followed the French Revolution, New York's phenomenal growth attracted large numbers of enterprising traders and mariners from other localities: Macys and Willets from Nantucket and Eastern Connecticut; Howlands, Delanos, Champlins and Grinnells from New Bedford; more Griswolds from Lyme; Hurlbuts from Essex; Morgans from Hartford; Wetmores from Middletown; Fannings and Phelpses from Stonington; Havens from Sag Harbor; Minturns and Centers from Hudson; Scovells and Lords from Saybrook. Still others; the De Rhams from Holland; Eckfords and Bells from Scotland; Browns from Ireland; the Loines, Bayards and Le Roys from France and many others from every nation of Western Europe were drawn from abroad through business connections established by local merchants. A complete list would read like a roll call of the distinguished families of today and would include, moreover, several who once occupied the center of New York's stage, whose names are now remembered only by the antiquarian and whose fleets vanished long ago.

* * *

Following the Reign of Terror, American commerce was ground between the millstones of France and Britain through more than twenty years of thinly disguised warfare.

New York shipping suffered severely. Hundreds of her ships and cargoes and thousands of her seamen were seized. For years British frigates and seventy-fours lay off Sandy Hook, sending their swift armed tenders in pursuit of incoming and outgoing vessels. If a ship, through speed or favoring weather, had the fortune to escape the British there were still the French with Spanish and an occasional Dutchman for makeweight. Many local merchants and mariners were ruined by losses incurred through tactics defensible only by the law of the jungle. Yet the wealth of the town continued to increase in an amazing fashion. One result of the depredations, in fact, was to foster that improvement in ships and seamanship which eventually won for America the supremacy of the clipper period.

New York already had several excellent ship-wrights, one of whom, Forman Cheeseman, son of old Thomas Cheeseman, built some of the best vessels produced in America in the 1790's. Among those who became active after the close of the Revolution was Ebenezer Young who built the *America*, in 1788, for Alexander McComb. She was a fine three-decker with stern and quarter galleries, of 561 tons register (her actual tonnage being, of course, much greater) and so far as has been ascertained the only three-decked merchantman aside from the *Maria-Wilhelmina* to be constructed in the city until the packet *Liverpool* was launched by Brown & Bell in 1843. It is true that several other three-deckers, and even a four-decker were built during the interval, but they were intended primarily for sale abroad as men-of-war and have, therefore, no place in this account save as indicating the degree of skill and competence attained by New York ship-builders during the first quarter of the last century. The *America* was put in the China Trade and sold in 1792 to Isaac Gouverneur, Jr., Peter and Robert Kemble, Nicholas Crugar and William Edgar. Another builder of this period was James Brewster, as was Samuel Ackerly who built, in 1802, the great ship *Manhattan*, of 667 tons. She was owned by the Rhinelanders and was the largest merchantman built in America for many years.

Other prominent builders who located in New York shortly before and after 1800 included Christian Bergh, noted for his sharp, fast ships; Henry Eckford, who first located his yard in Brooklyn and became one of the foremost designers of his day, training, incidentally, Isaac Webb, Stephen Smith and other notable builders; John Jackson, who built the frigate *John Adams* and the large China trader *Canton*, as well as other vessels, on the Wallabout; Elisha Blossom in Queens county, Amos Cheney in Brooklyn, and last, but not least, Charles, Adam and Noah Brown. Most of these were active until 1830 and later. With the arrival of such men upon the scene, Philadelphia's claims to superiority were effectively challenged. This is not to say that she ceased to produce fine able craft, but she no longer built larger, faster and better ships than New York, nor did she produce as many.

It is not easy to account for the rapidity with which New York overtook and passed the rival ports of Boston and Philadelphia during these early years. Certainly the great economic factor of her position as the natural outlet for the commerce of the West had not yet become operative. The territory from which she drew her trade was still limited. The larger ports of Connecticut operated foreign fleets of their own; the barren banks of the Hudson yielded but a scant surplus for export, while the richer areas to the North and West were handicapped by a lack of adequate water transportation beyond Albany and Troy.

Probably one element of the explanation lies in the fact that New York was almost completely cut off from land traffic. Every ton of her merchandise, except that consumed locally, had to arrive and depart by water, while in Boston and Philadelphia carriage by land constituted an item of some importance. New York merchants therefore, were not only able to concentrate wholly upon shipping but were compelled to supply more tonnage in proportion to volume of traffic than other places. Another element of the explanation may lie in the fact that New York's population was not only slightly more cosmopolitan than that of either Boston or Philadelphia, but it was somewhat less subject to the restraining influence of a strong conservative class. In the early days of the Republic, conservatism did not pay. It was necessary to take chances — frequently to the point of recklessness — if anything was to be accomplished. Merchants and shipmasters of America were not timid but, scanning the record, it seems fair to say that those of New York appear to have taken more chances and, on the whole, took them first. Other ports might build one or two excessively large ships; New York would build three or four. Other ports specialized in sharp, fast vessels, or in stout, burdensome craft; New York had all varieties and soon had them in greater numbers, trusting at first, apparently to skill, chance or daring for their profitable employment. For this, again, environment provides a partial explanation, since the town's only outlook was on the sea. True, differences, whether mental or physical, were not great and it is easy to exaggerate them, but in time they turned the scale. Possibly their most important immediate effect was to attract to the city large numbers of those energetic, ambitious, intelligent young men, who in every age are the first to scent boom conditions in the making. Before 1810 the registered tonnage of New York was nearly double that of her nearest rival.

When the economic history of the United States is written, proper stress will doubtless be laid upon the time factor in appraising the results of new developments. Many an early sea fight was determined by the first broadside. For years men, at home and abroad, had been trying to solve the problem of steam. In Philadelphia shortly after the Revolution, Thomas Fitch and Oliver Evans had built small steam craft which operated with a degree of success, but neither of them had been able to secure funds for reproducing their inventions on a commercial scale. It remained for Chancellor Livingston of New York to supply the necessary backing to Robert Fulton, with the result that in August, 1807, the *North River Steamboat*, of Clermont, made the first successful steamship passage in history. Before the War of 1812 opened New York had half a dozen steamboats in operation or under construction and had sent Nicholas Roosevelt to Pittsburg to build the first Mississippi river steamer. Before the war closed, her men had completed the *Demologus*, the first steam warship to take the water.

As an object lesson in leadership these achievements had a tremendous moral effect. Here, at last, was a clear cut case which could neither be minimized nor disputed. New York shipping men knew, or thought they knew—which amounts to the same thing—that henceforth the eyes of the world were upon them. They already looked on themselves as leaders in America but the steamboat was a world beater. Their former modest rivalries assumed new scope and meaning: in the future it was to be "New York brains and enterprise against

the universe." The matter had still another consequence. The successful navigation of the Hudson by steam undoubtedly advanced measurably the date of opening the Erie canal and contributed to the earlier and more rapid development of the West. In retrospect, it appears to have been one of several important factors which vastly accelerated growth throughout the United States while other sections of the New World were advancing slowly. What might have happened if Livingston had delayed his aid or if Fulton had developed his invention elsewhere, is difficult to say. On one point there can be no doubt: for the community sharing in such an achievement the thing had a positive value; for others its content was negative.

* * *

The declaration of peace in 1815 marked the second stage of the port's development. It had grown mightily in wealth and numbers since 1783. An estimate based on the census of 1820 would place the population of New York at not less than 130,000. Remarkable as this growth was it was nothing compared with what lay just ahead. Assured now, for the first time, of freedom at sea and security along the western frontier, her progress during the next decade far surpassed the wildest speculations of her citizens.

Growth, however, poses new needs and new problems, and the chief need of the young republic was better transportation. On land, it would be another 15 years before the matter was attacked, but on water a certain degree of improvement was considered not only possible but normal. For years slow advances had been made in speed and comfort. The Revolutionary War had refined the lines and added royals to the sail plan of fast merchantmen, and the War of 1812 had raised canvas another tier and popularized the "skysail yarder." Thirteen knots was now known to be a possible rate of travel. In the matter of accommodation the better first-class cabins now boasted a height of six feet, while steerage quarters between decks usually measured somewhat over rather than under five feet in the clear. Four and five hundred ton ships were still rare but there had been a decided increase in their number, and of these, New York, as a matter of course, had the lion's share, among them Isaac Bell's *Trident*, of 461 tons, Astor's *Beaver*, of 447 tons, the *Braganza*, of 469 tons, owned by Archibald Gracie & Sons, and a few more of about the same size. It was soon evident, however, that the supply of large vessels was far from sufficient. Merchants were wealthier and the country more populous. Larger cargoes could be bought and sold to advantage. A flood of immigration was setting in, for which additional passenger space must be provided. There was also a decided increase in foreign travel among well-to-do classes, and forward-looking merchants saw opportunities for profit by providing larger and more comfortable quarters for them.

In short, the inevitable post war boom was on, accelerated in 1816 by a partial crop failure abroad, which stimulated the demand for American foodstuffs and increased immigration to an abnormal extent. All sections profited by this condition, but most of all New York, which by now was strongly intrenched in the coastwise and foreign commerce of all important Southern ports. New York merchants were, in fact, rapidly becoming specialists in the carrying trade of the South, a matter depending more on initiative and efficiency

than on superiority of location or the bounty of nature. Other ports engaged in this sort of activity but, on the whole, their shipping was devoted more exclusively to local merchandising problems. It was but natural, therefore, that New York should take the lead not merely in improving but in expanding her shipping service.

The year 1815 noted a vast increase in the number and size of vessels laid down in local yards. Of the merchantmen, the *Nestor*, built by John Lozier and measuring 481 tons, was the largest. She was owned by John Pierpont, Levi Coit and Joseph Howland, Jr. Most of the new ships were smaller but there was a substantial increase in average size over that which had prevailed before the war. The *General Brown*, indeed, measured almost 900 tons. She was a three-decker built by Adam and Noah Brown who constructed in 1814 the *Fulton* (or *Demologus* already noticed as the first steam warship of the world) and who also built during the same year the *Saratoga* and other ships of McDonough's successful fleet on Lake Champlain. The *General Brown* was built with an eye to Latin-American naval requirements and did not, therefore, appreciably affect the local shipping situation.

An innovation of prime importance was effected in January, 1818, when the "Black Ball Line" opened the first "regular sailing service" in history. Theretofore the best and most reliable transportation had been furnished by the class of vessels called "regular traders." They were exceptionally well-built ships with superior cabin accommodations which plied regularly between certain ports, but they had no fixed sailing dates. They left when loaded or when it suited the convenience of owners. Consequently prospective passengers from distant points were usually compelled to live in local hotels or boarding-houses for days and even weeks while waiting for their ship to sail. The agents of the "Black Ball Line"—Francis Thompson, Isaac Wright and others—undertook to remedy this state of affairs by guaranteeing sailings on a fixed day of the month to begin in New York on January 5th and in Liverpool on January 1st, 1818. The service began as scheduled with four ships, the *James Monroe*, *Pacific*, *Amity* and *Courier*, three of which measured less than 400 tons, and was maintained without a break for more than sixty years. From the first it proved popular and met with deserved success. After several years other lines were formed until, by 1825, New York's packet service had been extended to other British and European cities and was so far superior to that afforded by other ports that she had virtually undisputed control of the richest and most remunerative part of the transatlantic trade. Thus began a service which became the very cornerstone of America's brief but undeniable shipping sovereignty. The packets were at once the envy and despair of Europe. No expense was spared to make them the safest, most comfortable and—of their type—the fastest ships afloat, and for years they provided, perhaps, the most efficient training school in existence for officers, merchants and designers. The imponderables of such experience and practice can not be estimated with any degree of accuracy, but it is safe to say the maritime record of America without the achievements of Captains Charles Marshall, N. B. Palmer, R. H. Waterman, Asa Eldridge, E. E. Morgan and a dozen more of the same stripe, all graduates of the Western Ocean packets, would lose much in both weight and color.

* * *

While the forgoing changes were being effected in sail, New York was making equally significant experiments in steam. The war of 1812 ended with the city in possession of a substantial majority of the steamboats on this side of the Atlantic, the largest of which, the *Car of Neptune*, measured upwards of 350 tons. We have seen that the first Mississippi steamer was built in 1811 by Nicholas Roosevelt, who had been associated with Fulton in some of his experiments. It remained for a New York engineer, B. French, in 1816, to design and build the first low pressure oscillating engine for the Mississippi river steamer *Washington*, and such was its effectiveness that the results of his work were adopted in principle by all river steamers from that time forth. The fly in the ointment was furnished by the attempt of Fulton and his backers to monopolize all river navigation under a grant by the New York legislature. This claim was quickly defeated so far as the Mississippi was concerned, but it was not until 1824 that the act was declared unconstitutional and the waters of New York thrown open to all comers.

The sea, however, was open to any who cared to navigate her waters in steam and here again New York enterprise came to the front. In June, 1809, the *Phenix*, a steamboat built and owned by John Stevens, made the first ocean voyage in history, running from New York to Philadelphia. Now, in 1818, merchants of the city laid down two steamships which they believed capable of making long ocean voyages and able, even, to cross the Atlantic. One of these was the *Savannah*, whose story is well known. The history of the other is more obscure, which is strange considering that she was a much larger and more powerful steamer than the Savannah, and far more suitable than that vessel for a transatlantic voyage. The *Robert Fulton* was a steamship of 750 tons, built by Henry Eckford for David Dunham & Co., of New York, and equipped with the most powerful engines ever put in a vessel. She was designed to run between New York and New Orleans, touching at Charleston and Havana and carrying passengers only, for which service she was very handsomely equipped. As an ocean steamship she was an undoubted success, and she made regular and fast trips to New Orleans for several years, her actual running time for the voyage being about 13 days. However, as a commercial venture she was in advance of her time. As yet, little demand existed for the sort of accommodation she offered Southern travelers and in 1825 she was sold and converted into a sailing ship. About 1827 she turned up in the Brazilian navy where, as the *Regeneracion*, 24 gun sloop-of-war, she made a reputation as one of the fastest naval vessels afloat.

By 1820 New York's 20,000 inhabitants had increased to 152,000. Ten years later her population reached 242,000, having long since left Boston and Philadelphia hopelessly in the ruck. In 1850 it amounted to 696,000, and long before the outbreak of the Civil War it had passed the million mark. Striking as this growth appears, it was less remarkable than the character of the port's development in the same period. By 1830 the world had learned not merely to expect from New York the finest merchantmen afloat but looked to her for a majority of the noteworthy improvements in motive power and speed design. There were excellent reasons for this. In 1820, in addition to the older ship-builders already noted, nearly a dozen exceptionally able younger men were active: Christopher Boyd, George James, Lewis and Joseph Webb, John Aikman, William Millen and James Morgan. During the

twenties these were reinforced by Blossom, Smith & Dimon, Isaac Webb, Sidney Wright, Brown & Bell, Jacob A. Westervelt, Francis and Scott Fickett and others, and the shipyards which lined the East River from Corlear's Hook to Twelfth street, were training ambitious youths like Donald McKay, John Willis Griffiths and Samuel Hartt Pook, who were later to play spectacular roles in the great clipper ship drama. And there were the engineers and inventors: James P. Allaire, John Stevens, Dr. Nott and many more, fired with strange, incomprehensible visions. There also was the raw material for a new business species—the great promoters—Cornelius Vanderbilt, the Skiddys, Isaac Newton, Daniel Drew and "Hell fire" George Law. These, with their immediate successors and descendants, constituted the backbone and furnished the motive force of New York's shipping industry until the demands of the clipper era brought an influx of new blood in the 'fifties.

Stimulated, doubtless, by competition of the new "Black Ball" variety, there was a decided increase in number and size of ships built at New York in 1821 and 1822. During these two years no less than 36 full-rigged ships were launched, aggregating 14,500 tons, an average of more than 402 tons per vessel, in addition to a large number of brigs, schooners and steamboats. By the end of 1822 the following new ships were afloat: the *Isabella*, measuring 520 tons, built by Henry Eckford; the *James Cropper* and *William Thompson*, of 495 tons each, built by Sidney Wright; the *Hannibal*, of 440 tons, from Fickett & Crockett's yard, and the *Florida*, registering 523 tons, laid down by Blossom, Smith & Dimon. Brown & Bell built the *New York*, of 516 tons, and Isaac Webb, the *Superior*, of 576 tons. These ships exceeded by a substantial margin the average tonnage of vessels of their day. The following year saw a further advance, when Isaac Webb launched the *Splendid*, measuring 642 tons.

A majority of the above vessels were built for the Black Ball service or for new competitive lines projected about this time. These included two rival Liverpool lines: the "Red Star Line," founded by Byrnes, Trimble & Company, which began operations early in 1822, and the "Swallow Tail" or "Fourth Line," organized during the summer of the same year by Thaddeus Phelps & Company and Messrs. Fish & Grinnell. Since the "Black Ball Line" had increased its service in 1821 by the addition of four ships (sometimes referred to as the "Second Liverpool Line") this gave New York weekly packet sailings to that port. Several other attempts on the part of owners of "regular traders" appear to have been made about this time to establish packet lines, but they were unsuccessful.

In 1822, also, the scope of the packet service was enlarged by the formation of the first Havre line by Francis Depau and his associates. Among ship owners identified with the early history of that service, Isaac Bell and William Whitlock, Jr., were prominent. During 1823 a second Havre line was organized, for which Crassous & Boyd, later Boyd & Hincken, acted as agents. Eventually these were united with a later line to form the "Union Line of Havre Packets." The first line of London packets was started during the summer of 1822 by Fish & Grinnell (later, by successive changes, Grinnell, Minturn & Company) and was operated in conjunction with their Liverpool "Swallow Tail Line" under the same familiar appellation. The second London line was founded by John Griswold and S. W. Coates with regular sailings beginning in September, 1822. It was known as the "Black Cross Line" and during

the 'fifties and later, after Captain E. E. Morgan assumed the management, as the "Morgan Line." New lines were to be added from time to time, some competitive and some to other ports, but the foregoing indicates in a general way the important field of the transatlantic sailing packets until they were displaced by steam some years after the Civil War.

Other ports soon attempted to follow New York's lead in the packet venture, but for the most part their efforts met with slight success. For many years only the Cope Line, of Philadelphia, was able to maintain a regular sailing schedule. Aside from this, New York held a complete monopoly of the transatlantic packet service until the Charleston line started in the late 'thirties. Train's Boston line, founded in the early 'forties, did not succeed in maintaining a regular schedule until 1845, while the Baltimore-Liverpool service did not attain stability until 1849.

One result of this local monopoly was to accentuate the rivalry between the several New York packet lines. Each year saw larger and faster ships laid down, until in 1826 the Black Baller, *Great Britain*, of 725 tons, was launched by Brown & Bell. This marked the limit in size until the larger packets of the 'thirties began to appear. Still, size was not everything. New York merchants and builders stressed speed and comfort even more than tonnage, so that their ships, large and small, were in great demand abroad. Before 1825 this led to the placing of orders with local builders for a number of warships of large size by the governments of Greece and South America. Christian Bergh built the Greek four-decker, *Hope*, in 1825, and other three-deckers were constructed about the same time, ranging from 1700 to more than 2000 tons in size. Orders of this character, of course, did much to strengthen the financial and technical position of the New York yards.

The monopoly had another result. It brought to the city hundreds of the smartest mariners of the period—men of that rarest of all types,—thinking men of action—masters able to design, rig and sail a ship, yet versed in the mysteries of maritime law, insurance, exchange and commercial transactions; equally at ease commanding a crew of the roughest elements or mingling with diplomats, princes or foreign celebrities. Stern, kindly men—true gentlemen, all—who, when their active work was done, had the unselfish wisdom and foresight to give their remaining best to the support of the city's merchant marine. Such a man was Francis Allyn, of the Havre packet *Cadmus*, who ferried Lafayette over from France on his last American visit in 1824. Such was Ezra Nye, of Cape Cod, who took the *Independence* to Liverpool and back in a trifle over 34 sailing days in 1836, and John P. Smith, who broke the record by driving the *Pennsylvania* to Liverpool in 14 days and 14 hours in November of the following year. Such, too, were Henry Champlin, Robert Griswold, Benjamin Waite, Edward G. Tinker, John Rathbone and the Holdredges and Palmers of Connecticut; Henry Huttleson and John and Joseph Delano of New Bedford; Seth and Josiah Macy, of Nantucket; Asa Eldridge, from the "Cape," and the Cobbs and Marshalls from "up state." From every section they came in numbers even now hard to reckon, and for 60 years rendered their priceless service.

* * *

By 1825, or thereabouts, the factors which were to determine the rate and direction of

New York's growth for the next generation could be listed: the Erie Canal; the fat frontier prairies now spouting golden harvests for European markets; the swelling flood of immigration; the slowly tightening control over the rich Southern and Oriental trades; unsurpassed shipyards and the builders, secure in the skill and mystery of their craft; stout, unbeatable ships; the promise of steam and, above all, the mariners—men like Captain Sam Reid, late of the privateer *Armstrong*, who had fought his little brig in the harbor of Fayal and soundly whipped a thousand picked blue jackets from the British fleet; men like James Rogers, George Maxwell, Miles Burke, John Stanton, William Bacon, Stephen Glover and three hundred more, who knew boarding pikes and long sixes as they knew ringtails and topmast stunsails, and who bought and sold rich cargoes or tacked ship in half a gale with the same unflurried judgment.

The older merchants and masters who had mapped the routes of trade were fast going, but their knowledge, their methods and, for the most part, their capital remained in the possession of tried and proved associates. Other, now aging, merchants were extending their activities to new fields; banking, insurance, manufacturing and real estate, founding new and ever greater enterprises on the profits earned at sea. Eventually such occupations would absorb the entire attention of the Rhinelander, Astor, Whitney and Schermerhorn families, but for the moment they were still engaged in shipping. Astor, indeed, was at the height of his trading career. In addition to the old *Beaver*, his fleet included such craft as the brig *Macedonian*, of 408 tons, then one of the largest merchant brigs afloat, and the *Seneca*, designed by Christian Bergh and one of the sharpest and fastest brigs out of New York. There were others whose names are now rarely heard, who then stood in the foremost rank of New York's merchant princes. Thomas R. Mercein was one. Besides small craft, he owned outright at one time twelve ships and brigs. J. P. Smith during the 'twenties was, perhaps, the most important figure in the China trade. Jacob Barker, the quaker, was another influential trader. His fleet included at various times many of the largest and finest vessels hailing from New York. The quakers, in fact, drew plenty of water in shipping circles during the early years of the Republic. For a time they virtually controlled the packet and whaling businesses, besides being tremendously influential in all other lines of trade. Many others, of the older merchants, deserve more than a passing reference: Peter Stagg, Robert C. Ainslie, John G. Coster, Stephen Jumel, John Kemp, David Wagstaff, the Murrays, Neilsons and Dunlaps, John Pierpont, Peter Harmony and John and Peter Crary. A majority of these, by 1830, were elderly men whose names would shortly disappear from the shipping registers, but all, in their day, had made important contributions to the development of the port and some had founded establishments which still survive.

The passing of such men, however, exposed no points of weakness in the city's commercial structure. Already the firms of Kneeland & Bogert, Foster & Giraud, N. L. & G. Griswold, Minturn & Champlain, Laidlaw & Gerault, Kingsland & Macy, Howland & Aspinwall and others were strongly entrenched and steadily broadening the scope of their respective operations. And for every firm of this character there were a dozen noteworthy individuals: John Griswold, Robert Center, George Newbould, Samuel Russell, Henry Remsen, the De Wolfs, Charles King, James Gillenden, Allen Shepherd, Benjamin Aymar,

Joshua Geer, Reuben Brumley, Silas Holmes, William Skiddy, Charles Morgan, Samuel Ward, George Sutton, Anson G. Phelps, Abraham Tanner, Abraham Bell; all by this time substantial owners and operators of shipping and destined to grow in importance for years to come. Just behind them in point of time were Stephen Whitney, A. A. Low, Robert Kermit, Mortimer Livingston, Eliphalet Kingsbury, Josiah Macy, Robert Olyphant, Moses Taylor, Samuel Fox—a list unfolding endlessly into the future.

During the eighteen-twenties the shipping business continued to expand at an unprecedented rate, but by 1831 a slight slowing up was noticeable—the first indication of a depression which was to spread and intensify year by year until, in 1837, panic swept the world, wiping out old business houses by the hundreds and retarding growth for years to come. Owing to the rapidity of her rise, New York seems to have suffered more acutely than most communities. Due partly to the same circumstance, no doubt, her recovery was more rapid. Many of the old firms were gone but the plant remained intact, and the knowledge and experience gained in counting-house and shipyard were unaffected. In addition, the advantages of New York's location were now becoming felt in a substantial way, and here the steamboat played an increasingly important part, bringing distant points nearer each year and constantly extending the area of her business influence.

Long before 1830 steamers were running regularly to the ports of Connecticut and Rhode Island as well as up the Hudson and down the coast. The first regular coastwise service started March 21st, 1815, when the *Fulton* began to run to New Haven. Three years later the same vessel inaugurated the service of the New London and Norwich line. The Connecticut River Steamboat Company started the Hartford line in 1825, and shortly thereafter the Providence line began operations. On the Hudson four separate concerns were running shortly after the abrogation of the Livingston monopoly in 1824, and in 1832 these were consolidated under the name of the Hudson River Steamboat Association.

About this time two notable men began to figure somewhat prominently in the steamboat world. In 1835, Cornelius Vanderbilt, who had been engaged in the business in a modest way for 15 years, brought out the new steamer *Lexington* (later burned with a loss of 150 lives) and put her on the Providence run as an opposition boat. At the same time Daniel Drew started an opposition line on the Hudson, calling it the "Peoples Line." These men and their associates provided, for many years, a brand of steamboat competition that varied from the amusing to the tragic, but which was always spectacular. Vanderbilt's new boat cut the running time to Providence to 12 hours and 28 minutes in 1835, which is about the length of the average passage today. Drew's boat, the *Swallow*, ran from New York to Albany in 8 hours and 42 minutes, including stops, during the summer of 1836. Under the spur of such competition New York steamboats increased rapidly in size and speed. In 1844 the *South America* reduced the actual running time between Manhattan and Albany to 7 hours and 14 minutes. This was lowered year by year until in the early 'fifties boats like the *Francis Skiddy* and *Isaac Newton* were skimming the river at rates ranging from 21 to 23 miles an hour. Long before this, however, the Vanderbilt-Drew interests had acquired virtual control of local steamboat traffic and Vanderbilt was reaching out for other worlds to conquer.

Nor were the New York steamers less remarkable for size than for speed. When William

H. Brown launched the *Empire* in 1843, she measured 320 feet in length and was the longest vessel in the world. The following year Robert L. Stevens built at Hoboken the first large iron boat constructed in America—the *John Stevens*, 245 feet long and capable of making 19 miles an hour. Other small iron vessels were built here about this time but for some years the experiment found few imitators. Large wooden craft, however, followed in rapid succession until the limit in size and magnificence was reached in great three-deckers like the *New World*, launched in 1848, and the *St. John*, built by John Englis & Son in 1864, a 417 foot craft, and the longest river steamer built during the last century.

The Southern steamship traffic developed more slowly. For some years it was carried on by a few small steam brigs and schooners. One of these, the brig *New York*, distinguished herself in April, 1823, by establishing a new record of 36 hours for the run from Norfolk to New York. Little of importance took place, however, until the Southern Steam Packet Company was formed in 1833 by James P. Allaire and others in New York to run between that city and Charleston. This company operated the small side-wheelers *David Brown* and *William Gibbons*, neither of which was 150 feet in length. Their service was hardly under way when Charles Morgan, who already had several sailing vessels in the Southern trade, put the new steamer *Columbia* on the route. In 1837 he added the *Home*, a fine vessel measuring 212 feet in length. The *Home* was considered the best steamer of her time, but her loss on Hatteras during her third voyage with nearly 100 of her passengers and crew put a damper on the service which lasted for years. In spite of this Samuel Glover had the twin screw steamer *Clarion*—so far as has been ascertained the first ship of that type—built in 1840 for the Havana run. It was not, however, until Spofford & Tileston established a line to Charleston in 1846 with the steamship *Southerner*, of 1545 tons, register, followed by the *Northerner* in 1847, that the real period of development began. In 1848 the famous Law Line to New Orleans was started but before it began operations the rush to California was on, and its run was immediately extended to Chagres in competition with Aspinwall's Line (later the Pacific Mail Steam Ship Company), a precedent Vanderbilt was not long in following.

Law's first steamers, the *Georgia* and *Ohio*, measuring 2700 tons, opened a new era in coastwise travel, and they were followed by others in rapid succession until his fleet numbered ten of the finest ships of the day and included such vessels as the *Crescent City*, *Illinois* and *El Dorado*, so familiar to forty-niners. In December, 1848, Aspinwall sent the *Panama* and *Oregon* around to San Francisco, and a year later he sent the *Caroline* out, followed shortly by the *Northerner*, purchased from Spofford & Tileston. The New York & Savannah Steamship Company (Mitchell's Line) was also founded in 1848, starting with the 1500 tonners, *Cherokee* and *Tennessee*, built by Webb. Supplemented from time to time by other lines and new figures, the traffic continued to grow and improve until checked by the outbreak of the Civil War, when many of the steamers were taken over by the government and furnished a service which contributed in no small measure to the success of the North.

While the foregoing expansion of the coastwise trade was under way, New York was also preparing for the first time to enter the transatlantic steamship field. The appearance of the little British steamers *Sirius* and *Great Western* in her harbor, April 23rd, 1838, failed to

impress local capitalists. Their wind packets were never larger, faster or more profitable, and they saw no reason to fear the competition of steam. After several years, however, they found it advisable to make some concession to the new motive power. The success of the Cunard line following the arrival of the steamer *Britannia* in Boston harbor in June, 1841, and the lessons of the Mexican War convinced them of the value of a powerful fleet of steamers, if for no other purpose than as a naval reserve. Accordingly, in 1846, the Ocean Steam Navigation Company was formed under the laws of New York, to build four vessels to run to Bremen, touching at Cowes; this route being chosen because of British opposition to the original plan making Southampton the Eastern terminus. They first built the *Washington* and *Hermann*, ships measuring 1734 tons, with a length of 235 feet, and the service started with the sailing of the *Washington* for Bremen, June 1st, 1847. Meanwhile, Captain Edward K. Collins, who operated the Dramatic Line of Liverpool packets, was busy with plans for a Liverpool line of steamers which should surpass the best performance of the Cunarders. As a result of his efforts the *Atlantic*, built by William H. Brown, and the *Pacific*, built by Jacob Bell, were laid down in 1848 and launched February 1st, 1849. They were followed by the *Arctic*, also built by Brown and launched January 29th, 1850, and the *Baltic*, built by Bell and launched March 2nd, 1850. All four ships were similar but not identical in model and equipment. They measured from 285 to 295 feet in length on deck and registered nearly 3000 tons. Their performance reflected credit on designers and engineers alike. A summary of runs of the *Atlantic* and *Pacific* over a period of six months, published in the New York Herald for December 6th, 1850, indicates that they surpassed the Cunard record by a fair margin, the American ships averaging 11 days, 13 hours and 13 minutes for the hard run to the westward, while the time of the Cunarders was 12 days and 13 hours. The *Atlantic's* run to Liverpool in 9 days, 17 hours and 12 minutes in February, 1852, was a record at the time, but it was surpassed the following August by the *Baltic's* remarkable time of 9 days, 13 hours to the westward.

During the 'fifties New York continued to build large transatlantic steamers in constantly increasing numbers and other lines were founded under American and foreign flags, until regular service was established with Havre, Cork and Galway, in addition to the Liverpool and Southampton lines. In 1856 the Collins line added the *Adriatic*, a huge vessel 352 feet in length over all, and registering 4145 tons. For the moment she was the largest wooden ship in the world although later Henry Steers was to build the *Great Republic*, with a length of 380 feet on deck and registering 4750 gross tons. She was launched in 1866 and was the largest wooden vessel ever built.

The construction of from one to ten or more steamers each year over the long period from the launching of the *North River Steamboat* to the completion of her huge successors sixty years later, not only benefitted New York shipyards and provided intensive training for a large corps of marine engineers, but had the further result of making the city the recognized center of engine construction in America. Accordingly, prior to 1850, when steamers were wanted at any point along the Atlantic coast, government agencies and private concerns alike were quite apt to look to New York to produce them. Thus, it was New York which, in 1837, built the *Fulton* (II), usually referred to as the second steam warship

of the United States, although the second was actually a steam galliot, the *Sea Gull*, also built in the city in 1822 for the purpose of chasing pirates in the West Indies. Again in 1840 the local yards were called upon to construct the steam corvettes, *Regent* and *Congress*, for the Spanish navy and the steam frigate *Kamschatka* for the Russians. At the same time the engines of the frigate *Missouri*, the largest and most powerful steam warship of her day, were designed locally. Two years later John Ericsson, who had been attracted to New York by its progressiveness in mechanical lines, devised the power plant of the sloop-of-war *Princeton*, the first screw-propelled warship ever laid down, and the first to provide adequate protection for machinery. In a very real sense, therefore, it was the enterprise of New York's shipping interests which fathered the steam navies of the world.

During the early part of this period by far the most important concern engaged in building and designing marine engines was the Allaire Company, which sprang from a brass foundry established in Cherry Street in 1806. James P. Allaire succeeded to the equipment of the Fulton Iron Works after Fulton's death in 1815, and thereafter his plant constituted an invaluable adjunct to New York's shipping until the close of the Civil War. The business eventually passed to T. F. Secor & Company who later built the monitors at Hoboken. Aside from two or three individuals who designed an engine or two, the next important concern of the kind was the Novelty Company, founded in 1830 by Dr. Eliphalet Nott, President of Union College. This business was taken over in the late 'forties by Stillman, Allen & Company who built the engines of the *Arctic, Great Republic* and other large ocean steamers, and who built the revolving turret of the *Monitor* in 1861. One of the next to appear was the Phenix Foundry, operated by James Cunningham and others which turned out the engines for the steamboat *Norwich* in 1836 and those of the *Francis Skiddy* in 1852, as well as many others. During the late 'forties Henry R. Dunham set up the Archimedes Iron Works and built engines for a long series of steamers, mostly river boats. Messrs. Hogg & Delamater started in business about the same time. Later, as the Delamater Iron Works, located on West 13th Street, Mr. Delamater constructed the engines of the *Monitor* and continued in business for many years thereafter building engines for coastwise steamships. The Neptune Iron Works supplied engines for a number of celebrated vessels during the Civil War. Fletcher, Harrison & Company were responsible for the equipment of the *Mary Powell* in 1861 and later, as the W. & A. Fletcher Company, built a number of Harlan & Hollingsworth engines. One of the latest in point of time was the Quintard Iron Works which, with W. & A. Fletcher Company remained in business long after most of the other firms had disappeared. All did valuable pioneer work in developing steam engines of various types and during the earlier period, especially, did much to hasten the day of efficient railroad transportation by solving in advance not a few of the practical problems of the locomotive.

* * *

While the "scientific gentlemen" of New York were thus engaged in the improvement of steam transportation, the old "canvas back" merchants and mariners were by no means idle. It cannot be said that they opposed the new motive power. Their attitude, rather, was

that of interested, albeit slightly derisive, patronage—an attitude destined to change as steamships increased in size, speed and carrying capacity during the 'forties, to that spirited, colorful rivalry which played so important a role in the development of the clipper ship. Even this rivalry, keen though it was, sprang less from apprehension than from pride in the old sailing craft. For this there was an excellent reason. The effect of steam on ocean freights was, and would continue for many years to be negligible. Long after the Civil War the great bulk of the world's merchandise still moved in sailing vessels, and even during the early years of the present century the opinion was prevalent that canvas would never be wholly displaced on the longer routes.

In every direction, therefore, during the 'thirties and 'forties, New York merchants continued to expand and improve their fleets with complete confidence in the future of sail. The Southern packet service was especially noteworthy for the rapidity and quality of its development. Starting in the wake of the Black Ballers in the early 'twenties, Messrs. C. & J. Barstow had founded the "Old Line" to New Orleans, to be followed shortly by the "New Line" of Silas Holmes & Company. John Laidlaw, Thos. L. Servoss, J. W. Russell, Phelps & Peck, Oroondates Mauran and others soon entered the field. Ripley, Center & Company and E. D. Hurlburt & Company operated between New York and Mobile. Wm. Whitlock, Jr., and J. & C. Seguine maintained lines to Savannah; Chárles Morgan, George Sutton and many more were active in the extensive Charleston trade, and J. G. Collins & Son, precursors of the famous "Collins Line," established a service to New Orleans, Vera Cruz and points in Texas. All this took place before 1830. Still later the firms of Spofford & Tileston, Stanton & Frost, the Cromwells, Nelsons and others appeared. The ships in these trades were small at first, usually measuring from 300 to 400 tons, and all were armed, for pirates were still active in Southern waters. For the most part they were heavily sparred and, since they were designed and fitted up after the best standards of the day for passengers, many of them were decidedly clipperly in appearance and performance. Ten and even eight day passages to New Orleans were not unknown. Spurred by the remarkable growth of the South and West, the ships increased rapidly in size and numbers until during the early 'thirties packets of five, six and seven hundred tons were common—ships like the *Natchez*, of later China fame, and the *Arkansas* and *Yazoo*. Nor did the matter end there. Southern commerce continued to forge ahead at a constantly accelerating pace until, in the late 'fifties, ships of 1800 and 2000 tons were loading cotton and naval stores, with results that contributed in no small measure to the importance of New York shipping.

Meanwhile transatlantic lines were multiplying. The late 'twenties saw the existing service to London, Liverpool and Havre extended by the establishment of a regular service to Greenock by Abraham Bell and others, a line to Belfast by Francis Thompson & Nephews and a new Liverpool line by Robert Kermit and Stephen Whitney. In 1836 Edward K. Collins founded the "Dramatic Line" to Liverpool, and two years later built the *Roscius*, the first thousand ton packet, and one which established new low averages for Western Ocean passages. Other lines followed in quick succession; one to Marseilles in the late 'thirties with the *Courier* and other diminutive 300 ton craft, soon replaced, however, by the *Baltimore* and others rating 600 tons and better; Woodhull & Minturn's Liverpool line

in '43, whose new ship *Liverpool* launched that year by Brown & Bell was the first of the three-decker packets and the largest American merchantman then afloat; D. & A. Kingsland's line to Liverpool in '46, and, in the same year, Dunham & Dimon's Glasgow line, with another to Belfast in process of organization by New York merchants. In all, by 1846, the port had 72 transatlantic liners of the finest types with more under construction, the later of which measured 1400 tons and cost $100,000.00 each, where the great packets of the 'thirties had rarely cost more than half that sum. There were, in addition, a large number of "regular traders" to Europe, many of which were only slightly inferior to the best packets in size and appointments. Among these were such ships as the *St. George* and *St. Patrick*, owned by David Ogden, Frederick Talcott and others, destined to become nucleuses of still later packet lines, comprised partly of famous clippers, the *Drivers*, *Racers* and *Dreadnoughts* of the 'fifties, and partly of mammoth packets ranging from the 1500 tonners, *Isaac Webb*, *Harvest Queen* and *Resolute*, to the 1800 ton *Calhoun*, *Constellation* and *Charles Marshall*, and the *Ocean Monarch*, whose 2145 tons fixed the uttermost range of true packet development.

Even if space permitted it would be impossible to convey an adequate conception of this period in the history of the port; to indicate more than a few of the factors or a fraction of the men and firms then engaged in making it the greatest center of modern times. The decade from 1840 to 1850—perhaps the most colorful, and certainly one of the most interesting America has yet seen—alone deserves a volume. It was an era of tremendous growth in wealth and population throughout the country. It witnessed the great expansion of steam power afloat and ashore; marine engines of a thousand horse and more; the completion in '45 of the Long Island Railroad, running from Brooklyn to Greenport, and the first important railway of the port, if one excepts the Philadelphia line which reached Jersey City in the late 'thirties. It marked an increase of nearly one-third in the area of the United States; the installation of telegraphic communication with Boston and Washington; the almost complete concentration in New York of the coveted China Trade and the lion's share of the Calcutta business, and greeted with unparalleled enthusiasm the first great clippers—*Houqua*, *Rainbow*, *Sea Witch*, *Samuel Russell*, *Memnon* and *Oriental*—all laid down in local yards. Following the European crop failures of '46 came the unprecedented export business and immigration of '47 and '48, when the crowded harbor resounded with deep sea chanties and flamed with color; when the frenzied building of huge sailing ships and still greater steamers taxed shipyards to the utmost and sent merchants scurrying to Eastern ports for still more ships. The discovery of gold in California and the almost simultaneous adoption of free trade by Great Britain, opening vast new channels of commerce for American ships, served merely to prolong and intensify throughout the early 'fifties an activity surpassing anything the world had seen.

* * *

The rest is well known: the beautiful California and Australian clippers, *Challenge*, *Sovereign of the Seas*, *Golden State*, *Red Jacket*, *Young America* and three hundred more, with their imperishable records; the tremendous expansion in banking, manufacturing,

speculation, ship and railroad building; the panic of '57, closely followed by lowering shadows of civil war; the long, unaided struggle of courageous, far sighted men to hold the nation's trade against the liberally subsidized fleets of Europe.... It is time, indeed, for our mythical observer to end his long vigil before India House. He has lingered there as opportunity offered through the storms and suns of seventy years—no impossible thing, since men still lived who had cheered as the redcoats marched away, that memorable afternoon in '83. He has marked the very inception and each successive stage of a majority of the revolutionizing marvels of ocean transportation; seen the port grow thereby from a half ruined, poverty stricken town of 20,000 huddled about his ancient square, to a wealthy metropolis of nearly a million souls; noted the strange sea change of its few, forlorn, dilapidated brigs and schooners into a vast fleet of ships and steamers, one of which might have stowed the freights of the early city. He has watched ship after ship as they set forth on voyages destined to surpass the greatest recorded seafaring achievements of the world, and seen his country rise from a despised to a respected maritime power, with a merchant registry of 5,000,000 tons and upwards. And he may retire content, knowing it was the work of stout hearted, strong handed men—and men alone—men not long since dubbed ignorant, unskilled and unintelligent by their superiors, but able, nevertheless, to contend with steadfast courage and independent mind against almost insuperable odds.

What followed was merely the rounding out of their labors. When the Civil War ended, America faced, as she will always face, the age old problem—transportation. The exigencies of war, however, had effected great advances along mechanical lines, and when the men of the city again turned to the arts of peace, it was to specialize in steamship construction, leaving sail to less congested communities. So long as wooden steamers served, New York continued to build a substantial majority of them, and beautiful craft they were. Ship for ship, no finer, stouter vessels have ever been launched than the *Montana*, *Henry Chauncey*, *Che-Kiang*, *Morro Castle*, *Manhattan* and a host of others designed by Henry Steers, William H. Webb, Roosevelt, Joyce & Waterbury, Lawrence & Foulke, the Poillons, Westervelts and John Englis. The *China*, *Japan*, *America* and *Great Republic* of the Pacific Mail Steam Ship Company—the largest wooden vessels ever built—were laid down in New York yards, as were most of the steamers for Spofford & Tileston, Livingston & Fox, C. H. Mallory & Company, the Morgan, Clyde and Ward lines and many others which flourished after the war. When iron supplanted wood, as it did during the 'seventies, it was found convenient to rely more and more on the roomier yards of Chester, Wilmington and Philadelphia, a fact which marked the rapid decline of shipbuilding in New York. Long before the process was complete, however, the city numbered 2,000,000 inhabitants, and shipping had become but an adjunct to the new and vaster activities of the port.

<div style="text-align:right">CARL C. CUTLER</div>

September, 1935

ACKNOWLEDGMENT

BOOKS, even catalogues, have their stories just like everything else. The story of this volume began some five years ago when a new member was added to Mr. Walter L. Clark's Art Committee. For many years, in fact from the beginning of India House, Mr. Clark has watched over the accumulating of its treasures. The new member was given the special assignment to go over the collection of paintings, prints, ship models, and other art objects, with the idea vaguely formed of a house catalogue.

The nucleus of this collection came from the Asiatic Society, and with this as a beginning it was substantially augmented from time to time by purchases, gifts, and loans, which became permanent, until it assumed a very important position in its field.

The collection was carefully examined and unimportant items were eliminated, a few of doubtful origin and a few that were not germaine for a collection of this type. The paintings were cleaned and a number of the prints were rematted and reframed, and also the ship models were surveyed by authorities and notes taken.

At this time it was found desirable to start a card index, as a basis of a catalogue, and numbers were appended to the various objects in the collection. Mr. Rennard McClees made a rough catalogue of the collection. With this as a basis the records were searched to find out the name of the donor of the paintings, and as much of their history as possible. This was added to from time to time by information obtained from any of our members.

Nevertheless we could obtain no positive identification or histories for many of the more important paintings until the Committee was fortunate in securing the services of Mr. Carl C. Cutler, author of *Greyhounds of the Sea*, and no higher tribute can be paid to Mr. Cutler's abilities than the foreword in my friend Mr. Alexander Laing's novel of last year called *The Sea Witch*. In this epic of our glorious days on the seas with the clippers he chose the *Sea Witch* to play the major role and spent no end of time and work in research to reconstruct the period. So, with Mr. Laing's consent, I am herewith quoting his paragraph of tribute to Mr. Cutler:

> "It is a pleasant duty to acknowledge my debt to Carl C. Cutler, author of *Greyhounds of the Sea*, a work which has superseded all other interpretive accounts of American clippers, and to which I made daily reference during the writing of my story. My only regret is that it was not published a year earlier, as in that case it would have saved me many months of independent research which added precisely nothing of importance to the great body of authoritative material presented lovingly, and in excellent order, by Mr. Cutler."

Mr. Cutler studied the collection for a number of months and through his diligent search and study of the house flags, old shipping records, and his general knowledge of the

subject, he has been able to identify all of the paintings. Through all of these combined efforts the present catalogue and its historical record has been made possible.

During Mr. Cutler's work on this it was necessary to completely review the history of shipping from the Port of New York, which has resulted in his contribution on the foreword or historical preface of this volume.

During the years that this work was in process the governors and a number of the members of the Club became very much interested in the collection and through gift and donation made it possible for the Art Committee to acquire an additional number of very important paintings of early ships, which had contributed greatly to the shipping history of the Port of New York. One of the more important of these is the famous extreme clipper *Sea Witch*, the only known portrait of this famous ship, which, through the generosity of one of the members of the Club, now hangs on its walls.

The more important ornaments which have been acquired in various ways by the Club have been listed as they are all germaine to the story which this collection tries to tell.

A few of the more important or unique items in the library have also been listed but the library as a whole has not as that would require too much space.

The ship models have received a brief review in the catalogue, only the more important being listed and represented by nine illustrations.

Mr. James A. Farrell, our President, who has such a personal feeling for all these things and who has donated many items to the Club, has outlined in his sketch of India House the reasons for the collection and its preservation.

This collection at India House is really a great deal more comprehensive than the name of the Club would indicate for it not only includes items concerning the India Trade, East India Trade and China Trade but memorials of maritime exploration and commerce covering all the Seven Seas. Of course, a century or so ago, when the expression "India Trade" was freely used, it was all one and the same—India, China and the East Indies—they were all on the other side of the world and thousands of miles between them mattered little, in fact few knew their relative latitudes and longitudes. And so it has come to be known as a collection of the China Trade.

After the process of cataloguing was over and our treasures were all in proper order we were again fortunate in getting Mrs. Harry Horton Benkard, who had studied much about the China Trade, to come with a plan of rehanging and rearranging, so that our collection is now beautifully shown in India House.

So to tell the story of our catalogue thanks would have to be extended to many of our members and many of our friends who helped and worked to finish the story.

To the governors of India House we are indebted for their enthusiastic support in promoting this chronicle of the business of the seas.

In closing it is my hope that they all had as much pleasure in the work as I did, and that future generations of India House will derive as much pleasure from the reading of this historical catalogue of our treasures as we did in the making, and so ends my special assignment.

HARRY T. PETERS

OIL PAINTINGS, WATER-COLORS
AND DRAWINGS OF SHIPS

OIL PAINTINGS, WATER-COLORS AND DRAWINGS OF SHIPS

[1] *ABNER COBURN.*—Oil painting by Lai Sung of the ship *Abner Coburn*, of Bath, 20" x 27". Reproduced as No. 312, in "Sailing Ships of New England."

The *Abner Coburn*, a handsome three deck, three skysail yard ship was built by William Rogers, at Bath, Maine, and was launched in October, 1882. She was named after a Governor of Maine whose term of office was from 1862 to 1863. 1878 tons: 223' x 43' x 28.8'. Owned by the builder and residents of Searsport.

For over ten years she was managed by her builder although much of her ownership was vested in residents of Searsport. Later the management passed to Pendleton, Carver & Nichols. In 1900, while on a voyage from Hong Kong, she was purchased by the California Shipping Co., of San Francisco. About twelve years later they sold her to Libby, McNeill & Libby. Prior to 1900 the *Coburn* was engaged in trade between the Atlantic ports and the Orient, also several passages to San Francisco round Cape Horn. The California Shipping Co. used her for off shore lumber carrying in the Pacific, and by Libby, McNeill & Libby, in connection with their salmon canneries in Alaska. While owned on the Pacific she was laid up idle for quite lengthy periods at a time. A few years ago she was burned at Puget Sound for the metal used in her construction. Her career was uneventful, although twice she narrowly escaped fire. Her first commander was Capt. George A. Nichols, who remained in command until his death on board, except during two voyages, one to Seattle, under Capt. Jas. C. Gilmore, and two round voyages to the Orient, made by Capt. James P. Butman. After the death of Capt. Nichols which occurred on the way to Hong Kong with cases of oil, Capt. Butman captained her on another voyage to the Orient. After that Capt. Benj. F. Colcord commanded her until she again changed hands.

The *Coburn* had an unusually long career, her name appearing on the register as late as 1925.

[2] *ADRIAN.*—Ink and tempera drawing by Evans (of New Orleans) of the ship *Adrian* of Boston, off the Southeast Pass of the Mississippi. Starboard view under full sail. Dated May 12th, 1846. The paddle towboat *Star* is also shown. 21¾" x 35".

The *Adrian* was built at Medford, Massachusetts, in 1836, by Messrs. Sprague & James. She registered 569.81 tons, and her dimensions for tonnage were 140' 2" x 29' 9". She was a two-decked, square-sterned ship, ornamented with a figure-head, and was designed for the cotton trade.

Capt. George Conn was the first commander of the *Adrian*, and her first owners were William Eager, of Boston, and the builders, Isaac Sprague and Galen James. The year following her launching she was commanded by Capt. John L. Rogers and was owned by Thomas A. Goddard, Jairus B. Lincoln, Nathaniel F. Cunningham, Thomas Child, Henry Wainwright and William Worthington, all well-known merchants of Boston. Among her later commanders were Captains Samuel Somes, of Gloucester, and John A. Russell. At the time the above drawing was made she hailed from Gloucester and was commanded by Stephen Cutter (?) of that place. Her owners then were John J. Loring of Boston, George H. Rogers, Elias Davis, Harvey C. Mackay and Francis H. Davis, of Gloucester. The following year the well-known Boston firm of Charles and Andrew Cunningham bought the controlling interest and her registry was restored to Boston, and she was placed under the command of Capt. J. Edwards Scott, of Wiscasset, Me.

[3] *AGNES*.—Oil painting by Lai Sung, of Hong Kong, of medium clipper ship *Agnes*, of Boston. 29" x 38". Reproduced as No. 318 in "Sailing Ships of New England."

The *Agnes* was built at Chelsea, in 1850, by John Taylor. 929.24 tons (new measurement, 1029 tons): 171' x 34' 3" x 23' 6". She was a square-sterned, two-decked ship with a figure-head, and a long half-poop.

Capt. J. Edwards Scott, late of the *Adrian*, was the first commander of the *Agnes*, and she was owned by Andrew and Abigail Cunningham, of Boston, and John Smith, John Dove and Peter Smith, of Andover, Mass., and George Scott, of Wiscasset, Me. Capt. Scott remained in command for some years. Later the *Agnes* was sold to Wm. F. Weld & Co. In 1869 she was still owned by that firm but her port of hail was Singapore, Capt. Knapp, Master. There were two other smaller ships of the same name afloat when the *Agnes* was built—one, of 398 tons, launched at Hoboken in 1848, and the other a Bremen ship of 502 tons.

[4] *AGUAN*.—Oil painting by A. Jacobsen (at New York) of the steamer *Aguan*. 21" x 36". Port view at sea.

The *Aguan* was a schooner-rigged, steam propeller, built at Glasgow, in 1886, by Duncan & Co. 1013 tons, net: 235.8' x 35'. Three decks. She was built for the Central American trade and was owned by the Honduras and Central American Steam Ship Company. Capt. James Adair, Commander. Her name does not appear in the registers of 1890.

[5] *ALMATIA*.—Oil painting of bark *Almatia*, of Boston. 17" x 23". Port view.

The *Almatia* was built at East Boston, in 1857, by William Hall. 473.39 tons: 135' 6" x 32' x 12' 1". She was a well-built oak vessel with one deck, a rounding stern and figure-head.

Capt. Joseph H. Smith was the first commander and James Gould and Joseph Young,

Agnes

[3]

Boston merchants, were the first owners of the *Almatia*. They sold her, however, within a few months to Thomas M. Cutler, of Boston, Eli Jones, of Woburn, Mass., and Henry M. Van Voorhis and John C. Van Voorhis, of Malden, Mass. Command was given to Capt. Albert B. Richardson, of San Francisco, who also purchased an interest. In 1869, her home port was given as San Francisco, Capt. Richardson still in command, and C. Richardson was given as sole owner. She was condemned at Manilla in 1885. Under the new rules her registered tonnage was reduced to 387 tons, indicating that her model was quite sharp.

[6] *ALPHEUS MARSHALL*.—Oil painting, signed by John Loos, Antwerp, of the bark *Alpheus Marshall*, of Nova Scotia, 1873. 20" x 29". Port view.

The *Alpheus Marshall* was built at Bear River, Nova Scotia, in 1872, in the yard of Alpheus Marshall under the supervision of Christopher Benson his master builder, being the largest vessel built in that port up to that time. 922 tons register. Draft 20'.

Capt. James H. Parker commanded the *Marshall*, which was owned and operated by A. Marshall & Co., of Bear River. Alpheus Marshall began to build and operate ships at Bear River during the 1860's, and continued in business for many years, being especially active during the prosperous days of Canadian shipbuilding from 1870 to 1880. Among the better known vessels from his yard were the bark *Annie V. Marshall*, 1099 tons, built in 1877, the *Josie T. Marshall*, 1072 tons, built in 1879, and the bark *Keswick*, 869 tons, built in 1882. He also built in 1881 a second bark, *Alpheus Marshall*, of 1096 tons, for Troop & Son, of St. John, a firm whose ships were known all over the world in the closing years of the last century.

[7] *ALTORF*.—Oil painting by an unknown sailor of bark *Altorf*. 22" x 31". Port view at sea.

The *Altorf* was built at Medford, Massachusetts, in the early part of 1842 by Sprague & James. 258.88 tons: 105' 7" x 23' 2". She was a square-sterned, two-decked vessel with a billet-head.

Capt. John Bogardus, of Boston, was the first commander of the *Altorf* which was owned jointly by the master and Sprague & James. In 1844, Lemuel C. Pope and Edwin Howland, Boston merchants, purchased an interest and the command was given to Capt. Nicholas T. Snell, of Salem, who also owned a share in the vessel. Toward the last of her career the *Altorf* was engaged in the Mediterranean and Central American trades under command of Capt. Prince. She became a total wreck on Alicrane Reef, November 2nd, 1848.

[8] *ARAGO*.—Oil painting by P. Tanneur (1795-1875) of the U. S. Mail Steamer *Arago*. Dated 1855. 54" x 69". Starboard view in the harbor of Havre.

The *Arago* was a wooden sidewheel steamer built at New York, in 1855, by P. A. Westervelt & Sons. 2240 tons: 290' x 40' x 31' 6". Clipper bow, round stern, two-masted, two topsail schooner-rig. Two oscillating engines built by Stillman, Allen & Company (Novelty Iron Works). Diameter of cylinders 65": piston stroke 10'. Iron paddle wheels, 33' in diameter.

After the loss of the pioneer steamers *Humboldt* and *Franklin* in 1853 and 1854, respec-

tively, the *Arago* and *Fulton* were built for the New York and Havre S. S. Co., which had the mail contract to France from the U. S. Government, one of the conditions being that they should be convertible into warships in time of need. They were considered to be among the finest vessels afloat and were fitted up in the best manner of the day to accommodate 250 cabin passengers. A number of the leading merchants and capitalists of New York were associated in the development of the company, among them Mortimer Livingston, who became the president of the company, the New York and Havre Steam Ship Company, and Isaac Bell, who succeeded Mr. Livingston as president. Capt. David Lines was the first commander of the *Arago*, followed by Capt. Henry A. Gadsden (in 1862).

The *Arago* was sold in 1869 to the Peruvian Government.

[9] BALTIC.—Oil painting by W. Yorke, Liverpool, 1870, of the *Baltic* as a sailing ship. 30" x 42". Leaving Liverpool under sail. Ex paddle steamship *Baltic* (see lithograph of steamship *Baltic*).

The steamship *Baltic* was built at New York, by Jacob Bell, and launched March 2nd, 1850. 2888 tons; 282' 6" x 45' x 31' 6". Three decks. Three masts. Bark-rigged. Monster figure-head. Machinery by Stillman, Allen & Company. Two side lever engines. Cylinders: 95" diameter. Piston stroke: 9'. Paddle wheels: 35' 6" x 12". Owner: New York & Liverpool, United States Mail Steam Ship Company. Commander: Capt. Joseph R. Comstock.

The last of the original quartet of Collins' steamers to take the water, the *Baltic* proved to be the fastest of the four, and eventually survived all her sister ships by many years. Her rig was altered after a few years by the removal of the mizzen mast to improve her steering qualities, and following the unexplained loss of the *Pacific* in 1856, she was fitted with several water-tight bulkheads. In August, 1852, she broke the transatlantic record by making the run from Liverpool to New York in 9 days, 13 hours. Following the collapse of the Collins Line in 1857, as a result of the refusal of the hostile Buchanan government to renew the mail contract the *Baltic* appears to have lain idle for a year, and after that she was run on the New York-Aspinwall route for a few months by the North Atlantic Steam Ship Company. She was chartered by the United States Government in 1861, one of her first services being to carry Major Anderson and the surrendered garrison of Fort Sumter to New York. In November, 1865, she was again put into the North Atlantic Steam Ship Company under Capt. R. H. Horner, for a short time. A few months later she was running between New York and Bremen, via Southampton, under the command of Capt. Albert G. Jones, in the North American Lloyds Company. In 1867 she was purchased by Isaac Taylor, together with the *Atlantic* and *Western Metropolis*, and placed in Taylor's new line, the New York and Bremen Steam Ship Company. None of these ventures were successful and in the winter of 1868-9, the *Baltic's* engines were removed and she was largely rebuilt, altered into a full-rigged sailing ship of 2552.12 tons register, and sold to Clarence W. Brown, of New York. Her lines being quite sharp, she made several fast passages from San Francisco to Europe with wheat. She was eventually sold to a German company, and on a voyage from Bremen to Boston ran into a gale and was strained so badly that it was determined to break her up, and she was scrapped at Boston in 1880.

Aguan

[4]

Oil Paintings, Water-Colors and Drawings of Ships

[10] *BALTIMORE.*—Water-color of the Havre packet *Baltimore*, of New York, under all plain sail. 34" x 24½". Inscribed: "New York and Havre Packet Ship *Baltimore*. Captain James Funck, 1838. Drawn and painted by Frederick Hage, Bridgeport, Conn."

The *Baltimore* was built at Williamsburg, New York, in 1836, by Messrs. Westervelt & Roberts. 658 tons: 139' x 32' 6" x 22'. Two decks. Square stern. Woman figure-head. Owners: Jacob A. Westervelt, Robert Carnley, Jr., William W. Pell and Capt. James Funck (sometimes spelled Funk) who was her first commander.

Boyd & Hincken, originally agents for the second Havre line, founded in 1823, and later agents for the Union Line of Havre Packets, had the *Baltimore* constructed to meet the demands of the rapidly growing business. Capt. Funck, formerly commander of the packet *Edward Bonaffe* and later of the *Erie*, took over the new ship early in 1837. He retained command for ten years, during which period the *Baltimore* established a reputation as one of the most successful and popular ships of the line. Following Capt. Funck, Capt. John Johnston, formerly of the packet ship *Rhone*, and later of the well-known *Isaac Bell*, of Fox & Livingston's Havre Line, then had her for a short time, after which Capt. Richard D. Conn, later of the packet *Mercury*, commanded her for several years. The *Baltimore* broke no records, as did several other ships of the Union Line, with 15 day passages to Havre, but she had a reputation for maintaining a low average for her crossings. She was sold out of the line in 1853, her new owners being Simon Lesuman and Emeline Sly, of New York, who placed her under the command of Capt. Frederick B. Northup.

[11] *BATAVIA.*—Oil painting by Antonio Jacobsen, New York, 1878, of British ship *Batavia.* 22" x 36".

The *Batavia* was built at Quebec, in 1877, by F. X. Marquis. 1110 tons: 189' 2" x 38' 2" x 22' 8". One deck and beams. Owner: Capt. O. Bernier. Her name disappears from the registers of 1880.

[12] *BLACK PRINCE.*—Oil painting by an unknown Chinese artist, done at Hong Kong, 1863, of the medium clipper ship *Black Prince.* 30" x 42". Reproduced as No. 557 in "Sailing Ships of New England."

The *Black Prince* was launched April 6th, 1856, by George W. Jackman, at Newburyport, Mass. 1061.25 tons: 181' 5" x 35' 6" x 23'. She was a handsome ship with a rounding stern and figure-head. The owners were James P. Bush and Moses B. Wildes, comprising the firm of Bush & Wildes, John H. Everett, Edward H. Fanchon and Capt. Charles H. Brown, her first master, all of Boston.

Capt. Brown was a clipper ship master of established reputation. He had commanded the *Whistler*, also owned by Bush & Wildes, from 1853 until her loss in Bass' Straits, in 1855, and had made several fast passages in her. The *Black Prince* ran principally between eastern ports and San Francisco and from San Francisco to China. Her Cape Horn passages were poor, as a rule, owing partly to her sailing in the unfavorable season, but she made one very good run of 38 days from San Francisco to Hong Kong on her first voyage in 1856. On her way to San Francisco, in 1858, Capt. Brown was forced to put into Montevideo by

mutiny and was delayed there nearly two weeks. In 1860, Capt. Howes succeeded Capt. Brown, and was followed in 1862 by Capt. Edwin Chase who retained command until the loss of the *Black Prince* in 1865.

On October 13th, 1864, she left San Francisco for Boston, with 700 tons of copper and 600 tons of other cargo. On February 15th, 1865, in latitude 38° North, 67° 54' West, the British schooner *Eliza* supplied her with provisions and the *Black Prince* reported that she had 3 feet of water in the hold and had jettisoned 80 tons of cargo. The following day the *Eliza* encountered a severe gale and the *Black Prince* was never heard of again. It is supposed that she went down with all hands. Her cargo was valued at $320,000, and the loss to insurance companies is said to have been $230,000.

[13] *BONITA*.—Oil painting by an unknown artist of medium clipper ship *Bonita*. 23" x 35". Reproduced as No. 339 in "Sailing Ships of New England."

The *Bonita* was built at South Boston, Massachusetts, by E. & H. O. Briggs. Launched May 12th, 1853. 1127.32 tons: 186' x 35' x 22' 6". Her bow was sharp but slightly convex, and ornamented with a gilded billet, without head or trail boards. She had a rounding stern ornamented with gilded scrollwork. Designed by Capt. James Huckins, of Boston, and owned by Capt. Huckins, Francis Huckins, James W. Huckins, Henry S. Hallett (who later purchased the controlling interest) and Leonard Ware, all of Boston.

Command of the *Bonita* was given to Capt. Charles F. Winsor, late of the new clipper *Golden Light* which was destroyed by fire a few days out from Boston on her first voyage. The following year Capt. Lewis G. Hollis, the able and distinguished Commander of the *Game Cock*, took the *Bonita*, making a fine passage of 118 days to San Francisco in the unfavorable season, thence going to Singapore and Calcutta, returning to Boston, May 24th, 1855, having been slightly less than one year on the round trip. Capt. Freeman Hatch, the famous master of the *Northern Light*, then took her over and went to Shanghai, sailing thence to London with tea, her passage to that port occupying 106 days. With Capt. Hatch still in command, the *Bonita* sailed from London April 17th, 1857, for Calcutta with railroad iron. Capt. Hatch was forced to put into Algoa Bay in a leaky condition, and the *Bonita* was condemned. Later she was reported as having been broken up at Cape Town in October, 1857.

[14] *BOSTONIAN*.—Oil painting by B. Tindall, London, of medium clipper *Bostonian*. 24" x 34". Reproduced as No. 342 in "Sailing Ships of New England." No. 26 is a reproduction of another portrait of the *Bostonian*.

The *Bostonian* was built by D. D. Kelly at East Boston, Massachusetts, in 1854. 1099.85 tons: 183' 6" x 35' 11" x 23'. Her stern was rounding and her bow was ornamented with a figure-head. She was owned by George Callender and Hartley Lord, comprising the firm of Callender & Co., of Boston, and William A. Rea, David D. Kelly, of Boston, and others.

Capt. James B. King, the first master of the *Bostonian*, did not retain command long, as she was commanded by Capt. Maling on her first voyage from Boston to San Francisco. Capt. Burnhan had her on the voyage from New York to San Francisco in 1857, neither runs showing any promise of unusual speed. During the most of her existence she was registered as a

Boston ship. In 1860 she is given as hailing from New York under the ownership of John W. Brookman and Henry D. Brookman of New York, Capt. Charles B. Brookman, master. She was wrecked near Guernsey, in 1861, becoming a total loss.

[15] *CASHMERE*.—Oil painting by an unknown artist of ship *Cashmere*, of Boston. 20" x 27". Reproduced as No. 349 in "Sailing Ships of New England."

The *Cashmere* was built at Medford, in 1869, by James O. Curtis. 936.99 tons: 164' x 34.3' x 21.9'. She had an elliptic stern and straight head. Owners: Henry Hastings, George Billings, Ralph Warner, Isaac S. Gross and Isaac Butts, of Boston, James B. Hatch, of Springfield, Cyrus Hall of Yarmouth, and her first master, Capt. Seth B. Kinsman, of Orleans, Mass.

The *Cashmere* was one of the famous fleet of sailing ships, operated and owned, in part, by Henry Hastings, of Boston, which included several medium clippers, the original models of which are in the Massachusetts Institute of Technology. Following Capt. Kinsman, the *Cashmere* was commanded by Capts. J. C. Collamore, H. Norton and E. Oliver. In 1885 she was rigged as a bark and, under the command of Capt. Nicoll, was totally wrecked the same year in a typhoon on the coast of Japan, all hands being saved.

[16] *CHALLENGE*.—Oil painting by Samuel Walters, of clipper ship *Challenge*, showing her under sail at sea. 24" x 36".

The *Challenge* was built at New York, by William H. Webb, in 1850-51. 2006.51 tons: 230' 6" x 43' 2" x 26'. Three decks. Round stern. Flying eagle figure-head. Owners: N. L. & G. Griswold, of New York. Commander: Capt. Robert H. Waterman.

The first three-deck clipper to be laid down, the *Challenge* was, when launched on May 24th, 1851, the longest and largest merchant ship afloat. A brief description of the launch appeared in the New York Herald on Sunday, May 25th, following the event. It stated in part:

> "She left her ways at five o'clock in beautiful style. Her beauty of mold and genuine clipper appearance were the theme of universal admiration from one of the largest assemblages we ever witnessed at a launch."

Several very complete descriptions of the vessel and her rig were printed about the same time. One of the best has been reproduced in full in Howe and Matthews' "American Clipper Ships." Another giving the details of the deck plan appeared in the New York Journal of Commerce on June 23rd, 1851. From the original sail and body plans it would appear that she was the most extreme large clipper ever built. Her under-body was cut away to an extent never shown by the model of any other large merchantman. Her sharpness is indicated by the fact that her angle of entrance was 30 degrees and angle of run, 34 degrees, and by the further fact that although measuring 2006 tons under American rules, her later register under foreign rules was only 1375 tons, a reduction of almost 40 per cent, and this at a time when the tonnage of the average full-built American ship was usually increased under foreign rules. In rig, also, she probably spread more canvas than any ship of her actual tonnage. Her main truck towered nearly 190' above her deck and she spread 12,780 yards of canvas

in a single suit of sails. Her lower swinging studding sail booms were 60′ in length, and when both port and starboard studding sails were spread, they stretched 160′ from leach to leach. She proved very fast under moderate weather conditions, as shown by the fact that in after years, when her rig had been reduced three successive times, she was reported as logging over 300 miles on several occasions. Her lines were too fine, however, to permit driving in winds approaching gale force; consequently she never made a day's run comparable to those of some of the larger flat-floored clippers—notably, the *James Baines*, *Sovereign of the Seas*, *Lightning* and *Red Jacket*. Contemporary reports agree in describing her as one of the most beautiful of the clippers, and her long, clear deck (flush, except for a short 20′ poop and a topgallant forecastle) was one of the handsomest decks ever seen on a ship. Her construction was exceptionally heavy. She was 11′ through the backbone and 20″ through the sides, and was diagonally braced with iron straps ⅞″ thick and 35′ in length and placed 4′ apart. She was built without regard to expense, costing $150,000.00, her owners making one condition only—that she should outsail anything afloat. Her draft has been given as 20′, but as a matter of fact, her deep load draft was 24′, and much of her sailing was done when loaded to a depth of 22′ and more. For instance, the log of her San Francisco passage in 1854 gives her draft when leaving New York on September 5th as 23′ 7″, in spite of which she made the run in 118 days, going from the Pacific crossing to port in the very good time of 18 days. Command was given to Capt. Robert H. Waterman, late of the *Sea Witch* (q. v.) and formerly of the *Natchez* and the "Black Baller" *South America*, and she sailed from New York for San Francisco on her maiden voyage July 14th, 1851. She arrived at her destination on October 29th, after a passage usually given as 108 days, which was excellent time, considering the unfavorable season, but which was a terrible disappointment to her master and owners. In addition, nine of the crew had been killed or succumbed to disease on the voyage, a fact which set in motion a debate enduring to the present; the mooted point being whether Waterman was a brute in human form or, on the contrary, a competent master forced by stress of circumstance to adopt stern measures against a mutinous crew. When the *Challenge* reached San Francisco she was placed under old Capt. Land, late of the clipper *Rainbow*, who took her to Hong Kong. On the return passage to San Francisco she did some of the best sailing of her entire career, making the crossing in 34 days (equalling the record at the time) and logging 360 miles in 23½ hours. Her run from the longitude of Japan to the Golden Gate in 18 days is still a record. The statement is sometimes made that it has never been equalled, but, as noted in the sketch of Capt. Edwards' life (q. v.) the mark had already been set earlier in the year by the clipper schooner *Sierra Nevada*. After a couple of trips across the Pacific the *Challenge* was chartered to load teas at Canton for London. Under Capt. Pitts she made a fine out-of-season run of 105 days to London, beating the *Nightingale*, *Surprise* and all other American and British clippers sailing about the same time. Her remarkable record of 65 days from Anjier to Deal established a mark which seems never to have been beaten, although equalled once or twice. After a second round to China, Capt. Pitts was succeeded by Capt. John Kenney, formerly of the *Richard Alsop*, another Griswold ship. In 1859, while commanded by Samuel A. Fabens, late of the clipper *Golden Eagle*, she was completely dismasted off the coast of China in a typhoon, after which she was

Arago

[8]

laid up in Hong Kong. Late in 1860 she was sold to Capt. Haskell, who took her to Bombay and sold her the following year to Thomas Hunt & Company, who put her under the British flag as the *Golden City*. In 1866 she was purchased by Joseph Wilson, of South Shields, who operated her for the next ten years in the New Orleans and East Indian trades. She was wrecked on the French coast in 1876, having lost her rudder while running down the English Channel bound for Calcutta.

[17] *CHAMPION*.—Oil print after S. R. Whipple of tug *Champion*. 18¼" x 21½". Presented by Robert C. Williams.

Built at Detroit, Michigan, in 1868, and in use on the Detroit River during the '70's. 363.36 gross tons: 147.7 net: 134.6' x 21.4' x 10.7'. Nominal h.p. 800.

[18] *CHARLOTTE*.—Oil painting, artist unknown, entitled: "Brig *Charlotte*'s departure from Newburyport for San Francisco, January 23rd, 1849." 19½" x 26".

The *Charlotte* was built in Bath, Maine, in 1847. 177 tons: 90' 1" x 24' 11" x 9'. She was a full-rigged brig with a square stern and billet-head. Owners: Charles H. Porter and Albert Currier, of Newburyport. Capt. William G. Bartlett, Master.

Although a number of ships had already sailed for the gold regions, the *Charlotte* must be numbered with the fleet which made up the first section of the "rush." The following advertisement is from the Newburyport Herald for January 18th, 1849:

> "For *California*—With Despatch. The copper and copper-fastened Brig Charlotte, now lying at Bartlett's Wharf, will sail for San Francisco, California, via Cape Horn, on or about the 20th of the present month.
>
> The *Charlotte* is a well built, substantial and fast sailing vessel, having superior accommodations, for passengers, and has been purchased expressly for the California service. She will be commanded by an experienced man, who has performed several voyages round Cape Horn, and who has spent some five years in that region.
>
> The price of a passage to San Francisco, will be *One Hundred Dollars* in the forward cabin, and $150 in the after cabin—the lowest price charged for a passage in any vessel now up for California.
>
> The superior accommodations and qualities of this vessel—the ability and experience of the captain, and the extremely low price charged for a passage, present the greatest inducements yet offered to those desirous of visiting the *Gold Regions*.
>
> Application may be made to *C. H. Porter* or *Albert Currier*, or to the Master, on board.
>
> A list of the passengers, as published in the *Herald* of the 24th, follows: Wm. G. Bartlett, master; Jacob Noyes, Jr., first officer, San Francisco. Passengers—Chas. M. Brown, William Bartlett, Jr., Rufus Rand, Chas. B. Stover, Henry Sweetser, Jas. K. Titcomb, Amos F. Jacques, Chas. W. Brown, Peter Atherton, Jas. H. Musso, Amos Goodwin, Jas. B. Brown, Thomas Gorwaiz, Franklin Marsh, Goe. Sawyer, Benj. Pratt, Jr., all of Newburyport;—Henry A. Hill, Wm. Smith, John F. Damon, B. O. Sanborn, Augustus A. Newhall, Augustus G. Plumstead, John Hovey, Jas. W. Folsom, Francis D. Rhoades, of Lynn;—Sam. P. Nye, Chas. G. Boardman, Edwin J. Christian, Wm. K. Reed, of Amesbury Mills;—Wm. Willey, Michael Tenney, of Salem:—C. H. Waters, Gardner Waters, Wm. M. Grefton, Wm. K. Hudson, of Waterville, Me.;—Greenleaf Page, Albert Foster, of Clinton, Me.;—Henry Gullifer, Rufus Kendall, of Kendall's Falls, Me.;—Geo. F. Kimball, of West Amesbury;—Jacob T. Follansbee, of Hempstead, N. H.;—Chas. Wardell, of Andover;—John L. Brown, of Salisbury."

An interesting incident of the ensuing voyage was the *Charlotte's* brush with the fast Baltimore brig *Lady Adams* bound for San Francisco, via Valparaiso, which is hereafter mentioned under item No. 43 (Brig *Lady Adams*).

[19] *CITY OF PUEBLA*.—Oil painting by A. Jacobsen, New York, 1887, of the steamship *City of Puebla*. 22" x 36". Port view at sea.

The *City of Puebla*, an iron screw steamship, was built in Philadelphia, in 1881, by William Cramp & Sons, for the Alexandre Line. 2623.88 gross tons: 1712.96 net tons: 320.6' x 38.6' x 16.6'. Two decks. Three masts. 2400 nominal horse power. Owner: Francis Alexandre of New York. Commander: Capt. John Deaken.

The *City of Puebla* ran for several years between New York, Havana and Gulf ports. Among the other steamers owned and operated by the Alexandre Line were the propellers *City of New York*, 1715.73 tons, built at Greenpoint, Long Island, in 1873, by John Englis, and the *City of Mexico*, 1026.93 tons, built in 1869 at the same place by the same builder, and the old wooden side wheeler *San Francisco*, built at Philadelphia in 1853. When the Alexandre Line was discontinued, she was sold in 1887 to Josiah N. Knowles, of San Francisco, and her registry transferred to that port. For some years thereafter she was commanded by Capt. John McIntosh.

[20] *COLUMBIA*.—Oil painting by unknown artist of packet ship *Columbia*. 24" x 35".

The *Columbia* was built in New York, in 1846, by William H. Webb, for the Black Ball Line of Liverpool packets, being the second ship of that name in the line. 1050.75 tons: 940.26, new: 169' 5" x 37' x 21' 4". Two decks. Square stern. Billet-head. Poop-cabin.

When launched on March 26th, 1846, the *Columbia* was regarded as one of the finest ships afloat. She was owned principally by Charles H. Marshall, Charles H. Marshall, Jr., Wm. H. Webb, George Bell, Gabriel Mead, Isaac M. Bryce and four commanders of Black Ball ships; James Bryant, Charles Hutchinson, Nathaniel Cobb and Benjamin L. Waite, all of whom (with a number of others) were large owners in the "Blackballers" during the fifties and sixties. Her first commander was Capt. John Rathbone. Like many of the staunch built packets, the *Columbia* had a long, eventful career. On the 13th of January, 1847, while bound from Liverpool to New York, she was struck by a heavy sea which washed away the wheelhouse, carrying with it Capt. Rathbone, the mate, second mate, five men and a boy, leaving the body of the third mate jammed under the tiller. Without an officer left to command the ship, and while the storm continued with utmost violence, the crew started to plunder the ship and passengers and a frightful orgy ensued. The incident made a profound impression on the travelling public at the time as Capt. Rathbone was one of the favorite packet commanders out of New York, the *Columbia* having, in fact, been built expressly for him. He was a native of Stonington, Conn. His first command was a small coasting vessel during the War of 1812, and he had taken part in the defense of his town against the British, playing a leading part in the attempt to torpedo the enemy's fleet off the port. His various commands had included the packet ships *Crawford*, *Talma*, *Kentucky* and *Nashville*, in the Southern trade and the well-known Liverpool packet *Oxford*. After his death Capt. Thomas

Baltic

[9]

B. Cropper succeeded to the command, and was followed by Charles Hutchinson, James Bryant and Henry A. Robinson. In 1869 the *Columbia* was altered to a bark and sold to George Howes and Effingham B. Sutton, of New York, and Jabez Howes, of San Francisco, her commander being John H. Mayhew, of Machias, Me. In 1887 she hailed from San Francisco and was owned by C. L. Dingley, of that port.

[21] CONSTITUTION.—Tinted drawing by Reisler of U. S. Frigate *Constitution*. Dated 1880. 28 3/8" x 42 3/4". Showing sail plan to scale.

The frigate *Constitution* was designed by Joshua Humphreys of Philadelphia, and constructed at Edmund Hartt's shipyard in Boston under the supervision of Col. George Claghorn, at a cost of $299,336.00. She was launched on the 21st of October, 1797. 1576 tons: 204' (over all) x 157' 10" (keel) x 44' 8". Draft: 22' 6". She was built of oak and her sides were 21 1/4" thick. Main mast: 104' 10" in length. Main yard: 95' in length. Armament: 30 24-pounder long guns; 22 32-pounder carronades.

The *Constitution* was one of four 44 gun frigates authorized by the Act of March 27th, 1794, the first provision for establishing a navy under the Constitution of the United States. Her record is too well known to warrant more than a brief recapitulation here. Under Capt. Samuel Nicholson, she sailed on her first cruise, July 22nd, 1798, bound for the West Indies in search of French armed ships. The following year Commodore Silas Talbot took command on a similar expedition to the West Indies. After the treaty of peace with the French in March, 1801, she was laid up in Boston until 1803, when she was sent to the Mediterranean under Capt. Edward Preble to deal with the Algerian situation. The Dey of Algiers was forced to sign a peace treaty on the 3rd of June, 1805, the *Constitution* being then commanded by Capt. (later Commodore) John Rogers, who had replaced Capt. Stephen Decatur late in 1804. The following year the *Constitution* returned to America in charge of Capt. Hugh G. Campbell, and was laid up nearly two years. In August, 1809, she was again put in commission as the flagship of the North Atlantic squadron under Commodore Rogers. Capt. Isaac Hull was placed in command in 1810, remaining in her until after the capture of the *Guerriere* on the 19th of August, 1812. During the rest of the war she was commanded by Commodore Bainbridge, who captured the frigate *Java*, and Capt. Charles Stewart, who captured the frigate *Levant* and the ship-sloop *Cyane*. After the war she was laid up in Boston until 1821 when she went to the Mediterranean as the flagship of Commodore Jacob Jones, being visited while there by Lord Byron and other notables. When this cruise ended in 1823, she was stationed in Boston until 1826 when she was again sent to the Mediterranean under Capt. Thomas Macdonough. On her return two years later she was again laid up in Boston and in 1829 was condemned and ordered to be broken up. From this fate she was saved by Oliver Wendell Holmes' poem.

On the 24th of June, 1833, the *Constitution* was docked in Boston, being the first ship to enter the new dry dock at the Navy Yard there. After being thoroughly rebuilt she was in active service under Capt. Isaac Hull and Commodores Elliott, Alexander Clarton and Charles Stewart until 1844, when she went on a cruise around the world in command of Capt. John ("Mad Jack") Percival, returning to Boston, October 5th, 1846. In 1848 she

again returned to the Mediterranean going from there to service on the African coast. During this time she was successively commanded by Captains John Gwynne, Thomas A. Conover and John Rudd. In 1854 she returned to Portsmouth and went out of commission, never again to figure as a fighting ship of the United States Navy. In 1860 she was sent to Annapolis as a training ship and was used there and at Newport for that purpose until 1871, when she went to Philadelphia for an overhauling. After repairs were effected she took goods to Havre in 1878 for the Paris Exposition, under command of Capt. Oscar C. Badger. On her return she was used for three years at New York as a training ship, and in 1882 was sent to Portsmouth, N. H., as receiving ship, remaining there for the next fifteen years. In 1897 she was ordered back to Boston for the celebration of the centennial of her launch. She arrived there on September 21st, in command of Commodore Samuel W. Very, the son of Capt. Very of the clipper ship *Hurricane*. On October 21st the *Constitution* was greeted in Boston harbor by the entire North Atlantic fleet. A public subscription was started for the preservation of the old ship and extensive repairs were made, after which she lay for many years at the Charlestown Navy Yard, an object of interest to continuous streams of visitors. After twenty years or more had elapsed her condition became such that a movement was started to completely rebuild her. As a result she was on June 16th, 1927, again placed in the same dry dock which she had first entered 94 years before, and was thoroughly reconstructed so that her present condition is equal to, if not better than, her original condition.

As a ship the *Constitution* was probably no stronger or faster or more powerful in armament than other American ships of her day and class. She was fast. Her log has recorded a speed of thirteen and one half knots, but the *Philadelphia* and *President* were probably faster. She was heavily sparred, carrying skysail yards, as Capt. Hull's log records in 1812, but other ships were as lofty. She had no obvious points of superiority over her sister ships, yet the fact remains that she established a record that is unsurpassed by any ship in any age. Three times pursued by fast and powerful squadrons she managed to escape from apparently overwhelming odds. She took part in forty-two engagements; captured twenty ships, and has never suffered defeat. Today she is an object of respect and affection to millions.

[22] *COURIER*.—Oil painting by Walters of fast sailing ship *Courier*. 21⅝" x 31½". Dated 1831.

The *Courier* was built at Medford, Massachusetts, in 1815. 388.53 tons: 111' x 28'. Two decks. Square stern. Figure-head. (Later changed to a billet-head.) Owner: Jeremiah Thompson, of New York. Commander: Capt. Robert Marshall.

Built for a "regular trader" between Boston and Liverpool just at the close of the hard sailing 1812 period, the *Courier* was heavily sparred and proved to be one of the fastest ships of her time. She was purchased from Boston in 1823 by Jeremiah Thompson who was one of the founders of the Black Ball Line, although she is not to be confused with the *Courier* of that line. In 1824 she was commanded by Capt. George H. Wallace and a couple of years later by the well-known packet master, Capt. Thomas Britton, being owned at that time by Joseph Walker, a New York merchant who had extensive interests in shipping. Walker sold her in 1828 to Abraham Bell, who, in turn, sold her a few days later to the

Batavia

[11]

famous coffee merchants, Foster & Elliot, a firm comprised of Andrew Foster, Andrew Foster, Jr., and George T. Elliot. She was placed under the command of Capt. William Wolfe, and thereafter spent most of her existence on the run between Rio and New York with occasional trips to Canton and other eastern ports, making a number of very fast passages. Eventually she foundered in a hurricane in the Indian Ocean in November, 1839, and was succeeded by the famous little *Courier* of approximately the same tonnage built in 1842 at Newburyport, by Townsend & McKay, after designs by Donald McKay. A third and larger ship of the same name was built in 1855 for Foster & Elliot. All three of these vessels were very heavily sparred and made some of the fastest passages ever made between New York and Rio de Janeiro. As all were designed to carry passengers as well as freight they did not differ essentially in lines or appearance from the smaller packet ships of their respective periods. The painting of the first *Courier* which is shown herewith may, therefore, be taken as a typical representation of the earliest regular packet liners.

[23] *COURIER*.—Oil painting by Evans of the Ship *Courier*, of New York. 29" x 36". Inscribed: "Ship *Courier*, Capt. Moses P. Lock."

The *Courier* was built at Haverill, Massachusetts, by Barnard Goodridge, in 1822. 293.05 tons: 99' 5" x 25' 9". Two decks. Square stern. Billet-head. Owners: John Hooper, of Marblehead, and Capt. Atkins Adams, her first commander.

Few vessels have had a more varied career than Goodridge's little *Courier*. At the time the above picture was painted she was nearly 25 years old; she had been a "regular trader" on the Western Ocean, a smart Mediterranean packet, and had spent years battering about the far corners of the world as a whaler, yet she looked as trim and staunch as when first launched. For the first eight years of her existence she was a general trader between Boston and European ports, during which time she was commanded successively by Captains Adams, William H. Cunningham and Richard Soule, the latter a well-known mariner of Duxbury, who also commanded the *Talma* and *Coliseum* and other Boston ships. Among Boston merchants who owned shares in the *Courier* before she was sold to New York, were Elisha Copeland, Jr., Edmund Dwight, James K. Mills and Seth Knowles. In 1831, her owner, John Brown, of Boston, sold her to Alexander Gibbs, a prominent whaling merchant of New Bedford, and Nathaniel Thayer, Josiah Stickney and Elisha Preston, of Boston. She was registered at New Bedford and converted into a sperm whaler, and sent out under command of Capt. Stephen W. West. In 1836, Alexander Gibbs sold his interest and the *Courier* was registered as a whaler of Dorchester, Massachusetts, and sent to the Pacific Ocean under command of Capt. Benjamin T. Crapo. After her return she was sold, in January, 1839, to Samuel Brown, of New York. Shortly thereafter Alexander M. Lawrence, of New York, purchased an interest in her and she was fitted up as a packet ship and put on the New York-Marseilles run under Capt. Michael Duggan. At the time the above painting, which is reproduced herewith, was made (cir. 1847), she had been withdrawn from the packet service to make room for a larger vessel. She was then owned by Russell Sturgis and commanded by Moses P. Lock, both of New York. Other New York men who owned interests in her at various times were James Robertson and George A. Phelps. After her sale to

Russell Sturgis she was operated for some years in trade between New York and Europe. Her later record is not known.

[24] COWPER.—Oil painting of the ship *Cowper*, of Boston. 24" x 36".

The *Cowper* was built at Charlestown, Massachusetts, in 1854, by Joshua Magoun. 1023.39 tons: 181' 6" x 34' 9½" x 24'. Two decks. Square stern. Billet-head. Owners: Alpheus Hardy, Joshua Sears, Joseph H. & George S. Curtis and James H. Beal, of Boston. Commander: Capt. John A. Paine, of Truro, Massachusetts.

Although called a clipper, the *Cowper* was much too full built to deserve that classification. She was, however, heavily rigged and a fine and successful ship in all respects, much of her career being spent in trade with California and the far East. Capt. Paine was succeeded in 1857 by Capt. Stevens, followed by Capt. Lowell. Although owned and operated during her entire existence by Alpheus Hardy & Company, her registry was transferred in 1866 to San Francisco. She was lost on Trinito Island, November 21st, 1869, on a voyage from San Francisco to Nanaimo, Vancouver Island. Capt. Thomas Sparrow, who later commanded the clipper *Wild Rover*, belonging to the same firm, was her last reported master.

[25] DANIEL WEBSTER.—Oil painting by William Hare of the bark *Daniel Webster*. Undated. 21½" x 26½". Inscribed: "Daniel Webster, of Boston, Richard Ryder, Master."

The bark *Daniel Webster* was built at Charlestown, Massachusetts, by Joshua Magoun in the early part of 1853. 263.75 tons: 107' x 25' 7" x 10' 8¼". One deck. Square stern. Billet-head. Owners: George G. Ryder, John H. Pearson, David Leavitt, Nicholas Land, Isaac Kendall, George Kingman, Benjamin Fernald and others, of Boston, Paul Curtis, of Medford, Elijah Crosby and others of Chatham, Massachusetts, Thomas and Horatio Whitridge, of Baltimore, and Capt. Richard Ryder, who was also her first commander.

Daniel Webster was a popular name among New England merchants during the middle of the last century, and when the above vessel was launched there were two other Boston barks of the same name afloat, one of which was sold to Japan and became one of the first warships of the modern Japanese navy. Much of the early career of the subject of this sketch was spent in trade between Boston and Southern and European ports. She was clipper built and proved unusually fast. Her measurement was reduced under the tonnage laws of 1865 to 214.06 tons, indicating that her lines were quite sharp. In 1873 it was further reduced to 197.35 tons, and at the same time she was altered to a schooner. She was then commanded by Capt. Dennis H. Haskell, of Boston and owned by the well-known merchants Daniel S. and John S. Emory, George H. Greely and John Crane of that port. For a time during the 60's she was commanded by Capt. David W. Nicherson. In 1881 she was condemned on the west coast of Africa as unseaworthy, and sold to foreigners.

[26] DEVONSHIRE.—Oil painting by Joseph de Silva of packet ship *Devonshire*. 24" x 36". Under sail at sea. Shown with her winter rig of short fore and mizzen-topgallant masts.

The *Devonshire* was built at New York, in 1847-8, by Westervelt & Mackay and

launched January 11th, 1848. 1149.91 tons: 173′ 6″ x 38′ x 21′ 10″. Two decks. Square stern. Female figure-head. (Later described as a three-decker, of 1327 tons, register.) Owners: John Griswold, Henry R. Morgan, Jacob A. Westervelt, George Moore, Elisha E. Morgan and Robert Carnley, of New York, and Charles C. Griswold, of Lyme, and Henry L. Champlain, of Essex, Connecticut. Commander: Capt. Elisha E. Morgan, late of the *Victoria* and other transatlantic packets.

Built expressly for Griswold's London Line (later E. E. Morgan & Sons), the *Devonshire* soon became a favorite ship with transatlantic travellers. On her second voyage under Morgan, in the autumn of 1848, she ran from London to New York in 18 days, time considered by many excellent judges of that period to be equal to 16 days from Liverpool. This was Morgan's last voyage in the *Devonshire*, as he was transferred to the new ship *Southampton* of the same line. Concerning the next voyage of the *Devonshire* the New York Herald for March 21st, 1849, has this to say:

> "This fine packet ship, commanded by Capt. R. H. Hovey, arrived at this port yesterday from London and Portsmouth. The *Devonshire* is almost a steamboat in speed. This passage across the Atlantic was made in 22½ days, and the *Devonshire* has never been 25 days on any one passage. She made the last passage to London in 16 days, taking to that port a Sunday Herald of December 31, whch was the only late paper on board, thereby conveying news to Europe four days later, at a time when steamers were sailing weekly."

Continuing her career the *Devonshire* is credited with landing her passengers in England 14 days from New York while under the command of Capt. Josiah M. Lord, who had her during the middle fifties. When the Morgan Line was discontinued she was sold abroad and in 1869 was reported as hailing from Dublin.

[27] *DE WITT CLINTON*.—Oil painting by S. Walters of packet ship *De Witt Clinton*. 28½″ x 42″. 1865. Presented by W. H. Douglas.

The *De Witt Clinton* was built at Greenpoint, Long Island, in 1848, by Perine, Patterson & Stack, for Taylor & Rich's Line of Liverpool packets. 1066.50 tons: 164′ 10″ x 37′ 9″ x 21′ 11″. Two decks. Square stern. Woman figure-head. Original owners: Henry L. Rich and William C. Taylor, copartners, Peter L. Bogert, Edward Funk, Lewis L. Squiers, Thomas W. Storrow and James Funk, of New York City. First commander: Capt. French.

After the *De Witt Clinton* had been in service for several years she was raised to a three-decker, her depth then being given as 29′ and her tonnage variously stated from 1079 to 1182 tons. Following Capt. French she was commanded by John Dunn and Edward Funk. She was sold in 1860 to Benjamin I. H. Trask, of New York, and Richard W. Sears and Abbott A. Cobb, of Boston, and Capt. Benjamin Mosher, of Biddeford, Me., who commanded her.

[28] *EASTERN STAR*.—Oil painting by an unknown artist of ship *Eastern Star*, of Boston. 31½″ x 42″. Stern view, clawing off a lee shore in a storm. Reproduced as No. 366 in "Sailing Ships of New England" but there called the *Donald McKay*.

The *Eastern Star* was built in Bath, by Purington & Springer, and launched March 18th, 1856. 1017 tons: 1132.41 tons (new) 180' x 35' x 24'. Two decks. Square stern. Billet-head. Full model. Owners: Capt. Edward Pousland, of Wayland, Mass., and James H. Fay, of New York City. First commander: Capt. Thomas Henry.

Capt. Henry was succeeded by Capt. H. W. Neal, who was followed by Capt. Curtis. The *Eastern Star* was sold abroad during the seventies and hailed, in 1881, from Liverpool. In 1889 she was rigged as a bark, still sailing out of Liverpool.

[29] *ELLA.*—Oil painting by an unknown artist of bark *Ella*. 21" x 29". View on starboard tack, passing lighthouse.

The bark *Ella* was built in Baltimore by J. A. Robb, in 1860. 149 tons: 86' 6" x 25' 4" x 8' 6". One deck. Medium model. Half-poop. Owned by J. A. Thompson, of Nassau. Commanded by Capt. D. V. Poole.

Note: There were two other barks of the same name at the time the above vessel was built, both somewhat larger and both hailing from Boston.

[30] *FLORIS.*—Oil painting by W. Yorke, Liverpool, 1870, of bark *Floris*. 19" x 29". Reproduced as No. 382 in "Sailing Ships of New England."

The *Floris* was built in East Boston, by James L. Townsend, in 1866-7. 950.92 tons: 168.3' x 34.3' x 22.5'. Two decks. Square stern. Billet-head. House cabin. Owners: Pliny and Thomas Nickerson and William H. Hutchinson, of Boston, and Joseph K. Baker and Joseph K. Baker, Jr., of Dennis, Mass. Commander: Capt. Thomas Ellis, of West Harwich, Mass.

Nickerson & Company, the managing owners, sold the *Floris* to go under the Dutch flag in 1872, and she was reported lost at Samarang later in the same year.

[31] *FLYING CLOUD.*—Original oil painting of clipper ship *Flying Cloud*. 36" x 42". Inset over fireplace in Marine Room. Presented by James A. Farrell, 1925.

[32] Original oil painting by Warren Sheppard of *Flying Cloud*. 1916. 24" x 36". Presented by Edgerton Parsons and H. F. Eggert.

The *Flying Cloud* was built at East Boston, by Donald McKay, and launched April 15th, 1851. 1782.48 tons: 229' x 40' 8" x 21' 6". Measurements under new rules: 1139 tons: 219' x 40' x 21'. Length, from knight heads to taffrail: 235. Length of keel: 208'. Two decks. Round stern. Figure-head of angel with trumpet extended. Sheer: 3'. Dead rise: 30". Round of sides: 6". Owners: Moses H. Grinnell, Robert B. Minturn and Henry Grinnell, comprising the firm of Grinnell, Minturn & Company, of New York City. First commander Capt. Josiah P. Cressy, late of the China packet ship, *Oneida*.

When the *Flying Cloud* appeared in New York she excited universal interest and admiration. Both the New York Herald and New York Commercial-Advertiser published lengthy descriptions of her, that of the Commercial Advertiser, in the issue of May 9th, 1851,

Courier

[23]

being a reprint, with added eulogisms, of the very complete article which had appeared in the Boston Atlas. In several respects the *Flying Cloud* was less extreme in model and rig than some other clippers designed about the same period. Although she was said to have the sharpest entrance lines which had appeared in New York, her bottom was much fuller than either the *Hurricane, Nightingale, Witch of the Wave,* or several others. Her rig, though strong and lofty, was relatively lighter than that of a number of contemporary clippers. Her main mast, for example, was approximately 166 feet from deck to truck. That of the *Challenge,* a ship only eighteen inches longer and thirty inches wider, although a deeper vessel, was fully 190 feet from deck to truck. Nevertheless, the *Flying Cloud* proved to be one of the most admirably designed ships ever built, as well as one of the fastest under a wide variety of conditions.

The *Flying Cloud* was originally intended for Enoch Train, of Boston, but he, to his later regret, sold her while on the stocks to Grinnell, Minturn & Company. She sailed on her first voyage to San Francisco on the 2nd of June, 1851, crossed the equator twenty-one days out and arrived in San Francisco in the then amazing time of 89 days and 21 hours from anchor to anchor, in spite of the handicap of battling very severe midwinter storms of Cape Horn—storms which almost wrecked her aloft, and would have done so if it had not been for the heroic efforts of Cressy and his men in effecting temporary repairs. When she returned to New York, Grinnell, Minturn & Company had her log printed on silk in letters of gold for distribution to the ship's admirers. The fourth voyage of the *Flying Cloud* is usually reported as having been made in the world's record time of 89 days and 8 hours, *from anchor to anchor*. In the interest of accuracy, however, it should be noted that there appears to have been no contemporary claim of the "anchor to anchor" feature of the run. The ascertainable facts are that the *Flying Cloud* weighed anchor at New York at noon, January 21st, 1854. She was reported by the San Francisco papers of April 21st, following, as having "arrived last evening from New York, making the passage in 89 days and 8 hours," no reference being made to the time of anchoring. However, at sundown April 20th, the lookout on the outer stations reported the vessels then in sight, adding "fresh breeze from the Southeast and flood tide," but made no mention of the *Flying Cloud* in the offing. There is, of course, the possibility that she had already reached her anchorage. (It would have been necessary for her to have anchored not later than five P. M., in order to make good the claim of 89 days and 8 hours, mean time, from anchor to anchor.) Failing this, the time stated must be regarded as her land to land, rather than anchor to anchor passage. Whatever the fact may be, however, in the continuation of her voyage the *Flying Cloud* ran to Hong Kong in 37 days, establishing a record of 127 sailing days from New York to Hong Kong, via San Francisco, a record which still stands as the all time sailing ship record for the course. Following the panic of 1857, the *Flying Cloud* was laid up for two years. In 1859 she was placed under the command of Alexander Winsor who took her to China and loaded tea for London, she being one of the last American ships in that trade. In 1863, she was sold to James Baines & Company of Liverpool and put on the Australian run. Later she was sold to Mackey & Company for the Canadian lumber trade. She went ashore in 1874 on Beacon Island, off the New Brunswick coast, becoming a total loss.

[33] *FRED P. LITCHFIELD*.—Oil painting by an unknown artist of the ship *Fred P. Litchfield*, of New York. 26" x 35". View at sea under full sail: twenty-four sails drawing.

The *Fred P. Litchfield* was built in Bath, Maine, by Goss, Sawyer & Packard in 1876. 1082 tons: 177.5' x 36.1' x 22.3'. Two decks. Elliptical stern. Owner: F. P. Litchfield. In 1887 she was rigged as a bark.

[34] *FRED WARREN*.—Oil painting by J. Hughes, of Liverpool, of ship *Fred Warren*, of Liverpool. 24¼" x 36". Dated 1867. Reproduced as No. 385 in "Sailing Ships of New England."

The *Fred Warren* was built at East Boston, in 1863, by G. & T. Boole. 1043 tons. Draft 21'. Built for and owned by G. Warren & Company, of Liverpool. Commanded successively by Captains Homewood, Phinney and Hammond. She does not appear in the registers of 1880.

[35] *GOLDEN STATE*.—Oil painting of the clipper ship *Golden State*. 18" x 23½". Under sail at sea.

The extreme clipper ship *Golden State* was built at New York, in 1852, by Jacob A. Westervelt, and launched January 10th, 1853. 1361.15 tons: 188' 2" x 39' 8" x 21' 6". Two decks. Square stern. Billet-head. Owners: James Chambers and Henry A. Heiser, comprising the firm of Chambers & Heiser, Robert Caruly, Alexander M. Lawrence, William R. Russell, William C. and Ogden Haggerty, Daniel L. Young and Ebenezer Farrington, all of New York. Commander: Capt. Levi F. Doty.

Few ships, when launched presented a more beautiful spectacle than the *Golden State* as she took the water, fully rigged, with all her yards crossed and part of her cargo aboard. She was a very handsome ship, almost identical in model and dimensions with the remarkably fast *Golden Gate*, an extreme clipper owned by the same New York interests. She sailed for San Francisco just thirty days from the date of her launching and on the third day out she passed the ship *Northern Crown*, bound also for San Francisco. The next day she passed the medium clipper *Ariel*. Both ships had left New York twenty-four hours before the *Golden State*. It looked as though she were going to beat records, but she had to put into Rio, thirty-six days out, practically dismasted. From San Francisco she went to Shanghai, and from there to London and so back to New York. On her second voyage, this time under the command of Capt. Andrew Barstow, later lost with all hands in the old *Lantao*, she left for San Francisco again, in company with the clipper, *Golden West*, arriving in San Francisco four days sooner. She then left for Shanghai on October 14th, at the same time as the clipper *Galatea*. They both had the same passage, 42 days. The next two voyages were to China. The fourth voyage under Capt. Henry L. Hepturn took 74 days in the homeward run from Anjier port—a very good but not a record passage. On the fifth voyage she had a mutiny on board; this was becoming rather common at that period. The mutineers escaped in boats to Penang, where they were taken into custody.

After arrival at Hong Kong, the *State* made a round voyage to Bangkok, followed by one to Australia. She arrived at Sidney in a very leaky condition. On the return journey to

Bavaria

[668]

New York, near Mauritius she spoke the clipper, *Electric Spark*. The two ships made the passage in 84 days. The *Spark* had left Hong Kong 9 days after the *State*, but had not put in at any intermediate port. She arrived three days after the *Golden State*.

She was now (June, 1860) owned by A. A. Low & Company, under the command of Capt. Charles Ranlet, formerly of the clipper *Surprise*, going to San Francisco, Liverpool, Yokohama and China. Then she again changed masters and under the command of Capt. Rowland T. Delano went to San Francisco and Callao. After that her operations were confined to trade between New York, China and Japan. She had the longest career of any vessel so engaged. In May, 1867, it was stated that her cargo of tea, recently imported, was the largest ever received at New York, and that it had been sold prior to arrival for $1,000,000. In 1869 she had large repairs made, being practically rebuilt. The *Golden State* left New York on January 13th, 1883, for the last time as an American ship. She was bark-rigged and was bound for Anjier. In the North Atlantic she sprung a bad leak in a storm and put into Rio in distress in March. Her cargo was discharged and she was sold to D. & J. Maguire of Quebec who renamed her *Anne C. Maguire*. She was operated in the Atlantic trade under the Argentine flag, until December, 1886, when she went ashore on Cape Elizabeth, near Portland, Maine, and broke up.

[36] *GRECIAN*.—Oil painting by Lai Sung of ship *Grecian*, of Boston. 27" x 38".

The ship *Grecian* was built at Kennebunkport, Maine, in 1876 by Messrs. Titcomb & Thompson. 1677.41 tons: 215.8' x 40.5' x 26.9'. Two decks. Square stern. Billet-head. Owners: J. Henry Sears and Andrew Nickerson, copartners, of Boston, Milton P. Hedge, of East Dennis and the builders and master. Commander: Albert W. Dunbar, of Barnstable, Massachusetts.

J. Henry Sears & Co. were the managing owners of the *Grecian*, the second large ship of that name. She was a fine ship, an excellent specimen of the best period of Maine shipbuilding, and always kept in good condition. She made six voyages from North Atlantic ports; three being to San Francisco; two to Hong Kong and one to Yokohama. She had the reputation of being a fast sailer, and Capt. Dunbar, her master, a driver; but her passages were only average as to length. Her two shortest were from San Francisco to Queenstown, 102 days and from Cardiff to Hong Kong, 104 days. In March, 1885, while bound from Iloilo to New York she stranded on Great Danger Bank, off the Island of Balabac, one of the Philippine group and became a total loss. All hands were saved. On being put up at auction the wreck and what remained of her cargo brought $660.

[37] *HARVEST QUEEN*.—Oil painting by J. Hughes of packet ship *Harvest Queen*. 27" x 41".

The *Harvest Queen* was built at New York, in 1854, by William H. Webb, her launching taking place on May 10th, 1854. 1383.15 tons (1625.09 tons, new measurement): 178' 3" x 42' 6" x 28' 6". Three decks. Square stern. Billet-head. Owners: Charles H. Marshall, William H. Webb, George Bell, Samuel Sloan, Alfred J. Cypriant, Charles Lamson and Charles Hutchinson, of New York; Luther B. Wyman and Stephen Cary, of Brooklyn, Benjamin S.

Waite, of Westport, Connecticut, and Nathan Cobb, of Tarrytown, N. Y. Commander: Capt. Edward Young.

The Black Ball Line operated the *Harvest Queen* as a Liverpool packet during her entire existence under the usual charter arrangement with the above owners and their successors. Capt. Charles Hutchinson succeeded Capt. Young in the command of the ship and he, in turn, was followed by Capt. Henry Janssen who assumed command in 1870.

The *Harvest Queen* was lost at sea in 1876. Shortly afterwards the company lost the ship *Neptune* and it had suffered the loss of the ship *Great Western* (a vessel of about the same tonnage as the *Harvest Queen*) a short time before. The line, the oldest sailing packet line in existence (having been founded in 1817), continued in existence a few years longer, but the operations were much curtailed. As was the case with the other packet lines, it attempted no bid for passenger traffic during the last ten years of existence. Its last ship was the *Charles Marshall* (1508 tons) which disappeared from the shipping records in 1885, and with her passing the Black Ball Line which had weathered the storms of nearly seventy years and had been in its day, the most famous of all the great sailing ship lines, came to an end. All the other old packet lines had been discontinued some years before, one of the last to go being that of Grinnell, Minturn and Company.

[38] *ISAAC WEBB*.—Oil painting by J. Hughes, of Black Ball packet ship *Isaac Webb*. 27" x 41". Starboard view, in heavy sea, under double reefs.

The *Isaac Webb* was built at New York, in 1849-50, by William H. Webb, and launched Saturday, February 2nd, 1851, at 1.15 o'clock P.M. 1359.74 tons (1497.47 tons, new measurement): 188' x 39' 9" x 28'. Three decks. Square stern. Billet-head. Owners: Charles H. Marshall, Charles Lamson, George Bell, Gabriel Mead, William H. Webb and Capt. Thomas B. Cropper, of New York City; John B. Kitching, of Brooklyn; Nathan Cobb, of Tarrytown, New York, and Benjamin L. Waite, of Westport, Connecticut. Commander: Capt. Thomas B. Cropper.

Because of her great size, the launching of the *Isaac Webb* (named after the father of the builder) attracted unusual attention. It was estimated that 5000 people witnessed the event, and the reporter of the New York Herald stated that when she brought to at her anchors in the East River "she rested like a swan on her destined element." The *Webb* had a long and successful record in the "Black Ball Line," so called from the huge black ball sewn on the lower part of the foretopsail and which had the same significance in the days of sail that the color of a steamship funnel has at the present time. Charles H. Marshall, the principal owner in the *Webb*, began his career as a master of early Black Ball ships. One of his later commands was the fast packet *South America*, in which he had, for first mate, Robert H. Waterman, who became famous as a captain of China clippers. When the original owners of the line retired in 1836 Marshall succeeded to control and thereafter the line was managed throughout its existence by C. H. Marshall & Company, which continued to operate Liverpool packets after all the other old packet lines had failed or withdrawn their ships.

Like a majority of the later packets, the *Isaac Webb* was a flat-floored ship with great carrying capacity, but with sharp ends to obtain the speed essential to the trade. Thus, the

Black Prince

[12]

Oil Paintings, Water-Colors and Drawings of Ships

Webb had a 4° angle of deadrise amidships as opposed to the 25° angle of the extreme clipper *Gazelle*. In the course of her long service the *Webb* was commanded by a number of well-known captains. Cropper was succeeded in 1855 by Capt. James M. Bryer, who, in turn, was followed by Charles Hutchinson, James C. Stowell, John H. Mortimer and others. In 1875, the *Webb* was still going, with Capt. William Wallace Urquehart in command.

In 1898 the Webb Institute published a number of plans of the most noted ships built by William H. Webb, the founder (he built 135 vessels between 1840 and 1869, a total of 134,722 tons, carpenter's measure) and Mr. Charles G. Davis has drawn upon this work in his "Ships of the Past" (Salem, 1929), which contains a splendid account of the *Isaac Webb*, as well as redrawn plans for the use of model builders.

[39] *JEANNETTE*.—Oil painting by James G. Tyler of the Arctic exploration ship *Jeannette*. 44" x 30¼". Dated, 1883. Picturing the abandonment of the ship after being crushed in the ice pack. (See lithograph of *Jeannette*.)

[40] *JONATHAN T. JOHNSON*.—Oil painting by S. Walters of the schooner *Johnathan T. Johnson*. 26" x 36".

The *Johnathan T. Johnson* was built at Newburgh, New York, in 1856, by Thomas S. Marvel, Jr. 169.11 tons: 92'6" x 28'6" x 7'6". Two masts. Square stern. Billet-head. Owners: Jonathan T. Johnson, Stephen E. Merrihew, Abram Van Dervoort and George Sweeney, of Brooklyn; Augustus and William S. Whitlock, copartners, and Sellick Nichols, of New York; Homer Ramsdell and David Moore, of Newburgh; George H. Robinson of Philadelphia, and David Glines, of Gray, Maine. Commander: Capt. Edward Cole, of Brooklyn.

In addition to the above vessel, Johnson and various of his associates owned the schooners *Margaret A. Johnson* (q.v.), *Cordelia Johnson*, *Bornt S. Johnson*, *Catherine Johnson* and *F. W. Johnson*. During the late fifties and early sixties they were engaged in salvage and wrecking operations along the Atlantic coast.

[41] *JOSEPH N. LORD*.—Oil painting of New York pilot boat No. 6, the schooner *Joseph N. Lord*. 25" x 30".

The *Joseph N. Lord* was built at New York, in 1839-40, by Jabez Williams. 98.53 tons: 73' x 19' x 8'. One deck. Two masts. Square stern. No figure-head. Owned and commanded by Capt. John Hyer, of New York.

In 1842, the well-known New York pilots, Josiah Johnson, William P. Turnure and John H. White, acquired an interest in the *Joseph N. Lord*. She was the largest pilot boat of her day, most of the fleet ranging from seventy to eighty tons register, and was considered an exceptionally able boat although lacking the smart appearance of later craft. Her builder, Jabez Williams, afterwards turned out the ships *Eclipse* and *Tornado*, two notable clippers, as well as many other important vessels.

[42] *KEARSARGE*.—Oil painting by an unknown artist of United States steam Sloop-of-War *Kearsarge*. 34" x 54¾". Under sail and steam. (See lithograph of same.)

[43] *LADY ADAMS and CHARLOTTE*.—Oil painting by an unknown artist of Brigs *Lady Adams* and *Charlotte*. 19" x 26". View at sea. Entitled: "*Brig Charlotte* (82 days out) passing the Brig *Lady Adams* of Baltimore bound to Valparaiso, April 14, 1849."

The *Lady Adams*, a full-rigged clipper-brig, was built at Baltimore, Maryland, in 1825. 274.31 tons: 100' 6" x 24' 8". Two decks. Square stern. Woman bust, figure-head. Owner: William Wilson & Company of Baltimore. Later owners: Hugh Birckhead, Charles R. Pearce and Richard B. Fitzgerald, of Baltimore. Commander: Robert Benthall.

Built at the time when Baltimore clippers were establishing a reputation for superior sailing qualities the *Lady Adams* proved to be one of the swiftest craft of her day. She plied principally between Baltimore and the west coast of South America, occasionally going to European ports. She made several fast runs between Baltimore and Valparaiso. One of her best achievements was a passage of 70 days from Gibraltar to Valparaiso—very good time—made in 1837. At various times she was commanded by Capt. Evans and Capt. Robert Benthall. The last report noted of her placed her at San Francisco, November 1st, 1849, under command of Capt. Butler.

[44] *LEBANON*.—Oil painting by unknown artist of ship *Lebanon*, of New York. 16½" x 23".

The *Lebanon* was built at Newburyport, in 1847, by John Currier for Stanton & Thompson's Line of New Orleans packets. 696.67 tons: 151' x 31' 8" x 21'. Two decks. Square stern. Billet-head. Deck cabin. Owners: James Thompson, Thomas N. Stanton, Annie A. Ogden and commander, all of New York City. Commander: Archibald G. Hamilton, later of the clipper ship *Wild Duck*.

Stanton & Thompson sold the *Lebanon* after the outbreak of the Civil War to Gordon & Talbot, of New York. In 1869 she was listed as a bark hailing from North Shields, England, owned by A. Strong & Company, and commanded by Capt. J. Pritchard. She disappeared from the records in 1874. A second *Lebanon* of 570 tons (bark-rigged) was built at Boston, in 1860.

[45] *LIZZIE OAKFORD*.—Oil painting by an unknown artist of ship *Lizzie Oakford*. 21" x 29". Starboard view passing Flushing, 1859.

The *Lizzie Oakford* was built at Chelsea, Massachusetts, in 1856, by Latham Stetson. 1186 tons (996 tons, new measurement): 174' x 35' x 23' 9". Two decks. Square stern. Owners: Osborn Howes, Nathan Crowell and others, of Boston. Commander: Capt. A. Kelly.

The story of the well-known Boston firm of Howes & Crowell is told in Capt. Osborn Howes' autobiography. The firm was engaged in the shipping business for about 34 years. Besides the *Lizzie Oakford*, it owned the ships *Osborne Howes*, *Newton*, *Josephine* and others, and traded with China, California, Australia and Europe. In 1875, at which time the firm was gradually selling off its vessels, the *Oakford* was commanded by Capt. M. Rocko. Her name disappears from the registers several years later.

Oil Paintings, Water-Colors and Drawings of Ships

[46] *MARGARET A. JOHNSON.*—Oil painting by S. Walters of schooner *Margaret A. Johnson*. 26" x 35".

The *Margaret A. Johnson* was built at Newburgh, New York, in 1856, by Tomlinson & Company. 180.40 tons: 95' x 28' x 7' 10". Two masts. Square stern. Billet-head. Centre-board. Owners: Jonathan T. Johnson, James C. Slaght, Stephen E. Merrihew, Samuel Adams, George H. Barker, William F. Hemmenway, James Beveridge and Abram Van Dervoort, of Brooklyn; Sellick Nichols, of New York; Nathan L. Tomlinson and David Moore, of Newburgh; Enoch J. Allen, of Litchfield, and David Glines, of Gray, Maine. Commander: Isaac N. Osborn, of Warren County, New Jersey.

In connection with the schooner *Johnathan T. Johnson* (q.v.) and others, the *Margaret A. Johnson* was employed in salvage and wrecking operations under the management of Jonathan T. Johnson, of Brooklyn.

[47] *MARIA.*—Oil painting by J. Walters of ship *Maria*. 21⅝" x 31½". Dated 1831. Under sail at sea.

The *Maria* was built at New York, in 1821, by Fickett & Crockett. 418.70 tons: 113' x 28' 10". Two decks. Square stern. Woman figure-head. Owner: Noah Scovell, of New York. Commander: Capt. Gilbert Fowler.

Designed expressly as a "regular trader" with London the *Maria* was a superior ship and typical in every respect of the packets of the early 1820's. She was commanded successively by Captains Fowler, William P. Bucher and John Evans. Under the latter, she went to China in 1826, arriving home on the 30th of March, 1827, in the very excellent time of 100 days from Canton. Scovell sold her in 1823 to Thomas H. Smith, a merchant of New York, and in 1827 George W. Bruen, another New York merchant, purchased an interest. In 1831 Foster & Elliot, of New York, bought her and placed her under the command of the well-known Capt. William Wolfe, late of the ship *Courier*. For many years the *Maria* continued to run in the coffee trade to Rio, Sumatra and other far eastern points making excellent passages. On September 10th, 1832, she arrived in New York from Rio, having made the run in 30 days which was claimed as the record at that time. Several years later she was commanded by the veteran ship master, Capt. S. Hammond, of Salem, who made several fine runs in her—that of 63 days from Mauritius to New York in 1839, having, apparently, never been equalled at the time. Several logs of voyages of the *Maria* are now in the possession of the Marine Division of the Weather Bureau, at Washington.

[48] *MARIA.*—Oil painting by an unknown artist of the ship *Maria*, of New York. 24" x 36½".

The *Maria* was built at Hoboken, New Jersey, by Barclay & Townsend, and launched in July, 1849. 397.43 tons: 127' 4" x 25' 10" x 13' 1". One deck. Square stern. Billet-head. Owner: Francis E. Siffkin, of New York City. Commander: Capt. Kimball R. Smith, later of the extreme clipper ship, *Ino*, of New York.

Originally designed for the South American trade, the *Maria* belongs to that fleet of smart little ships and barks which included such vessels as the ship *Courier* and bark *Hazard*,

and which established enviable records for speed in the coffee trade. The New York Herald for January 25th, 1853, refers to the *Maria* in the following terms:

> "The bark *Agnes* and ship *Maria* are good carrying vessels and at the same time rank with the fastest of the clipper class. Both have frequently made the passage from Rio Janeiro to this port in thirty, thirty-one and thirty-two days. The finish of the latter vessel is seldom equalled and cannot be surpassed."

The same paper in its issue for July 30th, 1854, stated that the *Maria* had recently run from Melbourne, Australia, to Rio de Janeiro in forty-four days—very remarkable sailing. The *Maria* was sold in 1859 to Charles W. Swift of New York and resold in 1860 to Capt. James S. Clark, of New York. Shortly afterwards Curtis & Dyckman, of New York, were associated with Capt. Clark in her management. Several years later her name disappeared from the records.

[49] *MARY GLOVER*.—Oil painting by Egide Linnig, Antwerp, 1858, of ship *Mary Glover*, of Boston. 22" x 34".

The *Mary Glover* was built at South Boston, in 1849, by E. & H. O. Briggs. 593.50 tons: 144' x 29' 11" x 22'. Two decks. Square stern. Billet-head. Charles J. Morrill and Ezra H. Baker, copartners, and John Land, of Boston, and Parmelia and Sarah C. Morrill, of Dorchester, Massachusetts. Commander: Capt. Josiah Chase, of Harwich, Massachusetts.

In 1854, Capt. Chase left the *Mary Glover* to take command of Baker & Morrill's new clipper ship *Starlight*, Capt. E. Chase becoming master of the *Glover*. Messrs. Howes & Company, of Boston, purchased the controlling interest in the *Glover* in 1857, but in 1866 her registry was transferred to San Francisco, Baker & Morrill being again reported as owners. She was still running out of San Francisco in 1887, the principal owner at that time being A. D. Moore.

[50] *NATCHEZ*.—Water-color by unknown artist, of steamboat *Natchez*. 18½" x 28½". (See lithograph of steamboat *Eclipse*.)

[51] *NIAGARA*.—Original water-color drawing by F. S. Cozzens of the Cunard wooden paddle steamship *Niagara*. 16½" x 25".

The *Niagara* was built by Robert Steele, at Greenock, Scotland, in 1846-7. 1631 tons, 249' x 38' x 25'. Two decks. Three masts. Bark-rigged. Two side lever engines by R. Napier. Cylinders: 92" diameter. Piston stroke: 8'. Owner: The Cunard Steam Ship Company. Commander: Capt. Alexander Ryrie.

In 1846 the Cunard Line which had operated its steamers between Liverpool and Boston since 1841, determined to put on another line between Liverpool and New York, primarily to meet the threat of competition of the proposed "Ocean Steam Navigation Company," of New York, which began operations in 1847, between New York and Bremen, via Cowes. The *Niagara* was one of the four new steamers, all paddlers, built for that purpose. The others were the *Canada*, *America*, and *Europa*. They were all about the same size and said to have been very much like the *Acadia*, an earlier and smaller steamer of the same line. The

Harvest Queen

[37]

Niagara made her maiden trip to Boston in June, 1848, and came to New York the following August, her passage of a little over 12 days from Liverpool being called "the shortest yet."

In 1852 she made the longest trip of 20 days 19 hrs., causing a good deal of anxiety for her safety. These wooden Cunarders were splendid sea-boats and she returned in due time. Under the subsidy contract she was one of the first steamers taken up as a transport in the Crimean War, being requisitioned on the 13th of February, 1854, at a price of £2 10s. per ton per month. She got away from Liverpool on the 23rd, with the 28th Regiment on board, arriving at Malta on March 4th and disembarking them to be carried on by smaller steamers while she came back to Liverpool for the 88th, later the Connaught Rangers. After that she was paid off until reinforcements were badly wanted for the winter. In 1886, she was sold out of the service to Glasgow ship-builders, who converted her into a sailing ship and sold her to Duncan Dunbar for the Australian trade. Soon afterwards she was transferred to Birkmyre & Co. of Port Glasgow and was wrecked near the South Stack on the 6th of June, 1875, carrying cotton from New York to Liverpool. No lives were lost and the captain was held blameless as he was deceived by incorrect soundings.

[52] *NIAGARA.*—Oil painting by J. E. Buttersworth of the United States Steam Screw Sloop-of-War *Niagara*. 24" x 30⅛". Shown with a small brig-rigged paddle steamship, possibly H. B. M. Ship *Leopard*, laying the first transatlantic cable. The picture is undated but apparently represents the *Niagara* approaching Trinity Bay, in Newfoundland, in 1858.

The *Niagara*, which was actually a very large Sloop-of-War, although frequently referred to as a frigate, was built at the New York Navy Yard, in 1854-7. Ship-rigged. Round stern. Eagle figure-head. 5540 tons, displacement: 4580 tons, register: 328' 10½" x 55'. Engines by Pease & Murphy (Fulton Iron Works) of New York. Three horizontal, direct acting cylinders: 72" x 36". Two telescoping smoke stacks. Armament: 12 guns. Total cost: $1,057,210.14.

When completed the *Niagara* was the largest, fastest and most powerful steam warship in the United States Navy, if not in the world. She was designed especially for speed and George Steers who had modeled and built the yacht *America* and several fast ocean steamships, was responsible for her lines and equipment. She was given about fifty per cent more power than was the usual practice at the time, and developed a steaming speed of 10.9 knots in smooth water. She was placed in commission in the Spring of 1857 and was first sent to England to assist in laying the Atlantic cable, under the command of Capt. William L. Hudson. Half the cable was placed in the *Niagara* and half in the *Agmemnon*, the two ships and the consorts leaving Valencia, Ireland, August 7th, 1857. Four days out the cable broke after part of it had been laid and the attempt was abandoned until the following year. In 1858 the second attempt was made, both ships having been newly equipped with improved cable laying machinery designed by William H. Everett, chief engineer of the United States Navy. This time the two steamers proceeded to midocean and each started home from there and the cable was laid successfully. After two weeks it failed, due to defective insulation and was not replaced until 1866 when a new more effectively insulated cable was laid by the *Great Eastern*. The next service of the *Niagara* was to return nearly 300 slaves, captured in the

slaver *Echo*, to Africa. In 1860 she carried the Japanese embassy back to Japan returning in 1861. Owing to her great size she was thought to be impractical for operations on the Atlantic Coast in the Civil War, and was sent to Europe on special service. In August, 1864, she captured the Confederate privateer *Georgia*. After the end of the war she returned to Boston where she was laid up until 1885, when she was sold to be broken up.

[53] *NORTH AMERICAN*.—Oil painting by Lai Fong of the ship *North American*, of Boston. 28" x 36". At sea, under full sail. Dated at Calcutta, 1890. Reproduced in Matthews "American Merchant Ships" at page 224 and again as No. 463 in "Sailing Ships of New England."

The *North American* was built at East Boston, in 1873. 1583.95 tons: 234' x 41' x 24'. Three decks. Elliptic stern. Figure-head. Owners: Henry Hastings and Edmund F. Hastings, of Boston, William Fox Richardson, of Cambridge, and James B. Hatch, of Springfield, Mass. Commander: Capt. George W. Tucker of Portsmouth, New Hampshire, formerly of the medium clipper ship *Coeur de Lion*, and later of the medium clipper *Midnight*.

At the time of her launching the *North American* was reported to be the most strongly fastened and best built ship ever constructed in New England, and for several years under Capt. George W. Tucker, her first commander, her beauty and grace of line excited universal admiration. Her maiden voyage served to establish the fast sailing ability that distinguished the entire career of the *North American*. She sailed from New York to Melbourne in 72 days, logging an average of 196 miles per diem; then to San Francisco in 51 days, averaging 204 miles daily; thence to Liverpool in 95 days with an average of 178 miles daily. An average of 8 knots per hour throughout. She was mainly engaged in trade with the Orient and on one leg of a voyage the remarkable time of 14 days was logged from the line in the Pacific to the San Francisco Bar. This time has never been beaten except by the 12 day record of extreme clipper *Comet* in 1856. It has been equalled only by the 14 day run of the clipper *Seaman* in 1851, and is one day shorter than the *Flying Cloud's* fastest. The average of her eleven passages from San Francisco to Liverpool was 119 days and that of the six best 110 days. The *North American* was lost in the Kei Channel, Japan, during a typhoon in July, 1892. At the time she was under the command of Capt. B. C. Creelman bound from Hiogo to New York and, in spite of her being stranded, all hands were saved. She was the last but one of the notable Hastings fleet of eighteen splendid ships.

Her commander at the time the picture was painted (1890) in Calcutta was Perry P. Arbecam.

[54] *NORTHERN LIGHT*.—Oil painting by F. H. Lane, of Boston, of the medium clipper ship *Northern Light*. 23" x 35". Reproduced as No. 464 in "Sailing Ships of New England." No. 701 in the same series is a reproduction of another painting of the same ship.

The *Northern Light* was built at South Boston, by E. & H. A. Briggs, and launched September 25th, 1851. 1021.47 tons: 171' 4" v 36' x 21' 9". Draft: 21'. Dead rise: 40". Figure-head. Owners: Capt. James Huckins, Henry S. Hallett and others of Boston. Commander: Capt. Bailey Loring.

Casa Fuca

[670]

While the *Northern Light* has generally been referred to as a medium clipper, she had, nevertheless, most of the characteristics of the extreme clippers of her day. She was heavily sparred and like all ships designed by Pook, presented a very handsome appearance. For a figure-head she carried an angel, full size with flowing drapery, with one arm extended overhead bearing a torch with a golden light. Her first voyage to San Francisco was 110 days, her best day's run on the passage being 355 miles—a very good performance on the Cape Horn route. On her second voyage to San Francisco she was commanded by Capt. Freeman Hatch and the run took 118 days, but her return trip to Boston established the sailing ship mark of 76 days, 6 hours for the course, a record which has never been approached, much less equalled.

The *Northern Light* was sold on April 20th, 1854, at auction for $60,000.00, the reputed purchaser being Capt. Doane. Thereafter she was commanded by Capt. William W. Young, followed by Capt. Seth Doane. She was abandoned at sea in a sinking condition, January 2nd, 1861, having been cut down in a collision.

[55] OBED BAXTER.—Oil painting, by an unknown artist, of bark *Obed Baxter*, of Boston. 17½" x 23". Reproduced as Nos. 459 and 703 in "Sailing Ships of New England."

The *Obed Baxter* was built at Newburyport, Massachusetts, in 1876, by George E. Currier. 916.26 tons: 180.2' x 34' x 19'. One deck. Elliptical stern. Billet-head. Owners: Nehemiah Gibson, Elliot Ritchie, Joseph Nickerson, Caleb T. Curtis, A. D. Witherell and Francio and Calvin P. Low, of Boston. Charles C. Sweeney, of Galveston, and George E. Currier and others, of Newburyport. Commander: Capt. Obed Baxter, of Dennis, Massachusetts.

Built expressly for carrying cotton, the *Obed Baxter* apparently passed her entire career in that trade. Capt. Baxter commanded her for nearly ten years after which Capt. Hathaway had her for a short time. He was succeeded in 1887 by Capt. Charles H. Colby who had served as chief mate in the noted clippers. *Nightingale*, *Grace Darling* and *Prima Donna*.

[56] OCEAN QUEEN.—Oil painting by C. S. Raleigh of ship *Ocean Queen*. 33" x 60". Dated, 1884. Reproduced as No. 467 in "Sailing Ships of New England." No. 212 of the same series shows another painting of her.

The *Ocean Queen* was built at Newburyport, Massachusetts, in 1847 by George Jackman. 824 tons: 159' 3½" x 36' 6½". Two decks. Square stern. Billet-head. Owners: Moses Davenport, Henry Shoof and John Osgood of Newbury, and Charles Hill of Jamaica Plains, Massachusetts. Commander: Capt. George Coffin.

[57] PARTHENIA.—Oil painting by D. McFarlane of the ship *Parthenia*, of Newburyport. 24" x 35". Dated 1855. Reproduced as No. 472 in "Sailing Ships of New England."

The *Parthenia* was built at Newburyport, Massachusetts, in 1852 by John Currier. 849.36 tons: 160' x 34'. Two decks. Square stern. Billet-head. Owners: Charles Hill, John Osgood, Henry Shoof, and John Currier of Newburyport. Commander: Capt. William Hinton, of Boston.

At another period in her existence the *Parthenia* was commanded by Capt. Sears. She was sold in 1863 to Joseph S. Burgess of New York and her registry changed to that port.

[58] *POTOMAC*.—Oil painting by an unknown artist of the bark *Potomac*. 18" x 23½". Reproduced as No. 478 in "Sailing Ships of New England."

The *Potomac* was built in 1833 at Duxbury, Massachusetts. 272.60: 101' x 24' 6". Two decks. Square stern. Billet-head. Owners: Reuben Drew and Joseph Drew of Duxbury. Commander: Capt. Ira Baxter of Barnstable, Massachusetts.

After two years the *Potomac* registry was transferred to Baltimore, and she sailed out of that port for several years. In 1844, she hailed from Barnstable and was then commanded by Capt. Richard Bearse, Jr., of that place. Her owners at that time were John A. Baxter and Ira Baxter. In 1853 she was owned by Charles B. Fessenden of Boston and commanded by Jonathan Hallett. Later in the same year she was condemned and sold abroad. She is reported to have been one of the forty ships of the famous "stone fleet" which were bought by the United States Government in 1861 and sunk to blockade the ports of Charleston and Savannah.

[59] *PRINCETON*.—Oil painting by George Atkinson of bark *Princeton*. Dated 1851. 23" x 35". View at anchor in harbor. Reproduced as No. 480 in "Sailing Ships of New England."

The *Princeton* was built at Bath, Maine, in 1842, by Levi Houghton. 296.5 tons: 105' x 25' x 12' 6". One deck. Square stern. Billet-head. Owners: Levi Houghton, Elijah D. Manson, Charles Owen and Silas A. Houghton. Commander: Capt. Silas A. Houghton.

In 1857 the *Princeton* hailed from New York, her master and owner being Capt. Page. There was another bark of the same name built at New Haven, Connecticut, in 1852. Her dimensions and tonnage (296.44) were almost identical with those of the Bath built vessel.

[60] *RED JACKET*.—Oil painting of the clipper ship *Red Jacket*. 32" x 48". Starboard view at sea. (A painting of the *Red Jacket* done by Edouard Adam at Le Havre, 1854, is owned by F. V. Smythe).

The *Red Jacket* was built at Rockland, Maine, by George Thomas and launched November 2nd, 1853. 2434.86 tons: 250' x 45' 7" x 31'. Three decks. Round stern. Indian figure-head. Owners: Isaac Taylor and Edwin R. Seccomb, of Boston. Commander: Capt. Asa Eldridge, who also owned an interest in the ship.

Samuel H. Pook, perhaps one of the ablest naval architects this country has produced, designed the *Red Jacket* and she proved to be one of the most successful, as she was one of the handsomest of the extreme clippers. Her original model, now in the Boston Marine Museum, shows her to have embodied utility and beauty in a very rare degree. Her maiden voyage from Boston to Liverpool in January, 1854, was made in the record time of thirteen days, one hour and twenty-five minutes from dock to dock. On Thursday, January 19th, she ran 413 nautical miles, on the strength of which "all hands spliced the main brace." Her achievement so impressed the owners of the White Star Line that they immediately char-

China

[264]

tered her for the round voyage to Melbourne. She made the outward passage in just under 70 days and the return in 73. Her dangerous experience in the ice near Cape Horn on this voyage is the subject of a popular print. When she arrived at Liverpool, Pilkington & Wilson, the owners of the White Star Line, bought her for £30,000. She continued in the Australian trade for about ten years, part of the time under the command of Capt. Halleran. The ensuing fifteen years was spent largely in the lumber trade between Quebec and London. She was reported broken up about 1915 after spending many years at Gibraltar and Cape Verde, as a coal hulk.

[61] RESOLUTE.—Oil painting by Lai Sung of packet ship *Resolute*. 31" x 45". Port view at anchor.

The *Resolute* was built at New York, by William H. Webb and launched September 5th, 1857. 1413 tons (1644.54 tons, new measurement): 190' x 41' 5" x 28'. Three decks. Square stern. Billet-head. Owners: John S. Williams, William H. Guion and Stephen B. Guion, comprising the firm of Guion & Williams, William H. Webb, William K. Hinman, William Edwards and Thomas F. Freeman, all of New York. Commander: Capt. Thomas F. Freeman.

Capt. Freeman appears to have commanded the *Resolute* as long as she was operated as a Liverpool packet. She was built expressly for the Guion & Williams Line, and was the 114th vessel constructed by Webb since 1840, when he succeeded to the shipyard of his father, Isaac Webb. Early in 1872, the *Resolute* was sold to Capt. J. C. Nickels, of New York and A. K. Thompson and others, of Trenton, New Jersey. Capt. Nickels put her into the Far East trades, and she was continued in that business for some years. In 1886 she was reported as abandoned at sea, being then rigged as a bark. There were two others ships of the same name, contemporary with the *Resolute*; one, of 745 tons built at Freeport, Maine, in 1856 by Briggs and Company; the other, a clipper ship of 786 tons, built at New York in 1853 by Jacob A. Westervelt.

[62] ROBERT E. LEE.—Water-color by an unknown artist of the steamboat *Robert E. Lee*. 18¾" x 28⅛".

The *Robert E. Lee* was built at New Albany, Indiana, in 1866, by De Witt Hill. 1467.31 tons, 285' 6" x 46' x 9'. Two high pressure (120 pounds) engines. Cylinders: 40" diameter. Piston stroke: 10'. Paddle wheels: 38' x 16' 6". Eight iron boilers by Stuckey & Company: 28' x 42". Commander: Capt. John W. Cannon.

Although not quite so large as several others, the *Robert E. Lee* was regarded as one of the finest and fastest steamers on the western rivers. She was a great favorite and became, perhaps, the most famous of all the Mississippi boats. Her race in 1870 with the *Natchez* has become the steamboat classic. On that occasion both vessels stripped for the race and carried no passengers. The *Lee* arrived at St. Louis in three days, 18 hours and 14 minutes from New Orleans; the *Natchez* coming in six hours and 33 minutes later, according to one report of the race, and three hours and 28 minutes later, according to another. When the *Robert E. Lee* arrived at St. Louis, 30,000 people crowded the wharves, windows and house

tops to greet her. No similar event had ever created so much excitement. Capt. Cannon was tendered a banquet by the business men of the city, and it was estimated that more than a million dollars had been wagered on the race. It was reported at the time that the *Natchez* lost the race through the over-confidence of her commander, Capt. Leathers. Capt. Cannon had arranged for his fuel to be delivered on barges in mid-stream all the way to St. Louis, so that he was enabled to hook on to the barge and load without stopping. The *Natchez*, on the other hand, was compelled to tie up at the river bank while taking on fuel and so lost valuable time. As one newspaper wag remarked, "Captain Cannon scraped the gilt off the pilot house and made his crew shave their heads." A recent account states that the *Robert E. Lee* was burned on the Mississippi in the early 80's, but it is possible that her destruction took place earlier, since a second and larger *Robert E. Lee* was built in 1876.

See No. 362 for lithograph of same steamer.

[63] *ST. CLAIR.*—Water-color drawing by Charles W. Norton, of Boston, of the bark *St. Clair.* 16" x 20".

The *St. Clair* was built at Port Huron, Michigan, in 1865. 350 tons: 132.6' x 25.8' x 12.4'. One deck. Elliptical stern. Indian figure-head. Owners: Henry W. Peabody and Samuel Stevens, copartners, and James Power, of Boston. Commander: Capt. A. C. Burnhaur.

In 1866, Capt. Leonard W. Merrill, of Boston, succeeded to the command of the *St. Clair.* The following year she was sold to Vernon H. Brown, of New York, and her registry transferred to that port. Brown sold her within a short time to Norman P. Bolles and John G. Meiggs, of New York, after which her name disappears from the records.

[64] *SAMOS.*—Oil painting by an unknown artist of the barkentine *Samos.* 22" x 27". Starboard view.

The *Samos* was built at Pembroke, Maine, in 1854. 385.13 tons: 124' 6" x 29' 1" x 11'. One deck. Square stern. Billet-head. Owners: Elisha Atkins and Benjamin F. Bashford, of Boston. Commander: Capt. Silas G. Castner.

At the time the *Samos* was built the term "barkentine" had not been coined or, at all events, was not in general use. The rig seems to have appeared first about 1849 on sailing vessels, although used on steamships earlier, and until about 1857 it was usually referred to as a "Three masted brig." Most of the brief existence of the *Samos* was spent in trade between Boston and the West Indies or other Southern ports. She was wrecked near Sagua in May, 1858, becoming a total loss.

A second *Samos* was built at East Boston, in 1868. She measured 395 tons and was owned for many years by T. Nickerson & Company, of Boston.

[65] *SARAH ABIGAIL.*—Oil painting by an unknown American artist of the brig *Sarah Abigail.* 22" x 27". View, hove to, in a storm; boat putting off to the rescue of a British ship flying distress signal.

The *Sarah Abigail* (also given in official records as *Sarah & Abigail*) was built at

Oil Paintings, Water-Colors and Drawings of Ships

Cohasset, Massachusetts, in 1834, by Jonathan B. Bates. 210.85 tons: 96′ 2″ x 22′ 5½″ x 10′ 9½″. One deck. Square stern. Billet-head. Owners: Jarius Pratt and Samuel N. Cushing, of Boston, Jonathan B. Bates, William Bates, Bela Bates, Paul Bates, Jr., William H. Stoddard and Samuel Stockbridge, of Cohasset. Commander: Capt. Elisha Barker.

Few vessels changed owners more rapidly than the *Sarah Abigail*. Less than a year after her launching she was sold to John N. Barbour and John N. Sullivan, of Boston. Two years later she was owned by Henry Hall, John Kettell and John N. Sullivan, of the same place. The following year she was purchased by James Huckins, Zenas D. Bassett and Matthew Cobb, well-known merchants of Boston, and placed under the command of Nelson Scudder of Barnstable. Several Barnstable men, including Daniel Crocker, Warren Hallett and Ebenezer Bacon, also owned small interests. Capt. Samuel P. Savage commanded her in 1839. In 1841, Capt. Isaac S. Doane, of Orleans, Massachusetts, had her. Robert Bennett Forbes, of Boston, was the next to own her, but he sold her in 1845 to Daniel Sharp and Henry Bradlee, Boston merchants. She was then commanded by George Drew. Early in 1849 she was again sold and placed under the command of Capt. Richard H. Yarrington, of Salem. Later in the year she was sold to Thomas Dimon, Ephrain Holmes and John B. Collingwood, of Plymouth, and the command given to Capt. Josiah Bartlett, of Plymouth, after which all trace of her is lost.

It is to be noted that she was reported sold abroad in 1843, but this, obviously, was erroneous.

[66] *SEA WITCH*.—Oil painting by a Chinese artist of the clipper ship *Sea Witch*, showing the vessel lying at anchor with sails furled, in the harbor of Hong Kong. 18″ x 24″.

The *Sea Witch* was designed by John W. Griffiths, one of the leading naval architects of his day, and built at New York, in 1846, by Smith & Dimon, who had previously built the clipper *Rainbow*. 907.53 tons: 170′ 3″ x 33′ 11″ x 19′. (192′ o. a.) Two decks. Square stern. Chinese dragon figure-head. Owners: Messrs. Howland & Aspinwall, of New York. Commander: Capt. Robert H. Waterman, of Bridgeport, Connecticut.

When the *Sea Witch* was launched on the 8th day of December, 1846, she was the largest and sharpest vessel of clipper lines that had ever been built, although her cargo capacity was 1100 tons and she was, therefore, not nearly so sharp as some of the later clippers, several of which could not carry their registered tonnage. She was heavily sparred, her mainmast being 83′ 2″ in length, and contemporary accounts agree in pronouncing her the handsomest craft afloat, although her rather straight sheer and square stern gave her a heavy appearance compared with the light, graceful lines of later clippers. Howland & Aspinwall, who were engaged in the South American and China Trade and appear to have favored the clipper type more than any other firm of that period, ordered the *Sea Witch* expressly for Capt. Waterman. They had previously owned and operated the Baltimore clippers, *Ann McKim*, the barque *Valparaiso* and other Chesapeake built vessels, and their experience with such craft doubtless had much to do with their determination to build the *Rainbow*. The remarkable passages of this ship under Capt. William H. Hayes demonstrated the case for the clipper with complete conclusiveness, and when, in 1845, Waterman converted

the old cotton drogher *Natchez* into a passable imitation of a clipper and brought her home from China in the unprecedented time of 78 days, they had the *Sea Witch* laid down for him without further ado. Waterman sailed from New York in the new clipper on December 23rd, 1846. Her outward and homeward passages set no new record for the entire course, but they did establish more new sailing marks than any ship had previously chalked up in a single round. Going out, the *Sea Witch* passed the Cape of Good Hope in 42 days, and Java Head in 70 days, 10 hours. Returning she ran from Anjier to the Cape in 26 days, and from Anjier to pilot, off New York, in 62 days. Her return passage was made *against the monsoon* in 81 days, and during the run she had averaged 264 nautical miles for 10 successive days. Each of these achievements established a new record—six in all. Twenty days after her arrival in New York she was loaded and off for Canton again, giving New Yorkers, incidentally, a demonstration of her sailing powers by breaking another record before she got clear of the port—ramping down to Sandy Hook, a distance of 19 miles, in one hour and three minutes. These records, creditable as they were, were completely overshadowed by her later performances. Waterman had her for three voyages, and on the second and third she set marks for the run from China to New York that have never been equalled by any other ship before or since—77 days in 1848 and 74 days, 14 hours in 1849. Continuing her work under Capt. George Fraser, who succeeded Waterman and commanded until he was murdered on board the ship in 1855, the *Sea Witch* had the distinction of being the first vessel to make the passage around the Horn to San Francisco in less than 100 sailing days, her run of 97 days in 1850 being a record at the time. She was lost on the coast of Cuba, near Havana, on the night of March 28th, 1856, after a creditable career of less than ten years—years which had, however, witnessed both the rise and decline of that most colorful of achievements; the American clipper ship.

[67] *SOUTHERN CROSS.*—Oil painting by Lai Sung, Hong Kong, of the medium clipper ship *Southern Cross*. 24" x 34". Starboard view at sea. This painting is reproduced as No. 512 in "Sailing Ships of New England." Another painting of the same ship reproduced as No. 264 in the same series.

The *Southern Cross* was built at East Boston, by E. & H. O. Briggs and launched March 19th, 1851. 938.48 tons: 168' 6" x 34' 9" x 21'. Two decks. Square stern. Eagle figure-head. Owners: Charles J. Morrill and Ezra H. Baker, of Boston, and Benjamin K. Hough, Jr., of Gloucester. Commander: Capt. Levi Stevens.

The owners of the *Southern Cross* put her at once into the California trade and most of her existence was passed on the Cape Horn route, with occasional trips to China. Capt. Paine succeeded to the command in 1853 and was followed by Capt. Thomas Prince Howes in 1854. The *Southern Cross* was not an especially fast ship for a clipper, and made no records. However, she seemed to be rather unfortunate in meeting with bad weather. Most of her Cape Horn runs were made in the unfavorable season. She was one of several clipper ships destroyed by Confederate cruiser *Florida*, being burned at sea just south of the line in the Atlantic, June 6th, 1863, while commanded by Capt. Howes. It has often been said that the disappearance of the clippers came as a result of the depredations of the Con-

The Hongs and Water Front — Canton

[110]

Oil Paintings, Water-Colors and Drawings of Ships

federate ships, the best known of which was the *Alabama*. But such losses were comparatively slight and it was purely economic considerations which led to the discontinuance of their building. An interesting contemporary account of the *Southern Cross* has been reprinted in Volume II of "American Clipper Ships," Salem, 1927.

[68] *SOVEREIGN OF THE SEAS.*—Oil painting of clipper ship *Sovereign of the Seas*, 25" x 35". Starboard view at sea. Reproduced as No. 513 in "Sailing Ships of New England," where another painting, No. 265, is also shown. The Old State House in Boston has a painting which is almost a duplicate of the one above described but with F. M. on the house-flag.

The *Sovereign of the Seas* was built at East Boston, by Donald McKay, and launched in June, 1852. 2420.83 tons: 258' 2" x 44' 7" x 23' 6". Two decks. Round stern. Figure-head. Owner: Donald McKay of Boston. Commander: Capt. Lauchlan McKay.

Donald McKay built the *Sovereign of the Seas* on his own account, giving the command to his brother Lauchlan. She was an extreme clipper and the largest merchant ship of her day. Her original model now in Mariner's House, North Square, Boston, indicates that she had very handsome powerful lines. While she never reported day's runs quite equal to the records of two or three of the three-deckers built later, it is possible, if not probable, that she was the fastest two-deck clipper ever built. Her maiden voyage to San Francisco, with a crew of 105 men and boys, was accomplished in 103 days, in spite of the fact that it was made in the most unfavorable season of the year and under the handicap of being almost totally dismasted in the Southern Pacific. Her return voyage from Honolulu was made in the then record time of 82 days. On this trip her log shows her to have made 19 knots an hour and to have run 420 nautical miles in 24 hours. After reaching New York she was sold to Funch & Meinke, ship-brokers, of New York. She was chartered by the Australian Black Ball Line in 1853, for a round between Liverpool and Melbourne, and on her run outsailed everything in the trade, going out in 78 days and returning in 68 days. She was sold in 1854 to J. C. Godeffroy & Son, of Hamburg and placed under the command of Capt. Mueller, who took her out to Melbourne again. On her arrival there the Melbourne papers stated that her log showed she had run 22 knots on several occasions, but again a fast passage was spoiled by her partial dismasting. She seems to have been rather unlucky under the German flag. Her end came in 1859 when she ran on the Pyramid Shoals in the Malacca Straits and became a total loss. A long description, reprinted from the Boston Daily Atlas at the time she was launched appears in Volume II of "American Clipper Ships," Salem, 1927.

[69] *STAG HOUND.*—Oil painting by Antonio Jacobsen, 1916, of clipper ship *Stag Hound*. 19" x 28". Reproduced as No. 267 in "Sailing Ships of New England."

The extreme clipper ship *Stag Hound* was built at East Boston, and launched December 7th, 1850. 1534.10 tons: 209' x 39' 8" x 21'. Two decks. Round stern. Stag hound figure-head. Owners: George R. Sampson and Lewis W. Tappen of Boston. Commander: Capt. Charles W. F. Behm.

The maiden voyage of the *Stag Hound* to San Francisco and return by way of China was

accomplished in less than eleven months and earned a net profit for the owners of $80,000.00, besides paying for the ship. Although she was regarded as very fast, the *Stag Hound* made no records. Her first run to San Francisco in 108 days was her best for that route. Following Capt. Behm, she was commanded by Captains Peterson and Jacobson, and in 1858 by Samuel B. Hussey, formerly of the extreme clipper *Westward Ho*. In August, 1861, she sailed from England with a cargo of coal for San Francisco. Fire was discovered on October 12th when the ship was off the coast of Brazil. Within sixteen hours the crew were compelled to take to the boats, and after watching the vessel burn to the water's edge they rowed fifty miles to Pernambuco.

It is sometimes said that the *Stag Hound* was the first large extreme clipper built. This is true only in the sense that she was slightly larger than other large extreme clippers such as the *Surprise* and *Sea Serpent* which had already been launched, and is subject to the further qualification that even larger extreme clippers were laid down in New York about the time the *Stag Hound* was started, one of which, the *Challenge*, was even more extreme than the *Stag Hound*, both in model and rig. The New York ships, however, being much larger, were not completed when McKay's ship was launched. An excellent contemporary description of the *Stag Hound*, reprinted from the Boston Atlas of December 31st, 1850, will be found in Volume II of "American Clipper Ships," Salem, 1927.

[70] SUPERIOR.—Water-color drawing of schooner yacht *Superior* by Charles W. Norton (Detroit, cir. 1875). 13" x 18½".

[71] SUSAN DREW.—Oil painting by an unknown artist of the ship *Susan Drew*. 21" x 36". Reproduced as No. 518 in "Sailing Ships of New England."

The *Susan Drew* was built at Duxbury, Massachusetts, in 1839, by Sylvanus Drew. 694.44 tons: 149' 8" x 31' 10" x 22' 10". Two decks. Square stern. Figure-head. Owners: Allen Putnam, William B. Parker, John F. Andrews, John P. Andrews and Jeremiah Page, of Salem. Commander: Capt. Jeremiah Page.

Designed for the China Trade, the *Susan Drew* was one of the larger and finer ships of her time, to be built for that traffic. She is best known, however, as one of the first fleet to carry United States troops to California shortly after the seizure of that territory in 1846 by the sloop-of-war *Portsmouth*. With the other old tea ships *Loo Choo* and *Thomas H. Perkins*, she was chartered in 1846 to carry part of Col. Stevenson's regiment to San Francisco. She arrived out in March, 1847, and then went to China for tea. On the way home from Canton she ran into a typhoon off Cochin China on the 10th of October, 1847, and was compelled to jettison her deck load of camphor to save the ship. She arrived in New York February 28th, 1848, being then under the command of Capt. Putnam. She was sold in 1849 to Victor Constant, Edward J. Lyon and George M. Bernard of Boston, and again sent to California, under Capt. Victor Constant. A journal kept by Lieutenant Hollingsworth gives an interesting account of this voyage. Another account can be found in Whidden's "Ocean Life" (p. 87). The Boston Marine Museum has the log of the *Susan Drew* for 1842.

De Witt Clinton

[27]

Oil Paintings, Water-Colors and Drawings of Ships

[72] *SWEEPSTAKES.*—Oil painting by D. McFarlane of the clipper ship *Sweepstakes*.

The *Sweepstakes* was built in 1853, at New York, by Jacob A. Westervelt to the design of his son, Daniel D. Westervelt. She measured 1735 tons, and was an ideal clipper built for speed and was one of the handsomest vessels of her day. She was a flier and in her passages from New York to San Francisco she averaged 106 days each trip. At her best in 1856 she made the trip in 94 days which was the fastest run of the year. In addition to a heavy passenger list she was loaded deep with 2400 tons of general cargo. This run is the eighth fastest on record for any clipper. Jacob A. Westervelt was a passenger and naturally was much pleased with her performance. Having completed her voyage to Shanghai she made the return trip from that port to New York in 100 days, which was fast sailing. She was commanded by Capt. George E. Lane who had a great reputation for cracking on sail. Because of her reputation for speed she was very popular with passengers going to California during the gold rush. This was usually a one way trip so there was no stop at San Francisco on the return voyage from China.

The *Sweepstakes* sailed under the house flag of the Swallowtail Line of Grinnell, Minturn & Co. They were New York merchant ship owners who ran regular packet lines to several ports. Each line had a distinctive flag of various colors according to destination but were all cut in the swallowtail design. The flag on the *Sweepstakes* was that of their ships bound for San Francisco and China. A Currier & Ives print of the *Sweepstakes* was sold on March 28th, 1930, at the Plaza Art Galleries for $500 and it is appraised in J. C. Bland's *Currier & Ives* at $1000. See No. 372.

Very little is known of the artist D. McFarlane except that he painted excellent pictures of ships. His painting of the *Dreadnought* is well known through the Currier & Ives print of it.

[73] *UNION.*—Oil painting by J. E. Buttersworth of the ship *Union* of Boston. 21" x 29". Quartering stern view entering Boston harbor. Reproduced as No. 527 in "Sailing Ships of New England." Nos. 525 and 526 show other portraits of this ship.

The *Union* was built at Medford, in 1850, by Samuel Lapham. 618.17 tons: 150' x 31' 7" x 21'. Two decks. Square stern. Billet-head. Owners: John T. Coolidge, Robert C. Mackay, Robert G. Shaw, G. Howland Shaw and Robert G. Shaw, Jr., of Boston. Commander: Capt. Edward Meacom.

Although sometimes referred to as a clipper, the *Union* had small claim to that classification. It is possible that she has been confused in that respect with the Baltimore clipper ship of the same name. She was, in fact, a rather full-built vessel, having been built for the heavy carrying trade of Calcutta, in which she spent most of her existence. In 1853 Robert C. Mackay bought out the interests of all the other owners and placed Capt. John C. Phipps in command. Later she was successively commanded by Captains Chapman, Small and Norton. Mr. Mackay sold her in 1863 to F. Cousinary & Company, of Calcutta. She was still reported in the shipping registers of 1870, although she had not been seen in American waters for several years.

[74] *WIDE AWAKE.*—Oil painting by S. Walters of clipper ship *Wide Awake*. 29" x 41".

The *Wide Awake* was built at New York, by Perine, Patterson & Stack, and launched July 2nd, 1853. 758.16 tons: 168' 6" x 31' x 17' 10". Two decks. Round stern. Owners: George B. Ironsides and Francis E. Siffkin, of New York. Commander: Capt. Kimball R. Smith.

Although one of the smallest of the extreme clippers the *Wide Awake* was a very handsome heavily sparred ship. Her maiden voyage to San Francisco took 113 days, the fastest time made by any ships sailing that year in August and September. She scored a margin of from four to eleven days over such clippers as the *Raven, Northern Light* and *Witch of the Wave*, and beat the *Southern Cross* forty-four days. From San Francisco she went to Hong Kong in forty-five days and proceeded thence to Singapore where she loaded for New York. Thereafter she engaged in trade between New York and Singapore, making consistently good passages of eighty days or thereabouts. She left New York in July, 1857, and was reported on her arrival at Singapore as sold to go under the Siamese flag. In 1860 she was reported as sold in England and shortly thereafter her name was dropped from the registers.

[75] *WILD RANGER.*—Oil painting by J. Hughes of clipper ship *Wild Ranger*. 30" x 42". See reproductions Nos. 540 and 766 in "Sailing Ships of New England."

The medium clipper ship *Wild Ranger* was built at Medford, Massachusetts, by James C. Curtis and launched April 7th, 1853. 1044.71 tons (930 tons, new measurement): 177' x 35' 4" x 22' 8". Two decks. Elliptical stern. Hound figure-head. Owners: Thatcher & Sears, of Boston. Commander: Capt. J. Henry Sears.

Although the lines of the *Wild Ranger* were rather full she was a very handsome, rakish ship, crossing three skysail yards. Her first three voyages were to San Francisco and, as all were made in the unfavorable season of the year, they throw no light on her sailing ability. Thereafter she made voyages to India, Melbourne and London. On the 28th of December, 1861, she sailed from London for Boston, and on the 3rd of January, following, she was in collision with the British ship *Coleroon* bound for London from Madras. Her starboard bow was stove, cutwater damaged, bowsprit sprung and fore-topgallant mast carried away. Putting into Falmouth two days later, it was found necessary to discharge her cargo, which was forwarded on the *Nonantum*. The collision had occurred in the day time and the *Wild Ranger* was adjudged to be at fault. She was libelled for £12,500 and sold at auction, bringing £4,550, the purchasers being Angel & Company, of Liverpool who renamed her *Ocean Chief*. She foundered at sea in 1872 on a voyage to Rio de Janeiro, having been in a collision with a steamer. Her owners at the time of her loss were James Baines & Company, of Liverpool. While under the American flag, she had been commanded for six years by Capt. Elisha Freeman, who succeeded Capt. Sears, and who was, in turn, followed by Capt. E. F. Sears.

[76] *WILLIAM H. CONNOR.*—Oil painting by an unknown artist of the ship *William H. Connor*, of Searsport, Maine. 27" x 38".

The *William H. Connor* was built at Searsport, by Marlboro Packard (also spelled

Eastern Star

[28]

Packer) and launched in June, 1877. 1423.84 tons: 210.4' x 40.5' x 24.2'. Two decks. Square stern. Billet-head. Owners: Benjamin F., James G., Phineas, John G., and F. J. Pendleton, Wilfred V., William G., and A. H. Nichols, William H. Park, John H. Colcord, James C. Gilmore, and others of Searsport, Stillman B. Allen and Nathan B. Carver of Boston, and a number of others from various Maine seaports. Commander: Capt. John G. Pendleton, brother of one of the principal owners.

Named for a prominent citizen of Belfast, Maine, the *William H. Connor* was the last, and also the largest, ship ever built at Searsport. She was a very fine and staunchly built vessel, costing over $100,000.00, and during her existence as a sailing ship was commanded only by Searsport men. Capt. Pendleton had her for a couple of voyages, after which Capt. Wilfred V. Nichols had her for a number of years, and then Capt. Benjamin F. Colcord. The *Connor's* record as a sailing ship was excellent. She was in the Far East trade for the most part and, by the time she had completed her third voyage, she had paid for herself. Her last voyage as a sailing ship was in 1900-2, from New York to Freemantle, Newcastle, Manilla and Hong Kong, returning again to New York, where she was sold to Lewis Luckenbach and converted into a coal barge. She was lost April 22nd, 1909, by collision with the schooner *Hugh Kelly*, not far from Sandy Hook, off the New Jersey coast.

[77] *WILLIAM P. FRYE*.—Oil painting by Antonio Jacobsen, 1915, of ship *William P. Frye*. 22" x 36". Port view at sea. Presented by P. A. S. Franklin.

[78] Oil painting of the same, by W. A. Coulter. 24" x 36". Bow view at sea.

The *William P. Frye* was built at Bath, Maine, in 1901, by Arthur Sewall & Company. 2998 tons: 332.4' x 45.4' x 26.2'. Four masts. Three decks. Owners: Arthur Sewall & Company of Bath. Commander: Capt. Jos. E. Sewall.

The owners of the *William P. Frye* built her for their own account and operated her throughout her existence. She was one of the largest and finest steel ships ever constructed in America, being virtually a sister ship of the big Standard Oil square-riggers, *Astral*, *Acme* and *Atlas*. Following Capt. Sewall, she was commanded by Captains James F. Murphy, H. A. Nickerson and H. H. Keihne. Most of her career was spent in the grain trade between the Pacific Coast and England. She will be remembered as the first American ship to be sunk by the Germans in the Great War, having been destroyed in January, 1915 in the South Atlantic by the converted cruiser *Prinz Eitel Friedrick*, while bound from Puget Sound to Queenstown, for orders, with grain. She was named after the United States senator from Maine who had long been a champion of shipping interests.

[79] *YOUNG AMERICA*.—Oil painting by Smith of clipper ship *Young America*. 30½" x 45". Under sail at sea. Presented by Harry T. Peters.

The *Young America* was built at New York, by William H. Webb, and launched April 30th, 1853. 1961 tons (1439 tons, new measurement): 243' x 43' 2" x 26' 9". Three decks. Round stern. Billet-head. Draft: 22'. Dead rise: 20". Owners: George B. Daniels, John Silsby, William H. Webb, Effingham B. Sutton, John Falconer, John B. Dickenson, Edwin

B. Strange and Albert B. Strange of New York, David S. Babcock of Stonington, Connecticut, Daniel L. Ross and Clancy J. Dempster of San Francisco. Commander: Capt. David S. Babcock, late of the clipper ship *Swordfish*.

The original cost of the *Young America* was $140,000.00. She was one of the finest clippers ever built; in fact, Webb considered her his best ship. While not quite so extreme in model and rig as the *Challenge*, she was in all respects an extreme clipper. Her main yard, 100 feet in length, was as heavy as that of the rebuilt *Great Republic*, a ship more than a thousand tons larger. The quality of materials and workmanship which went into her construction is shown by the fact that she survived more than thirty years of hard driving and earned several times her original cost for her owners; her record in this respect being very similar to that of the clipper ship *David Crockett*. Most of her service was in the New York-San Francisco trade, with occasional runs between San Francisco and England. She holds the record of 99 days from Liverpool to San Francisco, and her average of six return trips to Liverpool was only 108 days.

Of her runs from San Francisco to New York seven of the thirteen were made in less than 100 days, the fastest, 83 days, being the record for a loaded ship. A very complete account of her voyages is to be found in Volume II of "American Clipper Ships," Salem, 1927. In 1883, she was sold abroad to go under the Austrian flag, being renamed the *Miroslav*. In 1886 she foundered in the North Atlantic. Following Capt. Babcock, the *Young America* was commanded by Capt. Nathaniel Brown, Jr., late of the clipper ships *Aurora* and *White Swallow*. Capt. George Cummings succeeded to the command in 1864, leaving her after ten years to alter the steamer *Vanderbilt* into the sailing ship *Three Brothers*. Capt. E. S. Baker, of South Yarmouth, Massachusetts, formerly master of the *Black Hawk*, had her for some years, and in 1882 his brother, Capt. H. T. Baker took her over until she was sold foreign. James C. Bell, William Bell and Matthew Bird, of New York and George Jabez Howes, of San Francisco, were among the prominent shipping men who owned shares in the *Young America* at various times.

OIL PAINTINGS OTHER THAN SHIP PORTRAITS

OIL PAINTINGS OTHER THAN SHIP PORTRAITS

[100] *ASTOR HOUSE.*—Oil painting by John William Hill (1812-1879) of the old *Astor House*, New York City, built in 1832. 48" x 58". Done about 1854. View of the facade of the building with horse stages drawn up and other traffic.
Presented by James A. Farrell.
The *Astor House*, for many years, was the favorite meeting place of New York merchants and shipping men, and the painting presents an interesting view of the hotel and its surroundings in the busy prosperous days which preceded the great panic of '57.

[101] *E. A. S. CLARKE.*—Oil painting of E. A. S. Clarke by W. L. Clark. 1926.

[102] *HENRY W. DENISON.*—Oil painting of Henry W. Denison.

[103] *EAST INDIAMEN IN NEW YORK HARBOR.*—Oil painting of East Indiamen in New York Harbor by R. Pearson. 1882. 44" x 64". Showing in the foreground a large ship with a tug alongside and painted ports getting under way in a light breeze. Sailing lighters alongside and in the foreground. Other ships in the background. Lower New York and the Battery in the distance. Presented by James A. Farrell.

[104] *CAPTAIN THOMAS MANVILLE EDWARDS.*—Oil painting of Capt. Thomas Manville Edwards and the whaling barque *Ann*, of Sag Harbor, by an unknown artist. 32⅞" x 27½". Date of painting uncertain but probably done shortly after the return of Capt. Edwards in 1850 from a long whaling cruise in the Pacific, as master of the *Ann*. The portrait shows Capt. Edwards seated, holding a roll of charts. A carefully executed likeness of the *Ann* appears in the picture, the gift of which was accompanied by the original chart and log of the voyage, both of which are now in the possession of India House.
Capt. Edwards, who hailed from East Hampton, Long Island, came from a family prominent in the shipping activities of Sag Harbor nearly a century ago, when whaling was at its peak. Included among its members were Capt. Nathaniel Edwards, master during the

early '50s, of the ship *Timor*, another Sag Harbor whaler; Watson Edwards, one of the original owners of the celebrated clipper barque *Storm*, built at Sag Harbor in 1852, and Capt. L. B. Edwards, of the clipper topsail schooner *Sierra Nevada*, of Sag Harbor, which went around the Horn in the early days of the gold rush, and in January, 1851, broke the transpacific record by running from Shanghai to San Francisco in 34 days. On this voyage Capt. Edwards drove his little schooner from the longitude of Japan to San Francisco in 18 days, a passage still unbeaten by any other sailing vessel, so far as can be determined from available records. It is of interest to note that on this occasion Edwards brought a present of a chest of tea for President Fillmore, which was delivered in New York exactly 69 days from Shanghai. Capt. Thomas Manville Edwards was a worthy representative of a family which numbered among its sons successful hard-driving clipper masters, and his vessel, the *Ann*, was known as one of Sag Harbor's lucky ships. She had been built in Bath, in 1823, and measured 299, 33/95 tons. Originally ship-rigged and ornamented with a handsome woman figure-head, she had "whaled it" out of Sag Harbor since 1832, at which time she had been purchased from Philadelphia. Her shares were held by more than twenty families of the town, including the Mulfords, Hitchcocks, Coopers, Hedges, Brewsters, Hunttings, Fosters, Howells, Herricks and Rogers. At various times she was commanded by Captains Jeremiah W. Hedges, Samuel C. Lock, Ezekiel L. Curry, John Bishop, Charles Howell, Marcus B. Osborn and others. Following his voyage in the *Ann*, Capt. Edwards commanded the Sag Harbor whaling barque *Washington*, owned by the well-known New York merchant, Samuel Willets. The painting, which is reproduced here, is done in the manner typical of master mariners' likenesses of a century ago, as may be seen by reference to such familiar portraits as those of Capt. Robert H. Waterman, of the *Sea Witch* and Oliver Mumford, of the clipper *Tornado*, and like them suggests an alert, dominating, youthful personality, supplemented and reinforced by a native intelligence of superior rank.

Presented, together with the chart and log-book of the *Ann*, by Mr. Hendon Chubb, in memory of his brother, Mr. Percy Chubb.

[105] *JAMES A. FARRELL.*—Oil painting of James A. Farrell by W. L. Clark.

[106] *FLEET OF ENGLISH WARSHIPS LEAVING HARBOR.*—Pair of oil paintings of Fleet of English Warships Leaving Harbor by C. Horton. Circa 1840. 36" x 54" (each). Two views. Showing large squadrons of one, two, and three-deckers running down the channel in a fresh full-sail breeze.

[107] *JOSEPH P. GRACE.*—Oil painting of Joseph P. Grace by W. L. Clark.

[108] *MAYOR W. R. GRACE.*—Oil painting of Mayor W. R. Grace by M. N. Bly. 1925.

[109] *JOSHUA A. HATFIELD.*—Oil painting of Joshua A. Hatfield by W. L. Clark.

Flying Cloud

[32]

Oil Paintings Other than Ship Portraits

[110] *THE HONGS AND WATER FRONT—CANTON.*—Oil painting of *The Hongs and Water Front, Canton* by Chun Ling Soo. Circa 1849-1850. 37" x 73".

The painting of the old foreign trading settlement at Canton in China shows an open space fronting the Pearl River with a row of buildings which face due south. In the stream, Chinese junks and a foreign steamer, also two shells with members of the foreign business firms taking their rowing exercise.

The space occupied by the foreign community was about a thousand feet from east to west. The word "factory" was an importation from India designating and synonymous with "agency." Each factory consisted of a succession of buildings one behind another, separated by narrow spaces or courts, and running north. The Chinese word "Hong" was applied to any place of business, more particularly the Hong or security merchants' buildings. By the Chinese the places of business of foreigners were known as "the foreign Hongs"; those of the Security Merchants, "Foreign Hong Merchants." At the west, the Danish factory adjoined by Chinese shops on New China Street, which separated it from the Spanish. Next the French, and by its side that of the Hong Merchant Chungqua; old China Street here came in, and against it was the American, then the Imperial, by its side the Paoushun, next in order the Swedish, the English, then the mixed or "Chow-Chow." Now came a small lane —"Hog Lane." The high wall of the new English factory bordered the lane, having a next-door neighbor, the Dutch, and last the Greek factory.

The factories were the individual property of the Hong Merchants, and were hired of them. By law, no women were permitted to enter them. The business-rooms, counting-houses, godowns and store-rooms on the ground floor, and above living-rooms, and on the third floor the bedrooms.

The words "factory" and "Hong" were interchangeable although not identical. A foreigner speaking of his residence generally used the word "factory"; when, of a Hong Merchant's place of business, the "Hong." These buildings existed from 1745 and were finally destroyed for the last time upon Sir Michael Seymour's bombardment of Canton (1857).

The tall building appearing immediately in line with the smoke stack of the steamboat was Doctor Peter Parker's hospital and, as this view painted by a Chinese artist must have been made subsequent to the Opium War, we have vegetation immediately in front of the Hongs and in the part which had always been an open space called "The Square" (showing just at the left of the British flag) is the Foreign Church. In the old pictures prior to 1803 and subsequent to 1784, five flags appear, between 1803 and 1832, six flags, after 1832, in general the flag was only raised by the American, the English and the Dutch. During the thirty years from the withdrawal of the French during the Napoleonic Wars until the appointment of a Consul in 1832, no French flag appears. The chronology of these views is one of their chief interests. They seem to have been imported in sets of four paintings—"The Boca Tigris," "Macoa" (where the foreigners might maintain their residences), "Wampoa Anchorage," generally showing the pagoda and sometimes the foreign godowns, each with its flag, and the View of the Foreign Factories.

The first American Consul was Major Samuel Shaw after whom came interregnums

with several Consuls who served for short terms until Madison appointed Benjamin Chew Wilcox, who was Consul for about seven years. He induced the American physicians Doctors Parker and Bradford to establish themselves in Canton for the care of the foreign community. Benjamin Chew Wilcox was a resident of Canton and Macoa from the beginning of the 18th century almost continuously until 1829, when he returned to Philadelphia.

These four views were brought home by returning voyagers in much the same way that photographs and similar souvenirs of travel are brought home in our own time. Views and paintings of native scenes, foreign residents, portraits, etc., were painted by a distinguished artist, George Chinnery, R.H.A., who resided in Canton from 1822 until his death. The works of Chinnery are very highly esteemed by foreign residents in the East Indies and are purchased much as a family would purchase an important piece of plate. Chinnery's portraits of *Houqua*, the senior Hong Merchant are very distinguished and were considered the most important memento of a returned foreigner.

No other port in China was open to foreigners nor was a foreigner permitted on any pretext to enter the country outside of this strip in the suburb of Canton, or the Portuguese colony at Macoa.

The foreigners established boating and rowing clubs for entertainment and exercise, but these innovations did not meet with approval by the authorities and had to be discontinued, though later the Chinese concerned themselves less in the affairs of "the foreign barbarians" in the settlement on the banks of the Choo. All of the factories employed their own boats, sailing or rowing, for communication between the factories and the anchorage at Wampoa, ten miles below Canton.

This large painting of the Hongs and Water Front of Canton is perhaps the largest and most important painting of this kind known to any of the China Trade collectors. It is somewhat late but represents the very important period when the Trade was really at its height.

The history of this picture has been traced and it was purchased by the India House Art Committee from Mr. Max Williams, a dealer, who in turn had bought it from Mr. Harry Symonds, an importer, who informed Mr. Williams that he had purchased it at a very considerable price and brought it home as a souvenir.

It was represented as being the work of a famous Chinese artist, Chun Ling Soo, who was further represented to be the best artist of this type of painting.

The picture was exhibited at the Grolier Club in New York, in 1933, at their Exhibition of China Trade and given an important position in the middle of the Exposition as representative of the Trade as a whole.

[111] *HOUQUA.*—Oil painting of *Houqua*, the leading member of the Co-Hong, at Canton, China, during the first half of the nineteenth century, by George Chinnery, R.H.A. 25½" x 19½".

Houqua was the last chief or senior officer of a long succession of Hong merchants (the Co-Hong) who maintained a monopoly of China's foreign trade for more than a hundred years. The Co-Hong was established at Canton, the sole entry port of China, in 1720. It consisted of twelve merchants presided over or supervised by a thirteenth. All merchandise

Ganges

[673]

Oil Paintings Other than Ship Portraits

entering or leaving the Empire passed through the hands of these men, who bought or sold it outright or on a commission basis. In addition, they were charged with the collection of all import duties, port dues and other charges incident to international commerce, besides being the guardians of the persons and property of foreign merchants. They procured their privileges in the first instance by purchase, the initial cost in Houqua's time being normally about $200,000.00, supplemented at intervals by the official "squeeze," which might in individual cases amount to $100,000.00, or more, a year. In spite of these charges a majority of the Hong merchants became very rich. Houqua's wealth was estimated in 1834 to amount to $26,000,000.00, which would, of course, be equivalent to a much vaster sum today. Although personally abstemious to the point of frugality, Houqua lived on a princely scale in a magnificent home, surrounded by extensive gardens which the landscaper's art had turned into a veritable fairy land of lakes, fountains, grottos, temples and summer houses. His property included great tea and rice plantations, country estates, city houses, stores and banks, and cargoes of tea, silk and other oriental merchandise, afloat and ashore. In person he was slender, of medium height and rather delicate in health. A contemporary account speaks of him as noted "for sound judgment; true prudence; wary circumspection and wise economy." Notwithstanding his great wealth and undoubted ability, he seems to have been of a modest, almost democratic, disposition. He was especially respected and admired by the American merchants and officers with whom he came in contact, and he appears to have favored them above other nationals in his sympathies and dealings. Many stories are told of his accepting without demur heavy losses caused by the blunder of some shipmaster in carrying out his instructions, or his cancellation of huge debts due from some merchant who had the misfortune to get into financial difficulties. Among his friends and admirers may be mentioned Thomas H. Perkins and John P. Cushing, of Boston, who, in 1819, named one of their new ships, *Houqua*, in his honor. Twenty-five years later Capt. Nathaniel B. Palmer gave the same name to the fine China packet which he designed for A. A. Low & Company, and which proved so fast that it has sometimes been called the first of the modern clipper fleet. Many other well-known Americans, including Samuel Russell, Robert B. Forbes and Daniel C. Bacon, were numbered among Houqua's friends. The most prominent members of the Co-Hong during the later and more important years of its sway were Mouqua, Chunqua, Kingqua, Pwankeiqua and Gouqua. The "qua" was not a part of the foregoing names, but a suffix of respect, equivalent to "sir" or "mister." The rule of the Co-Hong ended in 1842, when four Chinese ports in addition to Canton were opened to foreign trade, as a result of the first "opium war." Houqua died in September of the following year at Honan, in the seventy-fourth year of his age, having been born in 1769, the year which also marked the birth of Napoleon and Wellington.

[112] *PRAYA GRANDE.*—Two oil paintings of the *Shamien Consulates* by an unknown artist. 17" x 27½". Side view from down the river. Presented by Henry C. Low, June, 1920.

The *Praya Grande* or Water Front of the City of Macao, China.

Macao was the earliest settlement in China by Foreigners, the Portuguese establishing their colony in this place. A great-uncle of Henry C. Low, Esq., resided there until 1830

when he was a partner of Russell & Co. Mr. A. A. Low founded the house which bore his name after his return from China in 1839. His brother was also in Canton for a number of years. When in Canton they resided in the factories but their families lived at Macao since foreign ladies were not allowed at Canton.

[113] *WILLIAM W. ROCKHILL.*—Oil painting of William W. Rockhill by B. R. Campbell.

[114] *SAILING SHIP IN STORM AT SEA.*—Oil painting of Sailing Ship in Storm at Sea by an unknown artist. 22" x 26".

[115] *ADMIRAL SCHLEY.*—Oil painting of Admiral Schley.

[116] *D. W. STEVENS.*—Oil painting of D. W. Stevens by B. R. Campbell.

[117] *WILLARD STRAIGHT.*—Oil painting of Willard Straight by W. L. Clark, 1919.

[118] *EDWARD H. STROBEL.*—Oil painting of Edward H. Strobel by B. R. Campbell.

[119] *YANKEE CHIVALRY.*—Oil painting of *Yankee Chivalry* by James G. Tyler. 30" x 42". An American warship standing by to rescue the crew of a Spanish man-o'-war she has just put into sinking condition. An incident of the last naval engagement of the Spanish War, 1898.

❋ ❋ ❋

COLLECTION OF ANTIQUE CHINESE CEREMONIAL PAINTINGS ON SCROLLS, FRAMED

[120] Warrior in Ceremonial Regalia. 8' 9" x 5', in an elaborately carved Canton frame, gilded, 7½" wide x 6" deep, carved in bas-relief by hand with figures, trees, birds, dragons, etc., etc., and signed by the artist.

[121] Chinese Goddess seated on Dog Foo. (Pair) 6' 3" x 3'.

[122] Chinese Priest. 6' 3" x 3'.

[123] Nineteen figures of Priests in Procession, in three rows. 6' 3" x 3'.

[124] Seventeen figures of Priests in Procession, in three rows. 4' 9" x 2' 5".

[125] Eight figures of Priests in Procession, in three rows. 5' x 2' 5".

[126] Two groups of four and five Priests respectively and two groups of six and eight female figures with fans and musical instruments. 5' x 3'.

[127] Priest and two servants, in garden. 5' 3" x 2' 9".

[128] Buddha standing on the clouds. 6' x 3' 1".

[129] Buddha on his Throne. 5' x 2' 4".

[130] Mandarin with two servants. 6' 6" x 3'.

Houqua

[I I I]

CATALOGUE OF SHIP MODELS
(Full and Profile)

CATALOGUE OF SHIP MODELS
(Full and Profile)

[150] *A. PRICE.*—Model of American ship *A. Price*. Three masts, square-rigged, fully equipped, no sails. 22" x 16".

[151] *BELVEDERE.*—Model of American whaling schooner *Belvedere*. Two masts, fully equipped, hull red, black strake, built entirely of bone. Glass case. 16" x 12". Presented by A. W. Goodrich.
 Native Eskimo work. As the Eskimos were extremely anxious to obtain work on the whalers they would make these models to prove to a captain that they were familiar with the rigging of ships and hence would be useful sailors.

[152] *BERTA.*—Model of German bark *Berta* of the period of 1870. Three masts, square-rigged, wooden sails set, in scenic background with sloop and tug-boat. Shadow-box glass case. 28" x 18".

[153] *DE VRIENDSCHAP.*—Model of Dutch brig *De Vriendschap* of the period of 1830. Two masts, fully rigged, with all sails including three staysails. Antique. 44" x 37".

[154] *ELIDA.*—Model of Norwegian bark *Elida*. Three masts, square-rigged, fully equipped, all sails including 4 staysails. Figure-head of a woman with arms folded. 37" x 28".
 The bark *Elida* was built at Bergen, in 1867, and registered at 611 tons.

[155] *GLADIATOR.*—Model of Canadian ship *Gladiator* built in 1856, by George H. Parke. Registered at 1501 tons. Three masts, square-rigged, fully equipped, no sails. 62" x 48".

[156] *GLORY OF THE SEAS.*—Original figure-head of the ship *Glory of the Seas*. Height of figure, 7' 6". Height, including pedestal, 10' 2". Presented by James A. Farrell.

The Marine Collection at India House

[157] *GLORY OF THE SEAS*.—Original builder's half model of the ship *Glory of the Seas*. Gilt below water line; black above. Length over all 52¾". Extreme beam (half breadth) 5⅜". Depth amidships (including keel) 9". Scale: 5 feet to the inch.

The *Glory of the Seas* was built by Donald McKay, at East Boston, Massachusetts, and launched in October, 1869. 2102.87 tons (later given as 2009 tons, net): 240.2' x 44.1' x 28'. 265' over all. Three decks. Round stern. Goddess figure-head. Owner: Donald McKay. Commander: Capt. Josiah N. Knowles.

Shipping was very dull when the *Glory of the Seas*, the last merchant ship to be built by Donald McKay, was completed, and it was found impossible to sell her at an advantageous price. McKay acordingly sent her to New York in charge of Capt. Baxter. She arrived at New York December 1st, 1869, and was taken up to load for San Francisco in C. B. Sutton's Line. It has been stated that Donald McKay himself commanded her on her first voyage, but this is an error, due probably to the fact that on the ship's arrival at New York, he was registered as both owner and master, a common practice pending the selection of a permanent commander. Richard C. McKay, a grandson of the builder, states that Capt. Giet commanded on the first voyage, which was made in 120 days. On the return of the ship to Boston she was purchased by J. Henry Sears & Co., and others, of Boston, Capt. Josiah N. Knowles being made master. Knowles gave up command in 1879, when he retired from the sea to become a shipping merchant in San Francisco. Following him, Capt. McLaughlin had her for several voyages, being succeeded by Capt. Joshua Freeman. The *Glory of the Seas* was not a clipper and was not exceptionally fast. Her best run from New York to San Francisco in 96 days was made in 1873-4, and by virtue of this passage she shares with the ship *Seminole*, of Mystic, Connecticut, the distinction of being the only vessels built after the clipper period to make the voyage in less than 100 days. She has also been credited with a 35-day passage from San Francisco to Melbourne in 1875, which, if substantiated, would constitute a record for the course. Her log-books show that she was generally fortunate in encountering favorable winds and weather. Most of her earlier voyages were made between North Atlantic and Pacific Coast ports. Her later years were spent as a member of the Puget Sound canning fleet. That she was well and staunchly built is indicated by the fact that she remained in active service more than fifty years, being finally burned for her metal at Endoline, near Seattle, Washington, in 1923.

See frontispiece.

[158] *ROMAN*.—Rigged model of the ship *Roman*. Length of hull over all, 26½". Beam amidships, 6¾". Length from end of jib boom to end of spanker boom, 44¾". Height from keel to main truck, 31½".

The *Roman* was built at New York, in 1825, by Brown & Bell. 492.20 tons, 118' x 30' 6". Two decks. Square stern. Billet-head. Owners: John L. Buckley, Thomas Buckley, Samuel Hicks, Henry W. Hicks, John H. Hicks, Robert Hicks and Benjamin D. Hicks, of New York. Commander: Jeremiah Dickenson.

For several years the *Roman* was operated as a "regular trader" on the run between New York and Liverpool, carrying both freight and passengers, and her model is typical of the

Gladiator

[155]

packet ships of that period. In 1829, having become outclassed by the new and larger ships built for that service, she was sold to David W. C. Olyphant and George W. Talbot, of New York. Talbot and Olyphant, a well-known firm of China traders, placed her under the command of Capt. Thomas Lavender and sent her to Canton. She continued in that service for many years and proved a fast and profitable ship. The New York American for June 3rd, 1837, refers to one of her passages as follows:

> "The ship *Roman*, Capt. Beneon," (This was Captain Hevlyn Benson) "of this port, left Sandy Hook on the 14th of October and reached the Lema Channel the 4th of February, being the shortest passage ever made from the United States to China via the Pacific Ocean. She was 34 days to the Equator, 56 to the Cape of Good Hope, 70 to St. Paulo, 88 to Sandal Wood Island, 98 to the Pacific Ocean via Damfries Straits, 113 days inside the Lema Islands."

After this voyage Capt. Benson was succeeded by Capt. McEwen, who had formerly commanded Robert I. Taylor's fast China packet *Sabina*.

[159] *ROYAL SOVEREIGN*.—Model of British first-rate ship-of-the-line the *Royal Sovereign*. 120 guns. Three masts, square-rigged, completely equipped, no sails. Made entirely of ivory, hull planked, carved galleries, ebony blacks and bronze cannon. Two boats in davits. In mirror base glass case. 41" x 32". Loaned by J. A. Farrell.

The magnificent Admiralty working model of the *Royal Sovereign*. These meticulously made government models are seldom met with on this side of the Atlantic and this one is of especial interest as being the flagship of the lee division of the British fleet at the battle of Trafalgar, under the command of Vice-Admiral Collingwood.

[160] *SMITH'S KNOLL*.—Model of Lightship *Smith's Knoll*. Fully equipped, basket light as mast-head. 12" x 9". In glass case.

[161] *STATE OF MAINE*.—Sailor made model of the *State of Maine* which was built about 1880, and was mainly commanded by Searsport men. Well-built model.

[162] *TUSITALA*.—Scale model of iron ship *Tusitala*, fully rigged, without sails. Length of hull, 31¼" over all. Beam amidships, 4⅞". Length from end of jib boom to end of spanker boom, 35". Height from keel to main truck, 21¼".

The *Tusitala* was built at Greenock, Scotland, in 1883, by R. Steele & Company, and launched under the name of the ship *Invergulas*. 1748 tons: 260' 4" x 39' x 23' 5". Two decks. Round stern. Figure-head.

Like many of the ruggedly built iron ships of the seventies and eighties the *Invergulas* long outlasted the demands of the Australian trade for which she was built. She is best known, under her original name, as the ship in which Conrad sailed as first officer. Mr. James A. Farrell has a letter from Conrad referring to this fact. The *Invergulas* passed through the hands of several owners, being named successively the *Sierra Lucena* and the *Sophie*, and finally when purchased in 1923 by Mr. Farrell, the *Tusitala*. As the *Tusitala* under the com-

mand of Capt. H. M. Mikkelson, she has the distinction of being the last full-rigged ship under the United States flag to be regularly engaged in deep-water commerce, the few remaining vessels of the "canning fleet," so-called, being operated virtually as private storeships. By an odd, but striking coincidence, therefore, America's remarkable sailing ship era, whch was opened more than three centuries ago by the arrival of a small British built vessel, is apparently to be closed by another ship from the mother country.

[163] *UNION*.—Model of American steamboat *Union*. Side-wheeler with walking beam. Single smokestack, two decks. 34" x 20". A crude but interesting model of the period.

[164] *WILD PIGEON*.—Original Builder's Model of Clipper Ship *Wild Pigeon*. 996.62 tons, 189 feet over all, 170' x 35.7' x 20'. (745 tons new measurement.) Length of model over all 68⅛". Extreme breadth of beam (half-breadth), 6 19/32". Depth amidships (rail to keel, incl.), 10¾". Scale, 3 feet to the inch.

The *Wild Pigeon* was built at Portsmouth, New Hampshire, in 1851, by George Raynes, who also built the *Sea Serpent, Witch-of-the-Wave, Tinqua, Fleetwood, Wild Duck* and other famous clippers. Although small, the *Wild Pigeon* was a very beautiful and an exceptionally fast and able ship. She was built for Oliphant & Son, of New York, and until sold to the British in 1863, always sailed out of New York. The New York Herald of March 5th, 1852, reported her maiden voyage in part, as follows:

> "The new clipper ship *Wild Pigeon*, Capt. Putnam, which sailed from New York, October 14th, made the shortest passage to San Francisco (102 days) of any vessel which sailed in October, having beaten the *Comet, Trade Wind* and *Golden Gate*, the least of which is 500 tons larger than she. She sailed in company with the *Golden Gate*, and ten to one were staked in New York in favor of the latter. . . . Capt. Putnam writes that under every circumstance she proved to be a perfect vessel, so much so that he could not suggest an improvement in her."

The record of the *Wild Pigeon* was long and varied. Her logs show interesting and creditable encounters with extreme clippers of the largest size, including the *Sweepstakes* and *Spitfire*. She was in the China Trade and once took a cargo of tea to England. The classic account of her race to San Francisco against the *John Gilpin, Trade Wind* and *Flying Fish* appears in Maury's "Sailing Directions for 1854," while her remarkable run from Talcahuano on the West Coast of South America around the Horn to New York in 50 days is still the record for the course. She foundered in the North Atlantic in 1892, being then the *Bella Juana*, of Barcelona.

Presented to India House by James A. Farrell.

[165] *WINATRUCE*.—Model of American steamship *Winatruce*. Half model backed by mirror. Fully equipped, with all deck fittings, on scale ¼" to 1'. In glass case 10' x 30".

[166] Model of Italian armed merchant ship of the period of 1650. Three masts, square- and lateen-rigged, with sails, hull black with white waterline and red strake. 45" x 32".

Golden Gate

[291]

Ship Models (*Full and Profile*)

Interesting model. The armament includes two cannon under the stern gallery and four swivel guns on the quarter deck. There are twelve armorial shields mounted around the stern and bow castles.

[167] Model of English 20 gun ship of the period 1690. Three masts, with fighting tops, partly equipped, no sails, hulls black, white strake. Antique 22″ x 22″.

[168] Model of Italian armed merchant ship of the period of 1740. Three masts, fully equipped, some sails set, antique hull, black with white strake and copper bottom. 84″ x 66″. Presented by J. A. Farrell.
 Superb antique model of Venetian workmanship, the rigging renewed as of the period, stern decorated with gilded carvings of lion's heads and Amorini, scarlet port covers, gilded cannons, silk banners, etc. Lower masts white with black mouldings, studding sail booms, boom irons, polished walnut blocks, and other fittings to scale; topsails set, others furled.

[169] Model of American ship of the period of 1800. Three masts, square-rigged, partly equipped, no sails, oak hull, black. 59″ x 45″.

[170] Model of British third-rate man-of-war of the period of 1800, warped to dock. Three masts, square-rigged, fully equipped, no sails, wooden hull, upper works of bone. Glass case. 32″ x 28″.

[171] Model of English ship of the period of 1800. Three masts, square-rigged, fully equipped, no sails. Glass case. 30″ x 22″.

[172] Model of American ship of the period of 1810. Three masts, square-rigged, fully equipped, no sails, hull black. 30″ x 20″.

[173] Model of American 14 gun brig of the period of 1820. Two masts, fully equipped, no sails, center raised cabin. 32″ x 26″.
 Interesting sailor made model of a broad-beamed, shallow-draft American armed brig.

[174] Model of American double topsail schooner of the period of 1830. Two masts, fully equipped, sails set, hull black, white strake. 106″ x 84″.
 A poorly executed model with an interesting rig.

[175] Model of American brig of the period of 1830. Two masts, square-rigged, fully equipped, no sails, hull oak, stained mahogany, simulated planking. 48″ x 34″.
 Interesting model of a slaving brig, one of the fast sailing 'black ivory traders.'

[176] Model of American merchant ship of the period of 1840. Three masts, with monkey-booms, square-rigged, fully equipped including boats, no sails, hull black, imitation copper sheathing. 38″ x 29″.

[177] Model of American bark of the period of 1840. Three masts, square-rigged, fully equipped, no sails, hull black, imitation copper sheathing. Two cabins, chain bob-stay. 24" x 16".

[178] Model of English iron bark of the period of 1840. Three masts, fully equipped, no sails, imitation gun ports, dark blue hull. In tow of steam tug. Glass case. 12" x 18".

[179] Model of American ship of the period of 1840. Three masts, square-rigged, fully equipped, no sails, hull black. Two cabins. 26" x 18".

[180] Model of American merchant ship of the period of 1840. Three masts, square-rigged, fully equipped, sails set, hull white. Figure-head of an extended eagle. Loaned by M. C. Hannah. 88" x 72".
Sailor made model, planked, with deck-houses and all equipment.

[181] Model of American ship of the period of 1840. Three masts, square-rigged, fully equipped, no sails, black hull, imitation copper sheathing. Glass case. 34" x 26".

[182] Model of American ship of the period of 1840. Three masts, fully rigged, sails furled, hull black. 38" x 24".
Sailor made model.

[183] Model of American packet ship of the period of 1845. Three masts, square-rigged, fully equipped, no sails, gun ports painted in, hull black, white strake. Dragon figure-head. 30" x 18".

[184] Model of American bark of the period of 1845. Three masts, square-rigged, sails set including three jibs and two stay-sails, white hull, imitation copper sheathing. 24" x 20".

[185] Model of American ship of the period of 1850. Three masts, square-rigged, fully equipped, no sails, hull black, gilt strake. 38" x 27".

[186] Model of American packet previous to the period of 1850. Three masts, square-rigged, fully equipped, no sails, hull white, black strake. Glass case. 11" x 7".
Sailor made model of a passenger vessel.

[187] Model of Baltimore topsail schooner of the period of 1850. Two masts, partly equipped, sails set, hull green, black strake. 36" x 28".
Fine model of the type frequently used for slaving voyages.

[188] Model of American merchant ship of the period of 1850. Three masts, square-rigged, fully equipped, no sails, hull violet, black strake. At anchor. Glass case. 34" x 24".

Isaac Webb

[38]

Ship Models (Full and Profile)

[189] Model of American clipper ship of the period of 1850. Three masts, square-rigged, fully equipped, wooden sails set, hull mahogany. With scenic background, shadow-box. Glass case. 2′ x 16″.

[190] Model of American clipper ship of the period of 1850. Three masts, square-rigged, fully equipped, no sails. Glass case. 48″ x 26″.

[191] Model of American ship of the period of 1850. Three masts, square-rigged, fully equipped, no sails, hull brown, white strake. 35″ x 28″.

[192] Model of American brig of the period of 1850. Two masts, fully rigged, no sails, hull red, black strake. 23″ x 18″.

[193] Model of American bark of the period of 1850. Four masts, square-rigged, no sails, hull dark brown, lighter brown strake. 48″ x 27″.
 Sailor made model.

[194] Model of American cargo ship of the period of 1865. Three masts, square-rigged, fully equipped but without sails, hull black and red. 74″ x 50″.

[195] Model of American clipper bark of the period of 1870. Three masts, square-rigged, fully equipped, wooden sails, hull black. Mounted with two smaller models and scenic background. Shadow-box glass case. 50″ x 24″ (case).

[196] Model of American ship of the period of 1875. Three masts, square-rigged, fully equipped, wooden sails set. With scenic background. Glass case. 30″ x 20″.
 Shadow box model, under full sail.

[197] Model of American steam yacht of the period of 1880. Two masts, fore and aft rig, sails furled, hull green, white strake. Single deck, midship cabin, one stack and one propellor. 36½″ x 20″.

[198] Model of British bark of the period of 1880. Four masts, square-rigged, fully equipped, no sails. 24″ x 16″.

[199] Model of American coasting schooner of the period of 1885. Two masts, fully rigged, no sails, mahogany hull, white strake. 41″ x 37″.

[200] Model of American ship. No sails, hull black, bronze below water line.

[201] Model of American clam sloop. One mast, fully equipped, no sails. 17½″ x 13½″.
 A rare and interesting model.

[202] Model of an oil tanker. Presented by the Standard Oil Company of New York.

[203] Model of Dutch merchant ship of the 18th century. Three masts, square-rigged, hull blue, yellow strake. Built of tin, sails furled. 44" x 40".

[204] Model of Japanese junk. Two wing sails set. Built in the 19th century. 15" x 15".

[205] Model of Japanese junk of the 19th century. Made of pine and fully equipped, with single sail and rigging. 32" x 30". Presented by G. R. Morse.

[206] Model of Spanish galleon of the 15th century. Two masts, square-rigged. Made of leather with hull concealing demijohn. 50" x 42".
 Old table decoration used for serving wine. Supported on and tilting from a leather standard of two women.

[207] Model of South Sea Catamaran. 19th century. Sail furled. Mahogany hull, maple strake. 37½" x 4".

[208] Model of Venetian armed merchant ship of the 16th century. Four masts, partly square-rigged, partly lateen, fully equipped, sails set, gray hull with carved raised gallery stern. 50" x 42".
 Antique model, fitted with 12 guns. With jib sail and with sprit sail below jib boom; foremast square-rigged, main, mizzen and bonaventure-mizzen lateen-rigged. Mushroom anchor.

[209] Ship Models. A collection of original pen and ink drawings by Alfred Brennan (6).

[210] Model of an Old Man of War. Original tempera drawing by Jay Hambidge.

[211] The Model Builder. Original pencil drawing by Jay Hambidge.

Illinois

[310]

LITHOGRAPHS, ETCHINGS, WOODCUTS AND DRAWINGS

LITHOGRAPHS, ETCHINGS, WOODCUTS AND DRAWINGS

[250] *ADRIATIC.*—Lithograph of paddle steamship *Adriatic.*

The *Adriatic* was built at New York, by George & J. R. Steers, and launched April 7th, 1856. 5888 tons, carpenters' measurement: 4144.70 tons, register: 345' (354' over all) x 50' x 33' 2". Three decks. Two masts. Brig-rigged. Round stern. Plain head. Two oscillating engines of 2000 actual horse power, each, by Stillman, Allen & Company. Cylinders: 100" diameter. Piston stroke: 12'. Paddle wheels: 40' x 12'. Owner: The New York & Liverpool, United States Mail Steam Ship Company, of New York. Commander: Capt. West, formerly of steamship *Atlantic.*

The greatest crowd that had ever witnessed a launching in America gathered at 7th Street and the East River to see the *Adriatic* take the water on the morning of April 7th, 1856. It was estimated that 60,000 people were present, nearly 1500 of whom swarmed the decks and rigging of the bark *Grape Shot*, (q.v.) lying near by. The *Adriatic* was the largest wooden ship in the world and her engines were the largest that had ever been built in the United States. Only one steamship, the iron steamer *Persia*, was longer, and the *Adriatic* was proudly hailed as the first of a fleet which would effectively demonstrate the superiority of American steamship designers and builders. However, owing to the fact that it was necessary to make changes in her engines she did not leave New York on her maiden trip until November, 1857, and she made but one voyage in the Collins Line, as all sailings were discontinued in January, 1858. She was taken over by the North Atlantic Steam Ship Company with the other Collins steamers and ran from New York to Havre, via Southampton, until March, 1861, when she was sold to the Lever Line and put under the British flag. Before she was accepted for the British Mail Service, she was given four trials over a measured mile, and developed an average speed of 15.908 knots, showing that she was at that time one of the fastest large steamships afloat.

[251] *ALBANY.*—Colored lithograph by N. Currier, of the U. S. Sloop-of-War *Albany.* 9⅛" x 10½". Undated. H.T.P. 1119.

The *Albany* was built in the New York Navy Yard, by Francis Grice, U. S. Naval Constructor. Her keel was laid in 1843 and she was launched in 1846. 1064 tons; 148' 7" x 34' 4" x 17' 4" (hold). Armament: 4 8"-guns and 18 32-pounders.

She took an active part in the blockade of the Mexican coast in the war that was waging when she was completed, but saw little service of importance thereafter. In 1854 she foundered at sea in a hurricane.

[252] AMERICA.—Colored lithograph of schooner yacht *America*. 16½" x 14". Published by Dean & Son.

The *America* was built at New York, by Wm. H. Brown, from the design of George Steers and launched May 3rd, 1851. 170.50 tons. 93' 6" x 22' 6" x 9'. Draft: 11' aft, 6' forward. Foremast: 79' 6". Mainmast: 81'. Rake: 2⅞" to the foot. Main boom: 58'. Main gaff. 26'. Bowsprit: 32'. Lower sails: 5,263 square feet. Ballast, all inside: 45 tons. Owners: William H. Brown first registered as sole owner, but three days later, Commodore John C. Stevens, George L. Schuyler, Edwin A. Stevens, Hamilton Wilkes and J. Beekman Finlay, all of New York. Commander: Capt. Richard Brown.

On the morning of June 21st, 1851, she sailed for Havre, with 13 persons on board and made the passage in a little over 20 days, having been becalmed for five days. Her best day's run was 284 miles. She went to England and after issuing two challenges for races, neither of which were accepted, Stevens entered her in the Royal Yacht Squadron Regatta on the 22nd of August and beat the 13 British yachts with great ease. On the first of September she was sold to Lord John de Blaguire for £5000. Thereafter she passed through several hands being finally purchased by Henry E. Decie, of the Royal Western Yacht Club of Plymouth, in July, 1860, as the schooner *Camilla*. Decie turned up with the *Camilla* at Savannah, Georgia, in the Spring of 1861, and in May of that year appears to have made a voyage to England on secret service for the Confederacy. In March, 1862, she was discovered sunk in the river above Jacksonville, Florida, and was raised by the Union forces under Admiral Du Pont and used during the war as a despatch boat. In 1864 she was used as a schoolship by the Naval Academy, and served in that capacity for the greater part of the time until 1873. In June of that year she was sold to a representative of General Benjamin F. Butler, of Massachusetts, for $5000.00, who used her every season and spent a great deal of money on her. After Butler's death she was laid up at Chelsea Bridge for several years. In 1897 Butler Ames, a nephew of General Butler, had the *America* once more fitted out and used her as a yacht until October, 1901, when she went out of commission as a private yacht for the last time. For 16 years she lay at Chelsea Bridge, Boston Harbor, or near the South Station in Boston, being finally sold to Charles H. W. Foster, of Marblehead. Then, in 1921, through the cooperation of Charles Francis Adams, James Jackson, F. Nelson Perkins, Charles K. Cummings and William U. Swan, Massachusetts yachtsmen, the *America* was restored to the Naval Academy at Annapolis, where she now lies.

An excellent contemporary description of the *America* is to be found in the New York Herald for June 21st, 1851.

[253] ARCTIC.—Engraving of steamship *Arctic*. 6½" x 8⅞". Starboard view, moored to quay. Oval in square. Inscribed: "Dag. by Bechers & Piard. . . . Engraved by W. L. Ormsby. . . . U. S. Mail Steamer *Arctic*. . . . Engraved for Stuarts Naval & Mail Steamers of the U. S."

Isaac Wright

[675]

Lithographs, Etchings, Woodcuts and Drawings 63

[254] Lithograph of the same. 17¾" x 25½". Starboard view of the wreck sinking. Passengers leaving by boats and rafts. Inscribed: "Parsons del.... From a Sketch by James Smith, of Jackson, Missouri, a passenger on Board the *Arctic*.... Entered ... 1854, by N. Currier.... S. District of New York.... Wreck of the U. S. Steam Ship *Arctic* off Cape Race, Wednesday, September 27th, 1854." (Then follow the particulars of the calamity.) ... "New York, Published by N. Currier, 152 Nassau St."

The *Arctic* was built at New York, by William H. Brown, and launched January 29th, 1850. 2856.75 tons: 285' x 45' 11" x 32'. Three decks. Three masts. Bark-rigged. Round stern. Monster figure-head. Two side lever engines by Stillman, Allen & Company (Novelty Iron Works), of New York. Cylinders: 95" diameter. Piston stroke: 9' (also given as 10'). Paddle wheels: 35' 6" x 12' 2". Owners: New York & Liverpool, United States Mail Steam Ship Company. Commander: Capt. Luce.

Although built by Brown, the *Arctic* was designed by George Steers, the designer of the yacht *America* (q.v.), and built under his supervision. It was Collins' intention to make her a faster ship than his first two steamers, the *Atlantic* and *Pacific*, and Steers was successful in turning out a model which accomplished that purpose. The *Arctic* proved to be about one-half a knot faster than the *Pacific* and in February, 1852, she ran from New York to Liverpool in 9 days, 17 hours and 12 minutes, breaking all existing records. Many of the New York notables were present on her trial trip, Friday, October 18th, 1850, including Capt. Asa Eldridge, Edward K. Collins, Nathaniel B. Palmer and Joseph R. Comstock, who was to command the *Baltic*. She was more heavily sparred than either the *Atlantic* or *Pacific*. She is mainly remembered for the tragedy of her end. On the 27th of September, 1854, she was rammed and sunk by the French steamer *Vesta* about 40 miles off Cape Race, and no less than 322 lives were lost, including the wife, son and daughter of Capt. Collins, the founder and principal owner of the line. It was thought at first that the *Vesta* was in greater danger and valuable time was lost in going to her assistance. The weather was very rough and foggy at the time and most of the boats were smashed, only two, with 14 passengers and 34 of the crew being picked up. Later a single survivor was rescued by a passing ship from a raft on which 76 had originally sought refuge.

[255] *AUSTRALASIAN.*—Lithograph of Screw Steamer *Australasian*. 17" x 27½". Port view at sea under steam. Inscribed: "The Royal Mail Steamship *Australasian*, 3100 tons. To the British and North American Royal Mail Steam Ship Company, this print is respectfully dedicated by the publishers. New York. Published by Currier & Ives, 152 Nassau St. Entered ... 1861.... Southern District of New York." (Dimensions of ship and engines flank title.)

The *Australasian* was a screw steamer, built for the European and Australian Royal Mail Company by Messrs. J. & G. Thompson, of Clydebank, in 1857, at a period when auxiliaries were much in favour and when she was regarded as being a magnificent vessel. She had dimensions of 338' length, 42' breadth and 36' depth, which gave her a gross tonnage of 3321, her engines having a nominal horse power of 700. The company for which she was built did not last very long, and she was purchased by the Cunard Line, in whose fleet

she was the first iron screw mail steamer. They adapted her to their requirements on taking her over, in 1860, and at the same time renamed her *Calabria*, but she was never a success. It was often said that she was the worst vessel that the company ever owned, for although a remarkably fast ship in smooth water, she rolled like a barrel when it was rough, and her vibration was excessive. In 1861 she was forced back to Queenstown with the loss of two of her propeller blades, and soon after she was given new engines and new boilers. In 1867, when the Fenians were giving trouble in Liverpool, it was considered desirable to send troops into the town. There being no barracks for them, and it being inadvisable to render their presence too conspicuous, the Cunard Line offered the *Australasian* and the *Africa* as floating barracks, and for upwards of a month they were occupied without any charge to the country. In 1881 the former ship was commissioned as a transport to the first Boer War, but peace was signed before she reached her destination. Later she was sold to the Telegraph Construction & Maintenance Company, and employed as a cable steamer until broken up in 1898 at Bolnes.

[256] *BEAVER.*—Photograph of steamship *Beaver*. 12" x 19½".

The *Beaver* was built by Messrs. Green, Wigram & Green, at Blackwall, London, in 1835. 109⅛ tons, 101' 4" x 20' x 11' 6". Two masts. Schooner-rigged. Square stern. Two side lever engines of 35 nominal horse power each. Vertical cylinders, 42" diameter. Piston stroke, 36". Paddle wheels, 13' diameter, 5' in width. The combined weight of boilers and engines was 63½ tons, and their cost £4,500 Sterling, both weight and cost being many times greater than that of engines of equal horse power today. Speed: 9¾ miles per hour. Armament: 5 9-pounders. Crew: 26 men.

The engines of the *Beaver* were constructed by Boulton & Watt, said to have been the first firm to engage in the commercial manufacture of steam engines, Boulton having formed a partnership for that purpose in 1774 with James Watt, the inventor. The *Beaver* was built for the Hudson's Bay Company and was designed for use on the Pacific Northwest Coast in connection with the fur trade. She sailed under the command of Capt. David Home, August 29th, 1835, in company with the ship *Columbia*, 310 tons, 6 guns and 24 men, as escort, and arrived at the port of Astoria, Columbia River, on the 4th day of April, 1836. She has the distinction of being the first steamship to ply the Pacific. Her career was long and eventful. The necessity for securing an adequate fuel supply for her engines led directly to the discovery of the bituminous coal fields on the Island of Vancouver within a few months after her arrival. In addition to her regular trips in the coasting trade she carried passengers to San Francisco in the Gold Rush of '49 and later in the Fraser River Rush of '58. The Hudson's Bay Company sold her in October, 1874, to Stafford, Saunders, Morton & Company, Victoria, who used her as a freight and towboat. She went ashore on the night of July 26th, 1888, in going out of Burrard Inlet, near the City of Vancouver and became a total wreck. The wreck remained on the shore for many years, an object of interest to sight-seers on passing vessels, and when finally broken up, much of her frame and engines were used in the manufacture of souvenirs.

[257] *BRITANNIA*.—Zincotype in colors of steamship *Britannia*. 9¾" x 17⅞". Port view in canal cut in the ice in Boston harbor. (Soon after publication of this print it was suppressed as the merchants in Boston realized that it depicted the port to a disadvantage.)

The *Britannia* was a wooden paddle wheel steamer built in 1840, by Messrs. R. Duncan & Co., of Glasgow. 1154 tons, 207' x 34' 4" x 22' 6". Engines by R. Napier & Co. Indicated horse power 740. Coal consumption 38 tons a day. Speed 8½ knots. Capacity 225 tons of cargo and 115 cabin passengers.

Following the successful transatlantic passages of the *Sirius* and *Great Western* in 1838, the Lords Commissioners of the British Admiralty asked for proposals for carrying the mails in steamships for Halifax and Boston. Samuel Cunard, a prominent merchant of Halifax, who had been actively interested some years before in steamship *Royal William*, felt that something should be done in the matter. He went to England and eventually joined forces with Robert Napier, an important Clyde ship-builder. They formed the British and North American Royal Mail Steam Packet Company, with a capital of £270,000 and contracted with the Lords Commissioners to provide four steamships to carry the mails, for which service the company was to receive £81,000 a year. Four steamships, the *Britannia*, *Acadia*, *Columbia* and *Caledonia* were built in 1840 by four different firms on the Clyde. They were all very nearly alike but the *Britannia* was completed first and became the pioneer ship of the line. She was designed only for cabin passengers and a small amount of freight since it was recognized that steamships could not compete with the sailing packets for the emigrant and heavy freighting business.

She had two decks, on the upper being situated the officers' cabins, galley, bakery, and cow-house, and on the main deck, two dining saloons, passengers' accommodation, and the like. It was arranged that she should take her maiden sailing from Liverpool to Boston by way of Halifax on Independence Day, 1840, and she was then found too large to go alongside the landing stage at Liverpool, having to take her passengers on board by tender in midstream. Including her delay in Halifax, her passage to Boston took 14 days 8 hours and was regarded as a triumph. While she was there, Mr. Cunard received no less than 1,873 invitations to dinner. She was regarded as a remarkably fine ship, but the real foundation of her success was that the Cunard Company realized the importance of building sister ships so that their patrons could always rely on the same service. In 1842, on the voyage during which Charles Dickens was a passenger, and which he described in such unflattering terms, the first recorded stowaway in a steamer was discovered. He was allow to continue the voyage to Halifax on handing over all the money that he had 10 pounds 12 shillings, and a gold watch worth 8 pounds. In 1844 she was caught in the ice at Boston, and the inhabitants themselves cut a passage seven miles long to enable her to reach open water. They refused to have the cost of this work refunded to them, although it was offered. In all she did forty passages across the Atlantic, and in 1849 was sold to the German Government for conversion to a man-of-war, being very nearly lost on her passage out. For many years she existed in Germany as a hulk.

The success of the Cunard venture had two immediate results in America. It produced an agitation in New York for an extension of the service to that city, or failing that, for the

organization of an independent line. It also appears to have influenced American Naval authorities to commence the construction of steam war vessels. In 1840-1, the steam frigates *Missouri* and *Mississippi* were built; American ship-builders had constructed the steam frigate *Kamschatka* for Russia and two Spanish war steamers of 700 tons each, and were actively laying down other steamers of which the screw bark *Clarion* became the best known. Meanwhile, E. K. Collins, of the Dramatic Line of packets, was actively urging the Government to subsidize the building of four large steamships for the New York-Liverpool runs, in imitation of the policy which the British Government had adopted toward the Cunard Line. Collins did not succeed in getting the authorities to adopt his proposals until 1848, when the famous Collins Line was organized. Meanwhile, the Cunard Line had extended the service to New York, its pioneer steamer, the *Hibernia*, arriving in New York, December 29th, 1847, followed shortly by the *Cambria*.

[258] *CATALPA*.—Colored lithograph of bark *Catalpa*, from a painting by E. U. Russell of New Bedford, published by the Forbes Lithograph Mfg. Co., of Boston, 1876. Port view at sea; hove to, boat pulling alonside. 10⅝" x 16⅞".

The *Catalpa* was built at Medford, Massachusetts, in 1844, by Waterman & Elwell. 260.47 tons (new, 206), 98' 8" x 24' 2" x 12' 2". She was a superior oak built vessel with one deck, a square stern and a billet-head.

Few vessels have had a more varied career than the little bark *Catalpa*. Her first master was that fine seaman, Justus Doane, who later commanded the clippers, *R. B. Forbes* and *John Gilpin*, and her first owner was Ephraim Lombard, a prominent Boston merchant. Next, she was commanded by Nathaniel Kendrick, and in 1845 she was purchased by John T. Coolidge and Robert C. Mackay, copartners, of Boston. Robert G. Shaw, G. Howland Shaw, and Robert G. Shaw, Jr., comprising another Boston firm, also owned an interest, and the command was given to Capt. Joseph C. Hoyt. In 1847, William C. Fay and William A. Hyde bought her and Charles Watson became her commander. Three years later, she was sold to Messrs. Henry A. Pierce, James Hunnewell and Charles Brewer, well-known Boston merchants, and the *Catalpa* joined the vast procession of ships that rounded the Horn in the exciting days of the gold rush. John Chadwick, who later had the fine clipper *Hoogly*, of Boston, commanded her on this occasion. The *Catalpa* next turns up as a whaler, out of New Bedford, owned by Nathaniel T. Gifford and commanded by Frederick P. Cole. About 1869 she was purchased by C. W. Brooks & Co., of San Francisco. It was while operating as a whaler out of San Francisco under Capt. George S. Anthony that the incident occurred which is the subject of the above picture and which is described at length in the History of Freemantle, published at Freemantle, West Australia, 1929. This was the rescue of six Fenian prisoners from the convict settlement near Freemantle, in 1876, through agents of the Clan-na-Gael Society. To carry out their plans they procured the bark *Catalpa*; agreed on a rendezvous off Rockingham; smuggled their comrades out of prison in broad daylight; drove to Rockingham and rowed out to the ship in a whaleboat. The *Catalpa* was pursued by a police boat which was unable to effect the capture of the Fenians and returned to Freemantle. A second pursuit in the steamer *Georgette* was organized with a considerable force

Japan

[316]

Lithographs, Etchings, Woodcuts and Drawings

under a fiery old Major Finnerty, who took along an old cannon as a badge of authority. The Major overhauled the *Catalpa*, fired a shot across her bows, and summoned Capt. Anthony to surrender, giving him fifteen minutes to decide, assuring him that if he refused he would open fire. Capt. Anthony ran up the American flag and told the Major to go ahead and shoot. After storming about for a while the choleric old Major left and the *Catalpa* made her way safely to America. Another famous Fenian, John Boyle O'Reilly, made a similar escape from Freemantle in 1869, in the whaler *Gazette*, coming to America where he engaged in literary work.

[259] *CENTRAL AMERICA*.—Lithograph of the steamship *Central America*, formerly the *George Law*. 9¼" x 13¼". Inscribed: "Litho. & Pub. by Childs, 152 late 84 South 3rd St., Phila.—Wreck of the Steamship *Central America*." (Then follows five lines describing the disaster.)

The *Central America* was built and launched as the *George Law*, in 1852, by William H. Webb, at New York. 2141.5 tons: 278' 3" x 40' 32". Three decks. Three masts. Round stern. No figure-head. Registered owners: George Law, Marshall O. Roberts and Bowes R. McIlvaine, of New York City (Trustees). The first commander of the *George Law* was Capt. John McGowen.

George Law ("Hell fire George") and his two associates began their operation of the "Law Line" in the autumn of 1849, with the steamship *Ohio*, 2432.23 tons, running from New York to Chagres, via New Orleans, with freight and passengers for California. As a result of abnormal traffic and excessive freight rates the line made money rapidly, and embarked on a policy of over expansion. When the slump came in the California trade in 1853, it fell upon evil days. In the summer of 1854, Marshall O. Roberts, Bowes R. McIlvaine and the veteran merchant, Moses Taylor (shortly succeeded by James Van Nostrand) were appointed trustees to manage the line which then consisted of the steamships *Illinois*, *Georgia*, *Ohio*, *Falcon*, *Crescent City*, *Empire City*, *George Law*, *Cherokee*, *Philadelphia* and *Eldorado*. Toward the end of 1855 a reorganization took place after which the line was operated as the United States Mail Steam Ship Company; Roberts becoming the first president. The name of the *George Law* was changed to *Central America* and she eventually foundered in a hurricane, September 12th, 1857, while on a voyage from Chagres to New York, with the supposed loss of 423 lives and 400,000 pounds in gold.

[260] *CHARLES CHAMBERLAIN*.—Lithograph by Endicott of tug *Charles Chamberlain*. 12¾" x 24½".

The *Chamberlain* was built in 1863, at Keyport, New Jersey, for the New York Harbor Tow Boat Company. 189.23 gross tons: 94.62 net, 131' 5" x 23' 8" x 9' 2". Beam engine. Cylinder 36". Piston stroke 8'. One deck. Square stern. No mast. No figure-head. In 1865 she was owned by R. Coffin & Company, of New York, and commanded by Capt. Rockfeller. She was sold in 1869 to Ralph C. Johnson, Jr., of New Orleans, being then under the command of Capt. George Baker. She was still listed in 1887 as hailing from New Orleans, having been altered to a propeller.

[261] *CHE KIANG*.—Lithograph by Endicott & Co., of steamer *Che Kiang*, of Boston. 18" x 33¾".

The *Che Kiang* was built at New York, in 1862, by Henry Steers. Engine by the Morgan Iron Works. 1264.10 tons, 254' 4" x 36' x 14' 4". One deck. Two masts. Sharp stern. Billethead. She was owned by John M. Forbes, of Boston, and commanded by Capt. John A. Brown.

[262] *CHENANGO*.—Colored lithograph by Endicott & Company of the United States gunboat *Chenango*. 15¾" x 29¾".

The *Chenango* was built at New York, in 1862, by Jeremiah Simonson. Displacement: 1173 tons. Register: 974 tons, 240' x 35' x 12'. Engines by Morgan Iron Works of New York. Cylinder: 59" diameter. Piston stroke: 8' 9". Armament: 8 guns.

The *Chenango* was one of twenty-seven double-ender, paddle wheel gunboats of the "*Sassacus* class," so called from the vessel which became famous by ramming the formidable Confederate ram *Albemarle*, an act which almost caused her own destruction, but which injured the *Albemarle* so seriously that she retired and never reappeared to fight again. All the gunboats of the *Sassacus* class were of wood, except the *Wateree*, which was iron. All were built in 1862 at various places along the North Atlantic coast and on the Mississippi. They proved admirably adapted to the work for which they were designed and rendered invaluable service in opening and guarding Southern ports and rivers. The *Chenango* was sold in 1868 and broken up.

[263] *CHESAPEAKE and SHANNON*.—A series of four lithographs showing the battle of the U. S. frigate *Chesapeake* with H. M. S. frigate *Shannon*. Lithographs designed by Capt. R. H. King after paintings by J. C. Schetky; on stone by L. Haghe. Published by Smith, Elder & Co., London.

The keel of the *Chesapeake* was laid in the Norfolk Navy Yard, in 1794, and she was launched October 2nd, 1799. 1244 tons, 124' x 40' x 14' (hold). Armament in 1807: 28 18-pounders; 12 32-pounders. Armament in 1813: 29 long 18-pounders; 2 long 12-pounders; 18 32-pounder carronades; 1 12-pounder carronade.

Originally designed and started as a 44 gun frigate, the *Chesapeake* was altered by naval constructor, Josiah Fox, who supervised her construction, to a 36 gun frigate. Her drafts and moulds were made at Philadelphia under the direction of Joshua Humphreys, Chief Naval Constructor, assisted by Josiah Fox. The career of the *Chesapeake* was brief and unfortunate. On the 22nd of June, 1807, she sailed from Norfolk, Va., under the command of Capt. Charles Gordon, with Commodore James Barron on board to relieve the *Constitution*. In her crew were three negroes and a white man which were claimed to be deserters from British men-of-war. The negroes were definitely proven to be Americans and the British were unable to furnish any evidence that Jenkin Ratford, the white man, was a British subject and our government at Washington had accordingly refused to deliver them up. Outside the Chesapeake Capes a heavy British frigate lay in wait for the *Chesapeake*, boarded her under pretense of sending letters home by her, demanded the men and when

Lizzie Oakford

[45]

Lithographs, Etchings, Woodcuts and Drawings 69

Barron refused to deliver them up, opened fire. The *Chesapeake* was wholly unprepared, as we were at peace with England, and it was obvious to her officers that she would be destroyed before her decks could be cleared for action. Her flag was hauled down and the men delivered to the *Leopard*, after three men had been killed and eighteen wounded on the *Chesapeake*. After this act, as treacherous as it was cowardly, the *Leopard* gave the negroes 500 lashes with the cat and Ratford was hanged at the yard arm. The last act in the drama of the *Chesapeake* came on the first of June, 1813, when Capt. Lawrence with another green, untrained crew, which had boarded the ship only that morning stood out of Boston Harbor to fight the *Shannon*. The story of that encounter and its result is too familiar to warrant repetition.

[264] *CHINA*.—Colored lithograph by Endicott & Co., of steamship *China*. Published by L. R. Menger, Dey St., New York. 18¾" x 35⅛".

The *China* was built in New York, in 1867, by William H. Webb. 3836.12 tons, 360' x 47.4' x 30.5'. Three decks. Three masts. Bark-rigged. Round stern. Plain head. Equipped with a direct acting engine. Cylinder 103". Piston stroke 12'. Four boilers. Owned and operated by the Pacific Mail Steam Ship Co. Her first commander was Capt. George H. Bradbury.

A sister ship of the *China*, the *Great Republic*, built in Brooklyn, by Henry Steers, in 1867, was put into the service by the Pacific Mail Company about the same time. She was commanded by Capt. Seth Doane, late of the clipper ships *Grace Darling* and *Northern Light*. Doane was Capt. Hatch's first mate when the *Northern Light* made her famous record passage of 76 days, 6 hours, from San Francisco to Boston. The *China* and *Great Republic* were practically identical in model and size. They were the largest American steamships of their day and when put on the transpacific run made excellent reputations for speed and seaworthiness. When the *China* was superannuated she was replaced by a second *China*, a fine steel propeller built in Scotland, in 1898, of 5060 gross tons register and 80 feet longer than the original ship.

[265] *CITY OF RIO DE JANEIRO*.—Colored lithograph by Endicott & Co., after C. Parsons of steamship *City of Rio de Janeiro*. Sister ship of the *City of Para:* the print serves to portray either. 17" x 27".

The *City of Rio de Janeiro* and *City of Para* were built by John Roach, at Chester, Pennsylvania, in 1878. 3548.30 tons: 345' x 38.6' x 19.9' x 8.6'. (Note: the same dimensions are given for both ships but the tonnage of the *City of Para* was computed as 3532.25 tons.) Iron propellers. Three decks. Three masts. Round sterns. Plain heads.

Both vessels were identical in model and were designed and constructed for service between New York and Rio de Janeiro under the management of C. H. Mallory & Company, of New York. Both were owned jointly by Charles H. Mallory, John Roach, Elihu Spicer, Jr., and George Howland. Capt. William Weir commanded the *City of Rio de Janeiro* and Capt. George F. Carpenter, the *City of Para*. Both steamers were fitted up without regard to expense and were considered to be among the finest ships afloat when launched. They were

on the Rio run for more than two years but the traffic was insufficient to make the venture more than moderately successful and in 1881 they were sold to the Pacific Mail Steam Ship Company, of New York. In the service of the Pacific Mail, the *City of Rio de Janeiro* was commanded by John M. Cavarly, a veteran sailing shipmaster, late of the medium clipper *Anglo-Saxon*. Capt. Miner B. Crowell commanded the *City of Para*. Both ships remained in the service of the Pacific Mail for many years. During the latter part of her career the *City of Rio de Janeiro* was commanded by William Ward.

[266] *COLUMBUS and VINCENNES*.—Lithograph after John Eastley of U. S. Ships *Columbus* and *Vincennes*. 12⅜" x 20½". Showing ships being towed from Jeddo Bay, July 29th, 1846.

[267] Companion piece to same. 12⅝" x 20½". Showing ships surrounded by Japanese boats in Jeddo Bay, July 20th, 1846.

The Ship-of-the-Line *Columbus* was built at the Washington Navy Yard, under the supervision of William Doughty, U. S. Naval Constructor. Work was commenced in June, 1816, and she was launched March 1st, 1819. 2480 tons: 191' 10" x 52' x 21' 10" (hold). Armament: 68 32-pounder long guns; 24 42-pounder carronades.

The Sloop-of-War *Vincennes* was built at the New York Navy Yard, under the supervision of United States Naval Constructor Samuel Humphreys and launched April 27th, 1826. 700 tons, 127' x 35' 9" x 15' 9" (hold). Armament: 24 24-pounder medium guns. Armament on January 1st, 1850: 4 VIII-guns, 16 32-pounders. Rated as an 18-gun sloop.

The most noteworthy service of the *Columbus* and *Vincennes* was their participation in the first expedition to Japan in 1845-6. This mission was unsuccessful in its immediate aim to open the ports of Japan to American trade, but it undoubtedly paved the way for Commodore Perry's success in this respect ten years later. During the Civil War the *Vincennes* was attached for a time to the West Gulf Squadron under Lieutenant Commander, John Madigan, Jr. She was sold to be broken up in 1867. The *Columbus* was still on the naval list in 1880.

[268] *COMMERCE*.—Woodcut on broadside of steamboat *Commerce*. 13" x 17". Starboard view.

The *Commerce* was built in New York, by Isaac Webb & Company, in 1825. 271.67 tons, 130' x 26' 4" x 8' 7". One deck. Square stern. No masts. She was owned by the stockholders of the Steam Navigation Company (William C. Redfield, Secretary), incorporated under the laws of the State of Connecticut. Commander: Capt. George E. Seymour.

The *Commerce* was a side-wheel paddle steamer of the type then known as a "Hudson river steam galley." In company with the "safety barge," *Lady Clinton*, she took a prominent part in the celebration in honor of the opening of the Erie Canal. As may be noted in the text of the broadside reproduced, fear of boiler explosions led the "Commercial Line" which operated the *Commerce* to use a tow barge for the accommodation of such passengers as preferred safety to speed. The *Lady Clinton*, 200 tons, built in 1825, was the first of these and

Lithographs, Etchings, Woodcuts and Drawings

was quite handsomely equipped, as no provision had to be made for motive equipment. Her dining saloon could serve 180 passengers. About this same time the fear of explosions led to the development of "team boats," as a substitute for steamboats and safety barges. The motive power of the "team boat" was a tread mill operated by six or eight horses. Both safety barges and team boats were fleeting incidents in the story of power transportation and disappeared within a few years. The steamboat *Commerce*, however, survived for nearly 70 years. In 1856 she was rebuilt and lengthened at Brooklyn, being renamed the *Ontario*. As a tow boat she continued in use around New York harbor for many years, being finally broken up at Perth Amboy in 1893.

[269] *CONSTITUTION*.—Copperplate engraving colored by hand. 9⅞" x 13⅞". Inscribed: "Signal Naval Victory, Achieved by Capt. Hull, of the U. S. Frigate *Constitution* over H. B. Majesty's Frigate *Guerriere*.... Designed, Engd. & Pub. by W. Strickland & W. Kneass. Philad[a] 21st Sept. 1812." Presented by Her Excellency Madame Bakhmeteff.

[270] The same; copperplate engraving, colored by hand, by C. Tibout after T. Birch. Pub. by Jas. Webster, 1813, reg. in Pennsylvania. 18" x 26½".

[271] The same; showing the ships in a different order. 18" x 25⅞".

[272] The same; lithograph by J. Baillie, N. Y. 8½" x 12½".

[273] The same; lithograph by N. Currier. 8" x 12½".

[274] The same; process print by Gilbo & Co. after W. A. K. Martin, Ambler, Pennsylvania, 1907. 7⅞" x 13¼".

[275] *COSTA RICA*.—Lithograph by Endicott & Company of the steamship *Costa Rica*. 14⅜" x 25½".

The *Costa Rica* was built in Brooklyn, in 1863, by Jeremiah Simonson for Cornelius Vanderbilt. 1950.11 tons, 269' x 38' 10" x 27'. Two decks. Two masts. Round stern. No figure-head. Side-wheel steamer. Beam engine. Cylinder: 81" diameter. Piston stroke: 12'.

Capt. Alfred G. Jones was the first commander of the *Costa Rica*. He was succeeded by Capt. Charles P. Seabury, followed in 1865 by the well-known Capt. Edward L. Tinklepaugh. At this time the vessel belonged to the Atlantic Mail Steam Ship Company, a corporation owned by Vanderbilt, and which at this time owned and operated the steamships *North Star*, *Northern Light*, *Ariel* and *Ocean Queen*, as well as several smaller vessels. In the autumn of 1865 Vanderbilt sold the *Costa Rica*, *Northern Light* and *Ocean Queen* to the Pacific Mail Steam Ship Company. Vanderbilt was again the registered owner of the *Costa Rica* in 1869, at which time she was commanded by Capt. Wm. G. Furber, formerly of the propeller *Mississippi*.

The Marine Collection at India House

[276] *CUBA and LIBERTY*.—Colored lithograph, proof before letters, of steam propeller *Cuba* leaving harbor in company with U. S. Mail propeller *Liberty*. 17½" x 35".

The *Cuba* was built in Fairhaven, in 1863, and was in the service of the U. S. Navy Department during the rest of the war. 1075.16 tons, 209' x 35' x 17' 8". Three decks. Two masts. Brig-rigged. Round stern. Billet-head. Two direct acting engines. Cylinders 36" diameter. Piston stroke 36".

In November, 1865, the *Cuba* was purchased by the partnership composed of James E. Ward, Henry P. Booth and Samuel C. Shepherd, of New York, who placed Capt. John R. Lundberg in command. About 1869 she was sold to S. Brown, of Baltimore, Capt. J. Duckenart commanding. In 1873, she was owned by Francis Alexandre of New York, who owned and operated a large fleet of medium sized steamships. At that time she was commanded by Capt. George W. Palmer. In 1879 she was sold to John Roach who converted her into a schooner at his yard in Chester, Pennsylvania, thus ending her career as a steamer.

The *Liberty* was built at Philadelphia, in 1864, by John D. Lynn. 1248.91 tons, 217' 9" x 34' 7". Three decks. Two masts. Brig-rigged. Round stern. Billet-head. Vertical direct engine. Cylinder 55" diameter. Piston stroke 44".

Louis E. Hargous, Jr., and Louis L. Conteulx, of New York, carpenters, and Joseph. B Hutchinson, of Bristol, Pennsylvania, were the first owners of the *Liberty*. While under their control she was commanded by Capt. Thomas W. Wilson. In 1875 she was owned by James E. Ward & Company, of New York, and commanded by Capt. John P. Lundberg. She was abandoned at sea April 7th, 1876.

[277] *DE SOTO*.—Colored lithograph published by Endicott & Co., after C. Parsons, of steamship *De Soto*. 18½" x 32½".

The *De Soto* was built in New York, in 1859, by Lawrence & Foulke. 1600.87 tons, 242' 6" x 37' 2" x 24'. Two decks. Three masts. Round stern. No figure-head. She was a side wheeler, fitted with one beam engine. Cylinder 66". Piston stroke 11'. Constructed for the New York and New Orleans Steam Ship Company: Richard C. Crochiron, President. Her first commander was Capt. James D. Bullock.

The company (which succeeded the New York and Alabama Steam Ship Company in 1855) also operated the steamships *Cahawba* and *Black Warrior*, both of which were about the same tonnage as the *De Soto*, as well as other small steamers. Herman T. Livingston and William B. Eaton, of New York, were the registered owners of the *De Soto* from the latter part of 1868 to 1870, Captains S. E. Lane and Thomas H. Manton acting as commanders during this period. In October, 1870, the *De Soto* was sold to the "Great Southern Steam Ship Company" of New York, which also owned the steamships *Northern Light*, *Rapidan* and *Bienville*.

[278] *DREADNOUGHT*.—Colored lithograph of packet ship *Dreadnought*. 16⅜" x 24⅛". Reproduced as No. 70 in "Sailing Ships of New England." (Two copies.)

The *Dreadnought* was built in Newburyport, by Currier & Townsend, and launched from their yard October 6th, 1853. 1413 tons, 200' x 41' 6" x 26' 6". Three decks. Round

Mary Glover

[49]

stern. Spar deck nearly flush, with a short low quarter-deck and topgallant forecastle. Owners: David Ogden, Daniel Girard, Francis B. Cutting, Suchardt Gebhard, Elisha D. Morgan, Thomas Richardson, William H. Gebhard, all of New York, and David Clarke, of Hartford. Commander: Capt. Samuel Samuels, of Brooklyn.

Few ships have been more strongly built or stoutly rigged than the *Dreadnought*. Her lines were those of a medium clipper and she was built expressly for, and under the supervision of, Capt. Samuels, who stated that it was his intention the ship should make a reputation or sink. Her story, during the ten years Capt. Samuels commanded her, is told in his autobiography "From Forecastle to Cabin." For ten years he never hove her to or sailed under less than double reefs. Sailors nicknamed her "The Flying Dutchman." Twenty of her eastward trips show an average time of 19 days to Liverpool and her average to the westward during the same period was 26½ days, nine of her runs being 16 days or under. As the result of an item published in the Illustrated London News for July 9th, 1859, currency has been given to the claim that the *Dreadnought* once ran from New York to Queenstown in nine days. Since then no less than four voyages have been put forward as passages on which the run was made. Examination of the logs of the voyages or comparison of claimed and actual sailing dates, however, compels the statement that the record is not proven on any of the voyages in question. Nor does it appear that Capt. Samuels, himself, ever made any claim to the record until the matter was brought to his attention late in his lifetime, no mention of the run being made in his autobiography.

After Capt. Samuels left the *Dreadnought*, she was commanded for several years in the Red Cross Line by Capt. William Cushing. In 1868 the ship was sold to Eugene Kelly, of New York, and put on the San Francisco run under Capt. Charles Gallagher. On the return voyage from San Franciso, in 1869, under the command of Capt. P. N. Mayhew, late of the clipper ship *Wild Pigeon*, she was wrecked off Cape Horn, the crew being picked up after fourteen days in the boats.

[279] *DUNDERBERG*.—Colored lithograph after C. R. Brown of steam ram *Dunderberg*. 23" x 38". Proof before letters, retouched by the artist and the entire caption pencilled in.

The *Dunderberg* was laid down in New York, in 1862, and completed July 22nd, 1865. Displacement: 7000 tons. Registered tonnage 5090, 380' 4" x 72' 10". Depth of hold: 22' 7". Height of casement: 7' 9". Draft: 21'. Length of ram: 50'. Horsepower: 5000. Diameter of screw: 21'. Weight of screw: 21 tons. Speed: 15 knots. Contract price: $1,250,000.00.

The United States Government entered into a contract with William H. Webb for the *Dunderberg*, on the 3rd of July, 1862, but owing to her great size and the weight of her armor she was not completed until after the end of the war. She was described in the contract as an "ocean-going, iron-clad frigate ram," and proved to be by far the most advanced and powerful fighting craft of her day. She had a double bottom, collision and transverse bulkheads and many other features then unusual and almost unknown. Her smoke stack was thirteen feet in diameter. After the war, the United States Government released her to Webb in

March, 1867, and he sold her to the French Government, which renamed her the *Rochambeau*. For some years she was regarded as the most formidable vessel in the French Navy. Her influence on naval architecture is to be noted in the ram bow and extreme tumble home of the sides, peculiar to French war ships during the latter part of the nineteenth century.

[280] *ECLIPSE and NATCHEZ*.—Lithograph of Mississippi River steamboat *Eclipse* racing with the *Natchez* (q.v.). 18¼" x 27⅛". Moonlight scene. Inscribed: "Sketched by H. D. Manning of the Natchez. Entered 1860, Currier & Ives. S. D. of N. Y. Lith. by Currier & Ives, N. Y. A Midnight Race on the Mississippi. N. Y. Pub. by Currier & Ives, 152 Nassau St."

The *Eclipse* was built at New Albany, Indiana, in 1852. 1117 tons, 363' x 36' x 9'. Two engines. Cylinders: 36" diameter. Piston stroke: 11'. Eight boilers: 32' 6" x 42". Paddle wheels: 41' x 14'.

The *Eclipse* was one of the largest and fastest boats ever built for the Mississippi trade, although her records were beaten nearly twenty years later by the *Robert E. Lee*. In 1853 she established a new record of 4 days, 9 hours and 31 minutes from New Orleans to Louisville, Kentucky. This was beaten by 12 minutes later in the year by the *A. L. Shotwell*, which led to the famous race between the two boats, described by Mark Twain. Both steamers stripped down for racing purposes, carrying neither freight nor passengers. The *A. L. Shotwell* was 53 feet shorter than the *Eclipse* and was able to clip the river bends more closely. However, this led to her going aground at one point, thus losing two and one-half hours, which cost her the race. It may be noted that the *Natchez* shown in the above lithograph is not the *Natchez* of the *Robert E. Lee* fame, but an earlier steamer.

[281] The same. Port bow view of steamboat *Natchez*.

The *Natchez* was built in Cincinnati in 1853. 699 tons. Owner and commander: Capt. Thomas P. Leathers.

Capt. Leathers had another much larger and faster *Natchez* built in Cincinnati in 1869. Approximately 1500 tons. Two high pressure engines. Cylinders: 34" diameter. Piston stroke: 10'. Eight boilers: 36' x 42". Paddle wheels: 42' x 16'.

Designed for the Vicksburg, Natchez and New Orleans Mail Line, the later *Natchez* proved to be very fast. Her speed record is mentioned by Mark Twain and was chalked up in 1870, when she ran from New Orleans to St. Louis (1,278 miles) in three days, 21 hours and 58 minutes.

[282] *EUTAW*.—Colored lithograph by Endicott & Son of United States gunboat *Eutaw*. 15⅜" x 29¾".

The *Eutaw* was built in Baltimore, by John J. Abrahams & Sons, in 1862. Displacement: 1173 tons. Registered tonnage 974, 240' x 35' x 12'. Engine by Hoxhurst & Weegan, of Baltimore. Cylinder: 59" diameter. Piston stroke: 8' 9". Armament: 8 guns.

Like the *Chenango* (q.v.) the *Eutaw* was a double ended gunboat of the *Sassacus* class. She was sold to be broken up in 1867.

Margaret A. Johnson

[46]

Lithographs, Etchings, Woodcuts and Drawings

[283] *FOH KIEN.*—Colored lithograph by Endicott & Company of steamship *Foh Kien*, of Boston. 15¾" x 28¾".

The *Foh Kien* was built in New York, by Henry Steers, in 1862. 1947.11 tons, 2094 tons (new measurement). 279' x 38' x 19'. Two decks. Two masts. Brig-rigged. Round stern. Scroll-head. One beam engine by the Morgan Iron Works of New York. Cylinder: 81" diameter. Piston stroke: 23". Owner: John M. Forbes, of Boston. Commander: Capt. William O. Johnson.

In 1869, the *Foh Kien* was owned by Paul S. Forbes & Company of New York, her registry having been changed to that port. She was a light draft wooden paddle wheel steamer, drawing only twelve feet at mean load line.

[284] *FRANCIS SKIDDY and ISAAC NEWTON.*—Colored lithograph of Hudson River steamboat *Francis Skiddy* racing with the *Isaac Newton* (q.v.). 18⅛" x 28". Inscribed: "F. E. Palmer, del. Entered ... 1864 ... Currier & Ives ... S. D. of N. Y. Lith. by Currier & Ives. A Night on the Hudson. Through at Daylight. New York, Published by Currier & Ives, 152 Nassau St."

The *Francis Skiddy* was built at New York, by George Collyer, in 1849. 1235 tons, 322' x 38' x 10' 4". Draft: 5' 6". Engine: vertical beam, by James Cunningham & Company. (Phoenix Foundry.) Cylinder: 70" diameter. Piston stroke 14'. Four boilers of iron on sponsons. Paddle wheels: 40' x 11'.

Originally built as the *General Taylor*, the *Francis Skiddy* was not fitted with engines until 1851, at which time she was renamed and started on a career which eventually involved many of the notables of the steamboat world. James McCulloch, of New York, purchased the hull of the *Skiddy* in 1850, John E. Andrew and George W. Coster acquiring a fifth interest at the same time. McCulloch did not retain his interest long after fitting out the steamer, for in the summer of 1852 Commodore Vanderbilt acquired the controlling share. Still later in the year he sold the majority interest to Eli Kelly and Daniel Drew, and for a time the *Skiddy* was run in the Erie Railroad Line to Albany, under an arrangement with the New Jersey Steam Navigation Company; Drew being an important figure in both concerns. The latter company (which, primarily, was the corporate name for the Stonington Steamboat Line) was, in fact, controlled by the New Jersey Steamboat Company which was the corporate name for the "People's Line" of Hudson River steamers, and in which Drew was all-powerful.

In 1855, Drew determined to establish, through the New Jersey Steam Navigation Company, a new night line to Troy, and in March, 1856, the *Francis Skiddy* and *C. Vanderbilt* were placed on the run. For this purpose the *Skiddy* was greatly enlarged and a number of staterooms added. She remained on this run for eight years and was regarded as one of the most popular of the river boats. While making what was intended to be her last trip in this service, she was wrecked by running ashore four miles below Albany, on the night of November 25th, 1864. Her engine was removed and eventually placed in the new steamboat *Dean Richmond*, and her hull broken up. When built, the *Francis Skiddy* was considered by many to be the fastest boat on the Hudson. She was able to make the run from New York to

Albany in seven and one-half hours—a remarkable performance which enabled her to make the round trip in a day.

The *Isaac Newton* was built in New York, by William H. Brown, in 1846. 1332.3 tons, 320′ 7″ x 40′ x 10′ 8″. Engine and boilers by the Allaire Works, New York. Cylinder: 81½″ diameter. Piston stroke: 12′. Paddle wheels: 39′ x 11′.

Capt. Curtis Peck was responsible for the construction of the *Isaac Newton*. It was his intention to put her on the Albany run as an independent day boat, but before she was completed he sold the controlling interest to the People's Line, in which Daniel Drew and Isaac Newton were the leading spirits. They put her on to the night run to Albany, her first trip being made on the 8th of October, 1846. At that time she was pronounced the finest night boat on the Hudson. For the first nine years of her existence the *Isaac Newton* had but two decks. In 1855 she was enlarged by John Englis, at Greenpoint, Long Island, and given an extra tier of staterooms. When alterations were completed she measured 1540 tons and was 405 feet in length, with a beam of 48 feet (78 feet, over the guards). With the *New World*, which was similarly enlarged at the same time, she shared the distinction of being the first to have three tiers of staterooms. The two vessels were regarded as the finest steamboats in the world after alterations, and in size and elegance they surpassed anything then afloat. The *Isaac Newton* was totally destroyed by fire opposite Fort Washington, while on a trip to Albany, December 5th, 1863, the fire being caused by the explosion of the starboard boiler. Six people were killed outright by scalding steam, and eleven injured, three of whom subsequently died.

[285] *FULTON*.—Lithograph of the United States steam war vessel *Fulton* (also called *Demologos*). Engraved by Endicott & Co., N. Y., for Stewarts Naval and Mail Steamers, U. S. 13″ x 9¾″.

The *Fulton* (or *Demologos*) was built at New York, in 1814, by Adam & Noah Brown. Launched October 19th, 1814. 2475 tons, 156′ x 56′ x 20′. Two masts. Two bowsprits. Lateen sails and jibs. Engine and boilers by Fulton's Engine Works, North River, New York City. Cylinder: 48″ diameter. Piston stroke: 5′. Center paddle wheel: 16′ x 14′. Armament: 2 100-pounder columbiads: 20 32-pounders.

The primary purpose for which the *Fulton* was designed was the destruction of the British fleet stationed off Sandy Hook during the War of 1812. Construction was authorized by an enactment passed in March, 1814, and the vessel laid down in accordance with plans drawn by Robert Fulton. The plans called for a ship with two keels (similar to the famous double hulled ship of Pepy's time), a double hull closed at bow and stern, with an open trough, sixty feet long and fifteen feet wide in the center, for a protected paddle wheel. There were four rudders, two at each end. The ship could travel in either direction. There was a furnace for heating shot red hot and a powerful engine to discharge hot water onto an enemy's decks. The guns were at the main deck protected by solid bulwarks four feet, ten inches thick. The upper deck had high bulwarks to protect the rifle men. Fulton had not planned to use sails to supplement steam but these were added at the insistence of Capt. David Porter, the first commander of the ship.

Maria

[47]

Lithographs, Etchings, Woodcuts and Drawings

The *Fulton* was the first steam warship the world had ever seen. Crude as it was, it would probably have served the purpose for which it was intended (the destruction or dispersal of the British blockading fleet stationed off Sandy Hook) if peace had not intervened. Moreover, it had two features of prime importance, both of which were omitted for some inexplicable reason from steam warships built during the next generation: viz., an enclosed and protected means of propulsion, and a protective armor (wooden) adequate to the requirements of the times. These two essential features were never again effectively combined in a steam war vessel until the Civil War. The trial trip of the *Fulton* took place on June 15th, 1815, and the results were satisfactory to the judges of the performance. Lafayette visited the ship in 1824 at the Brooklyn Navy Yard. The vessel was destroyed by fire, June 4th, 1829, at her dock in the Brooklyn yard, the fire resulting in an explosion which killed Lt. Breckenridge and twenty-three members of the crew, and wounded nineteen others.

[286] *FULTON*.—Cromolithograph of steamship *Fulton*. 6¾" x 9⅞". Port view at sea. Inscribed: "Lith. of Endicott & Co., N. Y. Engraved for the U. S. Nautical Magazine and Naval Journal. New York and Havre Steam Ship Co's., U. S. Mail Steamer *Fulton*. 2,300 tons."

The *Fulton* was built in New York, by Smith & Dimon, in 1855. 2307.92 tons; 2061.25 tons, new measurement, 287' 6" x 40' 10" x 32'. Four decks. Two masts. Brig-rigged. Round stern. Plain head. Two inclined oscillating engines by the Morgan Iron Works, of New York. Cylinders: 65" diameter. Piston stroke: 10'. Paddle wheels: 31' x 11'. Owned by stockholders of the New York and Havre Steam Ship Company. Mortimer Livingston, President. Commanded by Capt. James A. Wotton, late of the steamship *Franklin*, of the same line.

The New York and Havre Steam Navigation Company was organized in 1849 by several New York capitalists and shipping men, among whom were Jacob Westervelt, Isaac Bell and Mortimer Livingston, for the purpose of providing regular steamship service between New York and Havre. It began active operations early in 1850 with the steamship *Franklin*, 2183.80 tons, adding the *Humboldt*, of approximately the same tonnage, in 1851. When the *Fulton* was put in commission the name of the company had been changed to the New York and Havre Steam Ship Company. The *Fulton* was very richly finished and equipped. Her interior cabinet work was in satin, rose and zebra woods, and her cabins were decorated with paintings and gilt work. Altogether, she was considered a palatial steamer. During the Civil War she was chartered by the United States Government. She returned to line after the war, Isaac Bell, Jr., then being president of the company. Changing conditions, however, made the venture no longer profitable and in 1868 the line was abandoned. In 1869, William H. Webb purchased the *Fulton* and she was broken up during the following year.

[287] *GAME COCK*.—Colored lithograph of clipper ship *Game Cock*, of Boston. 19¼" x 26¼".

The *Game Cock* was built at East Boston, by Samuel Hall, in 1850, her launching taking place December 21st, 1850. 1392 tons, 1119 tons, new measurement, 190' 6" x 39' 10" x 22'. Semi-elliptical stern. Two decks. Figure-head, a cock in the act of crowing. Dead rise: 40".

Sheer: 3'. Swell of sides: 6". Draft: 20'. Owners: Capt. Daniel G. Bacon, William B. Bacon and Eben Bacon, of Boston, and Francis E. Bacon, of West Roxbury, Massachusetts. First Commander: Capt. Lewis G. Hollis, late of the ship *Samoset* of Boston.

Samuel Hartt Pook, the well-known naval architect, designed the *Game Cock*, producing a very handsome fast and able vessel, although she never developed the extreme speed of some of the larger ships. Her best run to San Francisco was 114 days, made in 1852, and her most spectacular performance was a passage of 19 days from Honolulu to Hong Kong, during the same year. Capt. Joseph Osgood succeeded Capt. Hollis, in 1855, and thereafter the *Game Cock* was successively commanded by Captains Josephus J. Williams, Benjamin F. Sherburne and Washington W. Hardy. In 1866, her registration was changed to New York, her owners then being Daniel Bacon, of New York, and Cyrus Wakefield, of Boston. Among those who held an interest in her at various times, were Laurence Waterbury, William S. Whitlock and Robert L. Taylor, all of New York. She was condemned at the Cape of Good Hope in 1880.

[288] *GEM OF THE PACIFIC*.—Colored lithograph of ship *Gem of the Pacific*. 8.13" x 12.15". Published by N. Currier, 1849. H. T. P. 1204.

A search of the principal custom houses of the North Atlantic coast has failed to disclose the identity of this ship.

[289] *GENERAL HOOKER*.—Cromolithograph of steamboat *General Hooker*. Port view under steam. 16⅛" x 24¾". Inscribed: "J. H. Bufford, Lith., 313 Washington St., Boston. General Hooker." (Dimensions flank each side of the title.)

The *General Hooker*, a side wheel river steamer, was built at Boston, in 1864, by William McKay. 270 tons, 142' x 22' 9" x 9'. Draft: 6'. Engines by McKay & Aldus.

Immediately on completion the *General Hooker* was sold to the United States Government and used in the transport service during the later operations of the Civil War. After the war she was repurchased by McKay & Aldus and in 1869 was being operated by them in the vicinity of Boston.

[290] *GOLDEN CITY*.—Colored lithograph by Endicott & Company of the Pacific Mail Steamship *Golden City*. 18" x 35½". Published by L. R. Menger, Dey St., New York.

The *Golden City* was built at New York, in 1863, by William H. Webb. 3373.56 tons (new measurements, 4250 tons, gross: 3589 tons, net): 343' (364', on spar deck) x 45' 1" x 31'. Three decks. Round stern. No figure-head. Draft: 17'. Vertical beam engine by the Novelty Iron Works, of New York. Cylinder: 105" diameter. Piston stroke: 12'. Paddle wheels: 40' x 18'. Owner: Pacific Mail Steam Ship Company. Commander: Capt. Oliver Eldridge, late of the clipper ship *Titan*.

When placed in the line, the *Golden City* was the largest and most luxuriously equipped ship owned by the Pacific Mail Company. She was very fast and had accommodations for more than 1500 passengers and soon became one of the most noted of the great sidewheelers. From 1863 to 1870 she ran regularly between San Francisco and Panama. On February

Lithographs, Etchings, Woodcuts and Drawings

22nd, 1870, while bound to Panama, she went ashore in a fog on the Coast of Southern California about twelve miles North of Cape San Lazzaro. No lives were lost but the ship and cargo, valued at half a million dollars, became a total loss.

[291] *GOLDEN GATE.*—Lithograph of steamship *Golden Gate.* 6⅞″ x 9⅛″. Port view at sea under steam. Inscribed: "Engraved by R. Major, N. Y. U. S. Steamer *Golden Gate.*" Engraved for Stuart's Naval and Mail Steamers of U. S.

The *Golden Gate*, a wooden paddle wheel steamship, was built at New York, in 1851, by William H. Webb. 2067.35 tons, 269′ 6″ x 40′ x 22′. Three decks. Three masts. Round stern. Spread-eagle head. Engines by Stillman, Allen & Company, of N. Y. Two oscillating cylinders: 85″ diameter. Piston stroke: 9′. Owner: Pacific Mail Steam Ship Company: William H. Aspinwall, President. Commander: Capt. Carlisle P. Patterson.

While not nearly so large as many steamships of her time, the *Golden Gate* was adjudged to surpass all others in point of equipment and mechanism. In particular her engines were said to be the largest and best oscillating engines ever built and no expense had been spared fitting up her cabins in a handsome manner. When completed she was sent on a trial trip to Annapolis where she was visited by President Millard Fillmore, Daniel Webster, several cabinet officers, and a considerable number of government officials. After her return, she sailed early in August for Panama and San Francisco, having been designed for service between Panama and the latter city. She passed her entire existence on that run carrying large quantities of gold in one direction and being packed with passengers on their way to the gold fields in the other. She was a wooden ship with accommodation for 600 passengers, and was capable of a speed of about 11 knots. In spite of the money which had been lavished upon her equipment, however, the ship was not lucky, for in 1854 she stranded near San Diego, and remained fast for a week before she was refloated. In 1857, leaving San Francisco with a number of passengers and 2,000,000 dollars in gold, she broke her shaft, and had to put back on one paddle. In 1862, on the same run, and again with a huge sum of gold, she caught fire off Mansanilla, on the Mexican coast, the outbreak being discovered while the passengers were dining. The shore was only 3½ miles away, but the flames spread so rapidly that it was with the greatest difficulty that she was beached, the upper deck falling before it could be done and killing and injuring a number of people. As soon as she touched, those who had no place in the boats jumped overboard and swam ashore, about 150 being saved out of the 330 that were on board. A schooner was chartered to go down with divers to try and recover the treasure, several cases of which were brought to the surface.

[292] *GOLDEN LIGHT.*—Colored lithograph by N. Currier of clipper ship *Golden Light*, of Boston. 9½″ x 14″.

The *Golden Light* was built at South Boston, by E. & H. A. Briggs, and launched January 8th, 1853. 1140.60 tons: 182′ (193′, over all) x 36′ x 22′ 6″. Two decks. Sheer: 2′ 6″. Dead rise: 27″. Swell of sides: 6″. Figure-head: a golden hand holding a golden torch with a golden flame. Stern: elliptical, ornamented with gilded carved work. Owners: Capt. James Huckins & Sons, of Boston. Commander: Capt. Charles F. Winsor.

Capt. Huckins and his associates also owned the *Northern Light* and the *Boston Light*. All three ships were medium clippers of very similar design, although the *Northern Light* was slightly smaller than the other two. According to contemporary accounts the *Golden Light* was a very handsome ship. Her bow was wedge-like, slightly concave below and flaring to convex above the water line. She sailed from Boston, February 12th, 1853, and was struck by lightning at nine o'clock on the night of February 22nd. At 6 P. M. the following day she was abandoned, the passengers and crew, thirty-five in all, leaving in five boats. Three boats, one of which was Capt. Winsor's, were picked up five days later by the British ship *Shand*. The others were never reported. The *Golden Light* and cargo were insured for $288,000.00.

[293] *GRANITE STATE*.—Original etching by F. Leo Hunter, 1901, of United States Ship-of-the-Line *Granite State*, formerly the *New Hampshire*. 10" x 13". Remarque proof. Presented by Herbert L. Satterlee.

The *New Hampshire*, 74 was launched at the United States Navy Yard, Kittery, Maine, January 23rd, 1864. 2633 tons, 196' 3" x 53' x 22' (hold). Armament, June 14th, 1864: 4 100-pounder Parrott rifles and 6 IX-inch Dahlgren smooth bores, to which was added, February 8th, 1865, 2 24-pounders.

Perhaps no ship that ever sailed was so long in building as the *New Hampshire*. The order for her construction was given April 15th, 1817, and her keel was laid late in 1818 or early in 1819. She lay on the stocks approximately forty-five years before completion. Her plans were prepared by United States Naval Constructor Samuel Harte, who supervised the early stages of her construction. It was the original intention to call her the *Alabama* but her name was changed to *New Hampshire* on the 28th of October, 1863.

After the war she was sent to Norfolk becoming the receiving ship at the Navy Yard there in 1868, remaining there for a number of years. About the turn of the century she was turned over to the Naval reserve and renamed the *Granite State*. She was stationed near the foot of West 79th Street, New York City, where she was to be seen for many years. Shortly after the close of the World War she caught fire and was badly damaged, and shortly thereafter was broken up.

[294] *GRAPE SHOT*.—Colored lithograph by N. Currier of the clipper bark *Grape Shot*. 8" x 12¾". Undated. H. T. P. 1206.

The *Grape Shot* was built at Cumberland, Maine, in 1853. 345.2 tons, 120' 2" x 26' 3" x 11' 11½". One deck. Round stern. Billet-head. Owners: Sebastian D. Lawrence, Sidney Miner and Francis W. Lawrence, of New London. Commander: Capt. Ebenezer J. Parker.

George Law, formerly of the Law Steamship lines, soon became the owner of the *Grape Shot* and operated her for several years in the Southern and Central American trades under the command of Capt. Robbins. In 1860 she was owned by P. N. Giraud, of New Orleans, and commanded by Capt. Homewood. In 1862 she was purchased by Ezekiel H., Thomas R., Henry and A. J. Trowbridge of New Haven, Connecticut, and placed under the command of Capt. Jason Frisbie. Throughout her career, the *Grape Shot* maintained a reputation as one of the fastest of the smaller clippers.

Natchez

[50]

Lithographs, Etchings, Woodcuts and Drawings

[295] *GREAT BRITAIN*.—Lithograph of the British screw steamship *Great Britain*. At sea under steam and storm sail. 15¼" x 23½". Inscribed: "Published, Homans and Ellis, New York, 1845. Painted by J. Walters. Lith. by C. Parsons." (Proof before the title.)

[296] Lithograph of the same. Port view at sea. 8⅛" x 12⅛". Inscribed: "Lith. & Pub. by N. Currier. 152 Nassau St., Cor. of Spruce St., N. Y. The Iron Steamship Great Britain. Off Sandy Hook, May 14th, 1852." (Dimensions flank each side of the title.)

The *Great Britain* was built at Bristol, England, in 1839-43 by the Great Western Steam Ship Company. 3448 tons (3282 tons, new measurement): 293' 5" (322', from figure-head to taffrail) x 51' x 32' 6". Three decks. Six masts—main mast square-rigged. Round stern. Figure-head. Crew: 350. Passenger capacity, about 360. Four oscillating, direct acting cylinders: 88" diameter. Piston stroke: 72". Nominal horse power: 1200. Speed: 12 knots. Owners: The Great Western Steam Ship Company. Commander: Capt. Hosken.

When completed, the *Great Britain* was the largest iron ship afloat. The Great Western Steam Ship Co. had secured a fair measure of success with their steamer the *Great Western* on the Atlantic passage, and considered that a larger ship would be more profitable. Mr. I. K. Brunel was consulted as to its construction, and it was shown that such a large vessel as the company required would not be practicable in wood, so he advised iron. Only small vessels had been so constructed up to that date (1839) so again no contractor could be found who was willing to undertake either hull or engines. The Great Western Company therefore laid down its own plant for iron ship-building at Bristol. Brunel's original design was for paddle wheels, but before the building of the hull had proceeded very far the arrival of the *Archimedes* at Bristol, which clearly demonstrated the superiority of the screw propeller, caused him to alter his plans. The ship was laid down in dry dock in 1839, and first floated on July 19th, 1843, but she could not enter the river because the dock entrance was slightly askew which would not allow her to turn and also there was insufficient depth of water over the sill. The result was that until these dock alterations had taken place the ship could not be removed, and she remained there fitting out until December, 1844. It was originally intended to call her the *Mammoth*, as she was larger than any ship, either naval or mercantile, afloat. The hull was very strongly constructed and was divided into six water-tight compartments which were then something of a novelty. As originally rigged she had six masts, and as there were no technical names for them they were known by the days of the week, starting on Monday, it being very truly remarked that there were no Sundays at sea in those days. There was much prejudice against the iron construction, but she confused her critics as will be shown later. On her steam trials, 11 knots were obtained at 16 r.p.m. of her engines driving a massive overhead crankshaft, supported on A-shaped frames. In the middle of the crankshaft was a massive drum 18' 3" in diameter and 38" wide. This connected with a smaller drum on the propeller shaft by means of 4 flat pitch chains, gearing up the latter to 53 revolutions to 18 of the crankshaft. Condensers were fitted, and also a remarkably simple thrust block, which consisted of a plain disc of steel 2 ft. in diameter, and a gunmetal disc of the same diameter, a stream of water acting as a lubricant.

On January 3rd, 1845, the ship left Bristol and arrived at London in 59.5 hours, the

average speed being 9.5 knots. She afterwards steamed to Liverpool, and on the 26th of July, 1845, commenced her first voyage to New York with about 60 passengers and over 800 tons of cargo, arriving safely after a passage of 14 days and 21 hours. The return voyage to Liverpool was completed in 14 days, the best day's run being 287 miles, and here she was drydocked where her plates, contrary to expectations, were found to be free from fouling. In another of her voyages she broke two blades off her six-bladed propeller, and proceeded to Liverpool on that occasion under sail, steering exceedingly well and making better progress than she usually did under steam. She was fitted with a new 4-bladed propeller, and continued her voyages until 1846, when she stranded in Dundrum Bay, County Down, Ireland. Here the strength of her iron construction showed to full advantage, for she lay there protected by a huge breakwater of faggots and timbers, for about 10 months. She was towed to Liverpool, where she was sold to Messrs. Gibbs, Bright & Co., for 24,000 pounds, although she had cost over 100,000 pounds. When reconditioned, she was re-rigged with four masts, and her engines are given as two cylinders: 82½" diameter. In 1853 she was put on the Australian route, and about the 60's was re-rigged as a three-masted ship. In 1881 she was offered for sale but was withdrawn at 6,500 pounds, after which she was disposed of privately and put to sea as a sailing ship. In 1886 she met with very heavy weather off the Horn and was condemned, becoming a hulk in the Falkland Islands, where she is still to be seen.

[297] *GREAT EASTERN.*—Lithograph of the British steamship *Great Eastern*. 17¾" x 28⅞". Port view at sea under steam, a large number of spectators in small boats watching her. Inscribed: "C. Parsons del. Entered ... 1858 ... Currier & Ives, N. Y. Lith. by Currier & Ives, N. Y. The Iron Steamship *Great Eastern*, 22,500 tons. Constructed under the direction of I. K. Brunel, F.R.S., D.C.L. New York. Published by Currier & Ives, 152 Nassau St." (Dimensions flank each side of the title.)

[298] Colored lithograph of the same by Currier & Ives. 10¾" x 17¼". G. Parsons, Del. Starboard view at sea under steam and sail. "Entered according to Act of Congress, in the year 1859, by Currier & Ives, in the Clerk's Office of the District Court for the Southern District of New York."

[299] Colored lithograph of the same after William Weedon. 12½" x 18¼".

[300] Lithograph of the same by Kimmel & Foster, 254 & 256 Canal St., N. Y. 14¾" x 19½". Arrival of the Atlantic Cable in Newfoundland, July 27th, 1866.

The *Great Eastern* was built on the Thames, 1854-9, by Scott, Russell & Company. Tonnage, variously stated, from 18,914 to 22,500 tons, 678' (692', on deck) x 77' 10" x 48' 2". Five decks. Six masts. Ten bulkheads. Draft: 29'. Four oscillating engines. Cylinders: 84" diameter. Four horizontal engines, Cylinders: 74" diameter. Stroke of pistons: 14'.

Mr. I. K. Brunel, who had an established reputation as a successful designer of large iron steamships, designed the *Great Eastern*.

In 1851 a company was floated for the purpose of building her and trading to the East,

Monmouth

[677]

as in those days the great difficulty with steamships on the Eastern run was coal supply, and the sailing ships were still maintaining their position. Brunel's idea was that she should ply between England and either Calcutta or Colombo, where smaller steamers could pick up her cargo and distribute it to various destinations. She had a gross tonnage of 18,914, and was built to Scott Russell's designs on the wave line principle. Messrs. Scott Russell & Co. were given the contract to build the hull and the paddle engines, while Messrs. James Watt & Co., of Birmingham, built the screw engines, Brunel having decided to use two means of propulsion. To obtain the tremendous strength necessary she was not only given a double bottom but also a tubular upper deck, and with other similar features of her construction, was one of the strongest ships ever built. Had she been allowed to run on the long-distance trades, for which she was designed, she might easily have been a success, instead of which she was a great financial failure.

The paddle engines were 1,000 nominal horse power, but indicated 3,411, while the screw engines, which drove a 4-bladed propeller, 24 ft. diameter, were 1,600 nominal and indicated 4,886 horse power. In order to avoid drag when sailing and using her paddles as well as an auxiliary, two 20 horse power engines were fitted to the propeller shaft in order to keep this revolving. She was partially square-rigged and could spread 6,500 square yards of canvas. She was fitted with 20 anchors, which, with cables, totalled 253 tons. Her launch (broadside on) into the Thames took place actually 3 months after the first attempt. Brunel was so anxious to avoid the huge mass taking charge that he checked her too soon on the ways, when the iron cradle griped the iron slip and held fast. She then had to be levered into the water by very expensive hydraulic machinery; this cost so much that the original company became bankrupt, and it was not until September, 1859, that the trial trip took place. She was an unlucky ship, for from the very first she had a number of accidents and lost several lives before she started on her maiden voyage across the Atlantic in June, 1860. Her purchasers put her on the New York Service, for which she was ill fitted, and lost money steadily, although her speed was 14.5 knots. However she proved a success trooping to Canada after the unfortunate *Trent* affair. As a passenger and cargo steamer, she could not be made to pay, but in 1865 she was employed on cable work, which she carried out with great success till 1873. By this time the company were in very low water, and it was actually suggested to raffle her at Liverpool, but eventually she was sold by order of the court, fetching 25,000 pounds, after she had cost 900,000 pounds to build. She was a fine ship in many ways, and her design contained some very valuable features in addition to its faults, conspicuous among which was the attempt to combine paddle and screw. Had she been used on the voyages originally projected, there is no reason to think that she would have been anything but a success. It was not until 1899 that her dimensions were exceeded. In the early 80's she was bought by an enterprising firm of cheap tailors, who ran her as an exhibition and floating fair wherever they were allowed to take her into harbour. In 1887 she was sold to ship-breakers and broken up in the Mersey. When the sealed double bottom was opened the skeleton of a man (a rivetter who was reported missing during her building) was found in one of the compartments, and superstitious sailormen explained her bad luck by recalling that it was always unlucky to carry a corpse on board.

[301] GREAT REPUBLIC.—Colored lithograph by N. Currier of clipper ship *Great Republic*. 8¼" x 12⅛". Port view at sea. Undated.

[302] The same; colored woodcut, 9" x 13¼".
 The *Great Republic* was built at East Boston, by Donald McKay, in 1853. 4555 tons, 335' x 53' x 38'. Four decks. Four masts. Round stern. Eagle's head figure-head. Dimensions after rebuilding. 3356 tons, 302' x 48' 4" x 29' 3". Three decks. Owner: Donald McKay. Commander: Capt. Joseph Limeburner.
 When launched, October 4th, 1853, the *Great Republic* was by far the largest merchant sailing ship ever built. Owing to her immense size public interest in the vessel was high and thousands attended her launching. She was very handsomely finished and many luxurious appointments were provided for passengers. An engine of 15 h.p. to hoist sails and handle cargo was installed to assist the crew of 100 men and 30 boys. Her rig was probably the heaviest ever put on a merchant ship of her approximate tonnage. She swung a main yard of 120 feet with other spars in proportion.
 She was towed to New York and all was in readiness for her maiden voyage when a great fire broke out, sweeping the New York water-front. Her four masts were cut away and every human effort made to save her, but it was found necessary to scuttle her and she was burned to the water's edge.
 The wreck was raised and rebuilt at Greenpoint, Long Island, by Sneeden and Whitlock for the purchasers, A. A. Low & Bro. Her upper deck was not rebuilt, leaving only three decks, and her masts and spars were considerably reduced. The fact that her registered tonnage was reduced by one-fourth to 3356 tons sums up the changes made. Her reconstruction was supervised by Capt. Nathaniel B. Palmer, who sent her original figure-head to his home in Stonington, Connecticut, and it is now to be seen at the Stonington Museum.
 It has always been a matter of regret to shipping people that McKay's masterpiece, as originally conceived and rigged should never have had an opportunity to show her ability. Her maiden voyage to Liverpool, with a rough passage, under very adverse conditions was made in 19 days. Some twenty-two months later we find her leaving Sandy Hook on her first run to San Francisco—that gruelling course which challenged all clippers. The *Great Republic* crossed the line in 15 days and 18 hours, *the fastest time on record* for this leg of the run, making San Francisco in 92 days.
 In 1866 she passed to British ownership, being renamed the *Denmark*, and was abandoned at sea in 1872 without loss of life. At that time she was owned by the Merchants Trading Company of Liverpool.

[303] GREAT REPUBLIC.—Lithograph of side wheel steamship *Great Republic*. 18¾" x 35¼". Lithograph by Endicott & Company, 59 Beekman St., New York. Published by L. R. Menger, 22 Dey St., New York.
 The *Great Republic* was built at Greenpoint, Long Island, by Henry Steers, in 1866-7. 4750 gross tons (3881.83, net tons), 360.3' (380', on spar deck) x 47.3' x 31.6'. Draft: 18'. Three decks. Three masts. Bark-rigged. Round stern. Plain head. Vertical beam engine by

North American

[53]

Lithographs, Etchings, Woodcuts and Drawings

the Novelty Iron Works, New York. One cylinder: 105″ diameter. Piston stroke: 12′. Four rectangular boilers: 10′ x 13′ x 23′. Working pressure: 20 pounds to the square inch. Owners: Pacific Mail Steam Ship Company. Commander: Capt. Seth Doane, formerly of clipper ships *Grace Darling* and *Northern Light*.

When the Pacific Mail Company decided to improve its transpacific service after the close of the Civil War, it had four sister ships built at New York City for that purpose; the *Great Republic*, *America*, *China* and *Japan*. As it turned out, they were the largest side wheel steamships ever built in America.

It was originally planned to open the new Oriental service on the 1st of January, 1867, and the construction of the *Great Republic* was hurried forward to permit her to inaugurate it. She had accommodation for 150 cabin passengers and 1,200 in the steerage, for at that time it must be remembered that Oriental immigration into the U. S. was not strictly barred as it is now. Coal difficulties were among the most serious with which she had to contend, and accordingly she was given a bunker capacity of 1,500 tons and at a load draught was capable of carrying 1,900 tons of cargo. Her speed was sufficient in fine weather to permit her to make the passage from San Francisco to Hong Kong, including the stop at Yokohama, in 30 days, but in stormy weather the single-cylinder engine would only make about 5 revolutions per minute and the engineers had to stand by to help it over the centre with the starting bar. In the 70's, new and more up-to-date tonnage having been built for the transpacific run, she was taken off the service and put on the coastal run between San Francisco and Portland, Oregon, a service of the greatest importance before the construction of the railway. On the 16th of April, 1879, she left San Francisco for Portland with nearly six hundred passengers, and arrived off the difficult bar of the Columbia River at midnight on the 19th. The night was fine and the water unusually smooth over the bar, so the captain decided to make the passage at once, but half way across she struck at half ebb. Although the passengers were safely landed, a boat with the first and second officers and 12 members of the crew capsized and all were drowned. Soon after the accident a heavy storm arose, and the ship went to pieces almost immediately.

[304] *GREAT WESTERN*.—Lithograph by Endicott & Company of steamship *Great Western*. 14¾″ x 23″. Starboard view at sea under steam. Inscribed: "Drawn by C. W. Cramp. On stone by G. T. Sandford. Lith. by Endicott, N. Y. The steamship Great Western of Bristol, Commander Lieut. Hoskins, R.N. Her first passage from Bristol to New York was made in 15 days." (Then follows one line of dimensions.) "N. Y. Pub. by Endicott, 359 Broadway."

[305] The same; lithograph by D. W. Kellogg & Company, Main St., Hartford, Connecticut. 15½″ x 11¼″. Showing ship under steam.

The steamship *Great Western* was built at Bristol, England, in 1837 by Patterson: 1340 tons, 236′ x 35′ 6″ (58′ 4″ over paddle boxes) x 23′ 6″. Engine by Mandslay, Son & Field. Two cylinders: 73½″ diameter. Horse power: 450. Weight of paddle shaft: 6½ tons. Diameter: 18¾″. Two decks. Three masts. Topsail schooner-rigged. Square stern. Owners:

The Great Western Steam Ship Company, of Bristol. Commander: Lt. James Hosken, R.N., G. K. Brunel, who later designed the steamships *Great Britain* and *Great Eastern*, drew the plans of the *Great Western*.

She was a wooden paddle wheel steamer and cost about $125,000.00, the engines alone costing $33,750.00. Her main cabin was 82' in length and was done in light salmon color with gilt decorations. When her hull was completed she was sailed around to London to receive her engines. Her return voyage to Bristol—700 miles—was made in the excellent running time of 56 hours. She was detained four hours on the trip by a small conflagration in the engine room, and in the ensuing excitement Brunel, Jr., son of the designer, fell down a hatchway landing in the hold twenty feet below and sustaining minor contusions. The *Great Western* was the first steamship designed expressly for the transatlantic service and may justly be regarded as the pioneer of the great Atlantic liners. She was the first vessel to be given a bunker capacity sufficient for the requirements of the voyage in unfavorable weather. Thus, the *Sirius* (q.v.) arrived in New York with but 35 tons of coal in her bunkers, while the *Great Western* had 145 tons still on hand. The *Great Western* steamed on her maiden voyage from Bristol the 7th of April, 1838, apparently unaware that the *Sirius*, a smaller ship of a rival company, had left Cork three days previously. The *Sirius* arrived at New York on the morning of April 23rd, the *Great Western* coming in four hours later. Her passage consumed 15 days, the best day's run being 243 miles, an average of 8.2 knots an hour. She consumed 655 tons of coal and was under steam throughout, although using her auxiliary sail power whenever possible. On her second voyage the *Great Western* made her westward passage in 14 days and 20 hours, and her eastward run in 12 days and 14 hours, beating the old sailing packets so decisively that she convinced many conservative travellers of the advantages of steam. In some respects the arrival of these two pioneer steamers was the most important event the Port of New York has ever witnessed. It made a tremendous impression on the entire population, as may be gathered from the following extract taken from an article in the New York Evening Post for April 24th, 1838:

> "*The Steam Packets.*—The arrival yesterday of the steam packets *Sirius* and *Great Western*, caused in this city that stir of eager curiosity and speculation which every new enterprise of any magnitude awakens in this excitable community. The Battery was thronged yesterday morning with thousands of persons of both sexes, assembled to look on the *Sirius* the vessel which had crossed the Atlantic by the power of steam, as she lay anchored near at hand, gracefully shaped, painted black all over, the water around her covered with boats more filled with people were passing and repassing, some conveying and some bringing back those who desired to go aboard. An American seventy-four in one of the ports of the Mediterranean, or of South America would hardly be surrounded with a greater throng of the natives.
>
> When the *Great Western*, at a later hour, was seen ploughing her way through the waters toward the city, a prodigious mass, blacker if possible than her predecessor, the crowd became more numerous, and the whole bay, to a great distance was dotted with boats, as if everything that could be moved by oars had left its place at the wharves. It seemed, in fact, a kind of triumphal entry.
>
> The problem of the practicability of establishing a regular intercourse by steam

Lithographs, Etchings, Woodcuts and Drawings

between Europe and America is considered to be solved by the arrival of these vessels, notwithstanding the calculations of certain ingenious men in England, at the head of whom is Dr. Lardner, who have proved by figures that the thing is impossible."

During her entire stay, the *Great Western* was thronged with visitors many of them coming from distant communities, and when she sailed again at 2.00 P. M. on Monday, May 7th, her passenger list included voyagers from all sections of the East. Nor did her ovation end here. A vast flotilla of steamers, sailing vessels and rowboats, bright with flags and gay uniforms, accompanied her on her way to Sandy Hook, filling the air at intervals with lusty cheers and the equally robust din of horn and whistle. In all, the *Great Western* made about 90 voyages during the eight years she ran between Bristol and New York. In 1847 she was sold to the Royal Mail Steam Packet Company for £25,000 and ran in their service for some time. As their tonnage increased, she was set aside as being too extravagant. She was sold to the ship-breakers in 1856 and scrapped at Vauxhall the following year.

[306] *HENRY CHAUNCEY.*—Colored lithograph by Endicott & Company of steamship *Henry Chauncey*. 17⅝" x 35¼". Published by L. R. Menger, Dey St., New York.

The *Henry Chauncey*, a wooden paddle wheel steamer, was built at New York, in 1865, by William H. Webb. 2656.67 tons, 319.45' x 43' x 28.1'. Three decks. Two masts. Hermaphrodite brig-rigged. Plain head. Five bulkheads. Beam engine. Cylinder: 105" diameter. Piston stroke: 12'. Owner: Pacific Mail Steam Ship Company. Commander: Capt. Alfred G. Gray.

During the most of her career the *Chauncey* was operated by the Pacific Mail on the run between San Francisco and Panama. Like all of Webbs' large steamers she was built principally of oak and chestnut, strongly cross braced with heavy iron straps, and proved a very efficient and satisfactory vessel for her time.

Capt. Gray was succeeded in command by Capt. William Rathbone. In 1882 the *Chauncey* had become superannuated and she was broken up.

[307] *HERRADURA.*—Colored lithograph of British ship *Herradura*. 12½" x 18½".

The *Herradura* was launched at Aberdeen, Scotland, in September, 1868, from the yard of Hall, Russell & Company. 612 tons, 169' x 30.6' x 17.6'. Two decks. Round stern. Iron and wood frames, planked with wood. Owners: William Le Lacheur & Son, of London and Guernsey. Commander: Capt. Le Lacheur.

The owners of the *Herradura* were engaged principally in trade with the West Indies and Central America and the ship was especially designed for the requirements of that trade. Although not an extreme clipper, she was fast, and it was reported that in 1872 she made the run from London to Punta Arenas, Central America, in 87 days—very fast time.

The Le Lacheurs finally sold her abroad and in 1887 she was listed as being under the Austrian flag.

The *Herradura* was the second vessel of that name, a bark *Herradura* of 500 tons, having been built at Sunderland in 1862.

[308] *HUDSON.*—Colored lithograph by J. Baillie, New York, of United States Frigate *Hudson.* 8¾" x 12¾".

The *Hudson* was built at New York as the *Liberator* by Smith & Dimon in 1825. 1735 tons, 176' 4" x 45'. Rated as a 44-gun frigate. Number and calibre of guns on her not found.

Originally intended for the Greek Government, the *Hudson* was purchased in 1826 for the United States Navy.

She appears to have engaged in no operations of special interest and was sold in 1844 to be broken up.

[309] *HU QUANG.*—Lithograph by Endicott & Company of the steamship *Hu Quang,* of Boston. 17½" x 33½".

The *Hu Quang* was a wooden paddle wheel steamer built at New York, in 1862, by Henry Steers. 1339.91 tons, 284' 4" x 36' x 13' 8". One deck. Two masts. Square stern. No figure-head. Owners: John M. Forbes and E. I. Hale, of Boston. Captain: John P. Roberts, late of the very fast clipper bark *Storm.*

About this time a considerable number of steamers were built at New York for service on the China coast and rivers. Among them were the *Shan Se Pao Tang, Ta Kiang,* and *Kiang Tsi,* the majority of which were propellers of 1000 tons, or thereabouts. Robert W. Olyphant, William W. Parkin, David C. Vail, Oliver K. Gordon, Anthony B. Neilson and Paul N. Forbes, of New York, owned heavy interests in several of the vessels, and it was currently reported that a company had been formed for the navigation of Chinese waters with a capital of a million and a half dollars. The *Hu Quang* cleared at New York for Shanghai on May 26th, 1862, and sailed shortly thereafter under command of Capt. Roberts.

[310] *ILLINOIS.*—Lithograph of the steamship *Illinois.* 7" x 10⅞". Starboard view off the coast under steam. Inscribed: "Chas. Parsons Del. . . . Engraved by Endicott & Co. . . . Engraved for Stuarts' Naval and Mail Steamers of the U. S. . . . U. S. Mail Steamer *Illinois.*"

The *Illinois* was built at New York, in 1850-1, by Smith & Dimon. 2133.65 tons, 266' 6" x 40' 10" x 31'. Two decks. (Afterwards reported as three decks.) Round stern. No figure-head. Two oscillating engines by the Allaire Works, New York City. Cylinders: 85" diameter. Piston stroke: 9'. Paddle wheels: 33' 6" x 11'. Owners: John L. Aspinwall, Samuel W. Comstock and William Edgar Aspinwall, of New York. Commander: Capt. Henry I. Hartstone.

It has been erroneously stated that the *Illinois* was first owned by George Law, but he does not appear to have been in any way connected with the vessel until 1853, when she is registered as owned by the stockholders of the United States Mail Steam Ship Company: George Law, President. After Law became financially involved in 1854, she was held and operated for a time by Marshall O. Roberts, Moses Taylor and Bowes R. McIlvaine, trustees. In 1857 she was owned by the Chagres Steam Ship Company, passing in 1860 to the possession of Cornelius Vanderbilt, who operated her irregularly for a time between New York, Southampton and Havre. When first built she was considered the finest steamer on the Chagres route. Her best performance was a run from Chagres to New York (estimated dis-

A Night on the Hudson

[284]

tance, 1980 miles) in six days, sixteen hours, a record which stood for some years. Again in May, 1852, she ran from Havana to New York (1032 miles) in 94½ hours, her best day's run being 337 miles, in the Gulf Stream. When the Civil War broke out she was purchased by the United States Government for transport service, carrying troops and exchanged Confederate prisoners. After the war she was sold and broken up.

Capt. Hartstone was succeeded in the command by Capt. John McGowen, who, in turn, was followed by Capt. Boggs.

[311] INDEPENDANCE.—Colored lithograph by N. Currier of the United States Ship *Independance* (*Independence*). 7.8" x 12.8". Dated 1841. H.T.P. 1135.

[312] The same; colored lithograph by George Filley. 16½" x 12½". Published by E. C. Kellogg, Hartford, Connecticut. 1842.

The *Independance*, seventy-four, was built in the Boston Navy Yard, under the supervision of Josiah Barker, United States Naval Constructor, assisted by Samuel Hartt. Keel laid August 18th, 1813; launched June 22nd, 1814. 2257 tons, 188' x 50' x 19' 5" (depth of hold). Armament: During the War of 1812 her guns were at Washington, D. C., and could not be brought up because of the blockade of Boston, so she was temporarily armed for the defense of the city. Commodore Bainbridge's requisition was for 30 long 32-pounders and 34 light 32-pounders. She was razed to a fifty-four in 1836, after which her armament was 30 32-pounders, 20 32-pounder carronades and 32 24-pounders.

[313] INO.—Colored lithograph by J. Hanson, of Clipper ship *Ino*. 24" x 36". Published by Nagel & Weingaertner.

The extreme clipper ship *Ino* was built at Williamsburg, New York, in 1850, by Perrine, Patterson & Stack, her launch taking place on Saturday, January 4th, 1851. 895 tons (673 tons, new measurement), 160' 6" x 34' 11" x 17' 5". Draft forward 17' 6"; aft. 18' 9". Owners: Siffkin & Ironsides, New York. Commander: Capt. Robert E. Little.

In proportion to tonnage few clippers were more heavily sparred than the *Ino*. She spread 9491 yards of canvas and in every port she visited she was conspicuous for her handsome model and rakish rig. She proved to be a fast sailer. Her maiden voyage to San Francisco took 134 days. 27 days to line, 66 days to 50 degrees in the South Pacific; thereafter light winds and was 34 days from the equator to port. She completed the voyage by going to Singapore in 57 days and back to New York in 89 days. Capt. Kimball R. Smith took command and had a fine run of 111 sailing days to San Francisco. She continued to voyage to San Francisco and the East, again under the command of Capt. Converse F. Plumer, making good sailing time always. Shortly after her arrival in New York in February, 1859, she was sold to Goddard & Thompson of Boston. On August 30th, 1861, she was sold by John M. Forbes and others to the U. S. Government, for $40,000. She was equipped with eight 32-pounders and a complement of 144 men and was rated as a sloop-of-war, 4th class. Some months later her armament was increased by one 20-pounder Parrot rifle. Under Acting Volunteer Lieut. Josiah P. Cressy, of *Flying Cloud* fame, she started on her first cruise, September 23rd,

1861. On her second cruise she left Boston, January 29th, 1862, in search of the *Sumter*. Her run to Cadiz was reported as 12 days, being the fastest on record. She ran into heavy weather, sustaining some damage and losing a boat, and had to put into Palermo for repairs. Commander Craven of the *Tuscarora*, having taken exception to the way in which Lieut. Cressy was obeying instructions, filed charges against him and in May the *Ino* was recalled to Boston. After that the *Ino* was under different commanders, among whom were: Acting Masters Edward F. Devens and James M. Williams, also Acting Vol.-Lieut. Charles A. French. On different occasions she was sent to search for the *Alabama* and *Florida*, when she would be disguised as a merchantman. Other cruises were made to New Foundland to protect the fishermen; to the Western Islands and the vicinity for the benefit of the whalers, and to the Equator and Cape St. Rocque to convoy merchantmen. On May 29th, 1863, she left New York as convoy to the ship *Aquila*, which had the knocked down ironclad *Comanche* on board for San Francisco. At other periods she was attached to the various blockading squadrons, at times having one or two armed schooners as tenders. In June, 1865, she was sent north from Key West and her career as a vessel of war was ended. All her commanders spoke well of her. Her greatest distance sailed in 24 hours was 310 miles, her least 13; maximum speed 14 knots. In 1867 the Government sold her to Samuel Reed & Co. of Boston, and she was renamed the *Shooting Star*. She made one voyage to San Francisco, in 1867, under the command of Capt. Peck. She left Hampton Roads on July 4th, the run being made in 102 days. At San Francisco she was sold to Rosenfeld & Birmingham, and was used to carry coal to that port from the mines at Nanaimo, B. C. The voyages were made regularly 8 times a year. She always looked smart. She generally carried between 950 and 1000 tons. Latterly she was bark-rigged. In 1877 she was at Philadelphia to load oil for Bremen, after leaving the Pacific the year previously, when she carried a cargo of ore from the West coast of Mexico to Hamburg. Later she was sold abroad, and in 1886 was at Barcelona as the Russian bark *Ellen* of Wassa, owned by her captain, Dahlstrom and others.

[314] INTREPID.—Engraving of United States ketch *Intrepid*. 9¾" x 13⅞".

The ketch *Intrepid* was captured in the Mediterranean in 1803 by the United States squadron blockading Tripoli. She was a vessel of about 100 tons and her armament consisted of four light guns. For a time she was used by the American fleet as a bomb ketch. She was blown up on the night of September 4th, 1804, while being taken into Tripoli harbor to be used as a fire ship for the purpose of destroying the fleet of piratical gunboats anchored there. Everyone on board was killed and the explosion still remains an unexplained mystery. Her commander on this occasion was Lieutenant-Commander Richard Somers who had entered the Navy as a midshipman in the frigate *United States* in July, 1798. In 1803 he was given command of the schooner *Nautilus*, 12 guns, to take part in the war with Tripoli, and was in command of that vessel when he volunteered for the service in which he was killed.

[315] JAMESTOWN.—Process print after W. A. K. Martin of the United States Sloop-of-War *Jamestown*. 22" x 17". Published by Gibbs & Company. Philadelphia, 1858.

The *Jamestown* was built at the Norfolk Navy Yard, under the supervision of United

Parthenia

[57]

Lithographs, Etchings, Woodcuts and Drawings

States Naval Constructor Foster Rhodes: Commenced June 13th, 1843; launched September 16th, 1844. 1150 tons, 163' 6" x 32' 2" x 17' 3" (hold). Original armament: 4 VIII-inch guns, 18 32-pounders. Armament May 5th, 1861: 6 5-cwt. VIII-guns, 14 42-cwt. 32-pounders.

During the Civil War the *Jamestown* was engaged in cruising for blockade runners and privateers. After the end of the war she was sent around to the Pacific and for some time was stationed at Sitka, Alaska. Later she was used as a training ship, and as the "Jimmytown" of the naval apprentices made several cruises to Europe during the early part of the present century.

[316] *JAPAN.*—Lithograph of steamship *Japan*. 18" x 34⅞". Inscribed: "Pacific Mail Steam Ship Co's. Steamer *Japan* ... Endicott & Co., lith., 59 Beekman St., N. Y. ... Pub. by L. R. Menger, 22 Dey St., N. Y. ... Entered ... 1868 ... by Louis R. Menger ... S. D., N. Y."

The steamship *Japan* was built at Brooklyn, in 1867, by Henry Steers. 4351.72 tons (3897 tons, new measurement), 362' x 49' x 30.8'. Three decks. Three masts. Bark-rigged. Round stern. Plain stem. Engine by the Novelty Iron Works, of New York. Cylinder: 105" diameter. Piston stroke: 12'. Owner: Pacific Mail Steam Ship Company. Commander: Capt. George H. Bradbury, formerly of the extreme clipper ship *David Brown*.

With her sister ships, *America*, *China* and *Great Republic*, the *Japan* completed the quartet of the largest paddle steamers ever built in the United States. She was designed for the transpacific passenger trade and soon established a record of 21 days from San Francisco to Yokohama, and 7 days thence to Hong Kong, both of which records stood for many years. In 1878 she was sold to Russian Pacific interests, but being handled none too carefully by her new owners, did not last long.

[317] *JEANNETTE.*—Colored lithograph of the steam screw yacht *Jeannette*, by C. R. Parsons. 17⅛" x 25¾". Published by Currier & Ives, 1881. H. T. P. 1445.

The *Jeannette* was built at Pembroke, England, as the *Pandora*, by the British Admiralty. 465 tons (243.81 tons, new measurement), 146' x 25' 8" x 12' 8". Three masts. Bark-rigged. Engines by Day, Summers & Company, Southampton, England. Two cylinders: 32" diameter. Piston stroke: 18.2". Two boilers of 40 horse power each. Owner: James G. Bennett, of New York. Commander: Lt. George W. De Long, U. S. N.

Bennett purchased the *Pandora* in 1879 from Sir Allen Young, who had bought her from the Admiralty and used her on a couple of trips to the Arctic. She was thoroughly refitted by Bennett and strengthened for Arctic exploration work and renamed the *Jeannette*, and sent out on the ill-fated expedition which bears that name. A theory had been developed that there was a drift of polar ice above Behring Straits in a northeasterly direction toward the North Pole and De Long was selected to test this theory in the *Jeannette*. In 1879, therefore, the expedition of 33 men set out around Cape Horn to San Francisco and proceeded thence through Behring Straits the latter part of August, in that same year. De Long pushed on until stopped by the ice to the northeast of Wrangel Land. There he was frozen in according to

the preconceived plan and there he remained with very little change in position for nearly twenty-two months. On the 12th of June, 1881, the *Jeannette* was crushed in the ice, sinking the following day. All the members of the party got safely on the ice and started with dog sleds and three boats which they dragged over the ice, for the mouth of the Lena River, several hundred miles to the southwest. The party suffered great hardships but kept together until the three boats were separated by a storm on the 12th of the following September. The second cutter with seven men was never heard from, but the whaleboat with eleven men reached the Lena delta on September 16th and had the good fortune to find a village almost at once where they were well cared for. De Long in the first cutter with fourteen men reached land the following day but there was no village at the location shown on his map, and after as extended a search as the condition of his men, many of whom were almost completely disabled, permitted, he was forced to establish a permanent camp. Here his men died one by one, De Long apparently being the last to succumb. The last entry in his diary was dated Sunday, October 30th, 140 days after leaving the *Jeannette*. The story of the expedition is preserved in several books and articles written by the survivors, and in the minutes of the Court of Inquiry held later in Washington and published in book form.

[318] *JOHN TRUCKS*.—Lithograph of the ship *John Trucks*, of Philadelphia. 18¼" x 24½".

The *John Trucks* was built at Philadelphia, in 1856, by William Cramp. 767.49 tons, 156' x 32' 7" x 16' 3". Two decks. Elliptic stern. Billet-head. Owners: Henry Simons, Stilwell S. Bishop, John Trucks, Edward C. Knight, Thomas H. Moore and Joseph Campion, of Philadelphia. Commander: Capt. Isaiah Sherman, late of the clipper ship *Stilwell S. Bishop*, of Philadelphia.

Following Capt. Sherman, the *John Trucks* was commanded by James F. Lindsay, also late commander of the *Stilwell S. Bishop*. The *Trucks* was a handsome ship similar in design to, but larger than the *Bishop*, which had already established a reputation for speed. During her existence the *Trucks* was changed to a bark rig and later was rerigged as a ship. She was sold to New York, in 1868, and her name does not appear in the register of 1869.

[319] *JUPITER*.—Tinted lithograph of steamer *Jupiter*. 20" x 32½". Published by Endicott & Company.

The sidewheel steamer *Jupiter* was built at Glasgow, in 1855. 276 tons, 185' x 18' x 8'. One deck. Two masts. Schooner-rigged. Sharp built.

Captured as a blockade runner, she was condemned and sold at New York City. In 1869 she was running out of Philadelphia, under Capt. Syms, in the coastwise trade. The *Jupiter* was typical of a large class of long, narrow and very fast steamers built in Great Britain and used as blockade runners during the Civil War.

[320] *KANAWHA*.—Lithograph of the United States Steam Gunboat *Kanawha*. 16⅞" x 26⅛". Inscribed: "Lith. by Shearman & Hart, 99 Fulton St., N. Y. Registered according

Quaker City

[355]

to Act of Congress in the year 1861, in the Clerks Office, of the District Court of the U. S., for the Southern District of New York."

The *Kanawha* was built at East Haddam, Connecticut, in 1861, by G. E. & W. H. Goodspeed. 575 tons, 176′ 6″ deck: 158′ keel x 28′ 1″ x 12′. Engines by the Pacific Works: two back acting horizontal engines. Cylinders: 30″ diameter. Piston stroke: 18″. Diameter of propeller: 9′. Armament: 4 guns.

One of the "Ninety Day Gunboats," of which twenty-three were built in various Northern ship yards in the autumn of 1861, the *Kanawha* rendered valuable but undistinguished service on the Southern blockade throughout the Civil War. She was sold out of the service in 1866.

[321] *KEARSARGE*.—Colored lithograph after Lebreton of United States Steam Sloop-of-War *Kearsarge*. 13½″ x 20″. Printed in France and published by W. Schauss, New York City.

The *Kearsarge* was built in the Navy Yard at Kittery, Maine, in 1861. 1461 tons, displacement 1031 tons, 198′ 9″ x 33′ 10″. Bark-rigged. Machinery by Woodruff & Beach, Hartford, Connecticut. Cost: $286,918.05. Armament: 2 XI-inch Dahlgren smooth bores; 1 30-pounder pivot rifle; 4 32-pounders. Complement: 22 officers and 163 men.

Shortly after the opening of the Civil War the *Kearsarge* was laid down at the Kittery Navy Yard. To save time she was made a virtual duplicate of the *Mohican*, a fairly satisfactory screw sloop-of-war built at the same yard in 1858. Commander C. W. Pickering was assigned to the *Kearsarge* and in January, 1862, was ordered to Cadiz in pursuit of the Confederate cruiser *Sumter*. It was not until January of the following year, however, that the *Kearsarge*, with the help of the *Tuscarora* and the clipper cruiser *Ano* succeeded in bottling up the *Sumter* at Gibraltar. Finding he was unable to escape, Capt. Semmes left the *Sumter* and later went to England and took command of the *Alabama*. Meanwhile Capt. John A. Winslow had been placed in command of the *Kearsarge*, the transfer having been made on the 8th of April, 1863, and when the reports of the destruction caused by the *Alabama* began to come in, he cruised in search of her. It was not until June, 1864, after the *Alabama* had been at sea for a year, that the two ships finally met off the coast of France. The story of their Sunday morning fight off Boulogne on the 19th of June, 1864, which resulted in the sinking of the *Alabama*, is one of the classics of naval warfare. An excellent account of it is to be found in Frederic Stanhope Hills "Twenty-six Historic Ships," and several interesting stories of the battle have been published by officers and men on both ships. After the war the *Kearsarge* was thoroughly repaired and for some years was attached to the North Atlantic and European squadrons. Lieutenant-Commander George Dewey was her executive officer on the European station in 1866. In 1868 she was sent out to the Pacific, remaining there nearly ten years after which she was again attached to the North Atlantic fleet. Capt. Winslow, her best-known commander, was made a rear-admiral in 1870. Another of her commanders was Capt. Charles D. Sigsbee, who had her in 1885-6. She was lost on Roncador Reef in the Gulf of Mexico on the 10th of February, 1894, while under the command of Commander Oscar F. Hyerman.

[322] *LAFAYETTE.*—Colored lithograph by Endicott & Company of iron paddle wheel steamship *Lafayette*. 17" x 33¾".

The *Lafayette* was built at Greenock, Scotland, in 1864, by Scott & Company, 1923 tons, 18' draft. Three decks. Two masts. Brig-rigged. Two side lever engines. Two cylinders: 94" diameter. Piston stroke: 8' 8". Two propellers. Owner: Compagnie Generale Transatlantique S. S. Commander: Capt. Rosson. She was burned in 1871.

[323] *LA TERREUR D'ALBION.*—Colored engraving of the armed raft *La Terreur d'Albion*. 12" x 17". Published by R. Lawrie & J. Whittle, No. 53, Fleet Street, London, 1798. Inscribed: "An Accurate and Perspective *View* of the *Raft* called, The *Dread of Albion:* as building at Calais, January, 1798."

[324] Colored engraving of the same. 12¾" x 9½". Inscribed: "A Correct Plan and Elevation of the *Famous French Raft*, constructed on purpose for the Invasion of England and intended to carry 30,000 men, Ammunition, Stores, etc., etc." Published February, 1798, by S. Y. Fores (name indistinct), No. 50 Picadilly, Corner of Sackville Street, London.

The two prints which purport to depict a huge raft or float that the French were said to be preparing at Calais, early in 1798, for the invasion of England, are obviously the products of imagination run riot. The first print shows a huge cigar shaped structure covered, except as to the ends with a great rectangular "bomb proof" house or "Great Hall," defended by fifty-four great cannon. Near each end is a circular armored turret containing tread-mills operated by horses for driving four paddle wheels which are the means of propelling the raft. There are also cannon in the ends of the craft, fighting balconies along the sides of the house, oars "to be used in necessity," and other minor features. The second print shows a great rectangular raft 700 feet long and 600 feet wide surmounted by an armored cone 180 feet high and 180 feet across the base. The cone bears a lateen mast or yard 500 feet in length supporting two sails. Oars, each apparently several hundred feet in length, project from the sides. Although pretending to represent the same object, it is obvious that the two prints are not wholly unlike but wholly untrustworthy. They are interesting, primarily, as throwing light upon the character and quality of war rumors and their dissemination in the stirring days of the Napoleonic Era.

[325] *MANHATTAN.*—Colored lithograph of United States Monitor *Manhattan*. 10¾" x 25¾".

The *Manhattan*, a single turret monitor, was built at Jersey City, in 1861-2, by Secor & Company. 1034 tons, 224' x 43' 3" x 12'. Machinery by Joseph Colwell. Armament: two XV Dahlgren guns. Commander: Capt. G. W. A. Nicholson.

With her sister ships the *Manhattan* saw much service at various points along the Atlantic coast during the Civil War. The principal engagement in which she took part was the battle of Mobile Bay, on the morning of August 5th, 1864. She followed her sister ship, *Tecumseh*

in the line of battle, the *Tecumseh* being torpedoed a short distance ahead of her and sinking almost at once, carrying down most of her officers and crew.

Altogether there were nine monitors of the *Manhattan* class, a somewhat heavier type than that represented by the *Weehawken* (q.v.). Together with many of the other monitors, she was laid up at the League Island Navy Yard and was never put into active service again.

[326] *MANHATTAN and VERA CRUZ.*—Colored lithograph by Endicott & Company of steamships *Manhattan* and *Vera Cruz*.

The *Manhattan* was built at Brooklyn, in 1865, by Lawrence & Foulke. 1337.51 tons, 219' x 36' x 20.4'. Two decks. Two masts. Schooner-rigged. Round stern. Plain head. One beam engine. Cylinder: 60" diameter. Piston stroke: 11'. Owners: American and Mexican Mail Steam Ship Company of New York; Charles A. Whitney, President.

The *Vera Cruz* was a sister ship of the *Manhattan* built at the same time by Lawrence & Foulke. The ships were practically identical in every respect, the registered tonnage of the *Vera Cruz* being given as 1340.1 tons.

Both the above vessels were built expressly for the American and Mexican Mail Steam Ship Company, one of the numerous concerns formed at the close of the Civil War to engage in the Southern trade. This particular venture did not prosper for the *Manhattan* was sold within less than two years to George W. Quintard of New York, who placed her under the command of Capt. Charles Collins, and ran her in the New York and Charleston Steam Ship Company, which was organized by New York and New Orleans capitalists. In 1869 she was commanded by Capt. M. S. Woodhull, Charles S. Whitney then acting as New York agent for the vessel.

The *Vera Cruz* was first commanded by Capt. Hugh M. Gregory. Both vessels disappear from the registers at an early date, the *Vera Cruz* before 1869 and the *Manhattan* shortly thereafter.

During the seventies the name *Manhattan* was given to a new and larger iron screw steamship. There was also a large British propeller *Manhattan*, contemporary with the paddle steamer *Manhattan* here described.

[327] *MASSACHUSETTS.*—Lithograph by A. Marmet, after O. Davids, of the United States Steamship *Massachusetts*. 18⅞" x 25⅛". Published in Rio de Janeiro.

The *Massachusetts* was built in East Boston, by Samuel Hall, and launched the 21st of July, 1845. 750.73 tons, 161' 3" x 31' 8" x 20'. Two decks. Square stern. Billet-head. Three masts; ship-rigged. Auxiliary engine of 175 horse power designed to give a steaming speed of 9 miles an hour. Owners: Robert B. Forbes, John M. Forbes and John L. Gardner of Boston, and Edward King, of Newport, Rhode Island. Commander: Capt. Ambrose H. White.

It was the intention of her owners that the *Massachusetts* should be the pioneer steamer in the "Ocean Line of Steam Ships," to run between Boston and Liverpool, the fleet to consist of four steamers. In pursuance of this purpose she was "built on an improved model of our finest and fastest packets, and furnished with auxiliary steam power to enable her to

secure her passage" (to and from Liverpool) "in the most adverse season in 20 days and in ordinary weather in from 13 to 16 days." She was believed in Boston to be superior in model workmanship and design to any ship ever built in New England. Her total cost was about $70,000.00. She was fitted with Ericsson's new propeller, 9½ feet in diameter, rigged abaft the rudder in such manner that it could be unshipped in a few minutes and the vessel converted into an ordinary sailing ship. Her smoke pipe was made to telescope when not in use. She was heavily sparred, spreading as much canvas as any ship of her size. Perhaps the most important innovation she introduced was the new Forbes double topsail rig, *she being the first ship ever built to carry double topsails*. Owing primarily to her small size, she did not prove a financial success in the trade for which she was designed, and after the Mexican War broke out she was sold to the United States Government and sent to the coast of Mexico on transport duty.

When gold was discovered in California she was one of the first ships to sail for San Francisco, late in 1848 carrying a regiment of soldiers for guard duty.

Returning to the Atlantic, she was dismasted in a hurricane on September 22nd, 1854, when about 70 miles northeast of Rio de Janeiro. Later she was converted into a sailing vessel with a bark rig.

When the Civil War ended she was sold in 1866, having been renamed the *Farralones*.

[328] *MERRIMAC*.—Colored woodcut of the United States Steam Frigate *Merrimac*. 9½" x 13¼".

[329] The same; colored lithograph by Currier & Ives of the Confederate Ironclad Ship *Merrimac*. 8.3" x 12.10". After F. Newman of Norfolk, Virginia, 1862. H. T. P. 1140. Starboard view engaging the *Monitor*.

[330] The same; colored lithograph by Shearman and Hart. 13¼" x 19¾".

The *Merrimac* was built in the United States Navy Yard at Boston, in 1855. 4636 tons, displacement 3200 tons, register 256' 9" x 51' 4". Three decks. Three masts. Ship-rigged. Machinery by R. P. Parrot, of Cold Spring, New York. Two cylinders: 72" diameter. Piston stroke: 36". Steam speed: 8.87 knots in smooth water.

When launched the *Merrimac* and her four sister ships, the *Wabash*, *Minnesota*, *Roanoke* and *Colorado* were regarded as the most powerful frigates in the world. The *Merrimac* was slightly smaller than the other four, but otherwise they were quite similar. The *Merrimac* sailed on her trial trip February 25th, 1856, and soon after went to Europe, visiting Southampton, Brest, Toulon, Lisbon and other ports where she was regarded as the handsomest frigate ever seen. She was the envy of all navies, which immediately started to build similar ships. In October, 1857, she sailed from Boston for the Pacific as the flagship of Capt. Long. She returned to Norfolk February 6th, 1860. When the Civil War started the Norfolk Navy Yard was abandoned by the Union forces and the *Merrimac* was set on fire and scuttled. She was raised by the Confederates, rebuilt to the berth deck and converted into an ironclad. A casement the width of the hull and 172 feet long was built in the central part

Resolute

[61]

of the ship with sides sloping at an angle of 45°. It was 7 feet in height and constructed of 20 inches of hard pine covered by 4 inches of oak and two layers of iron plate each 2 inches thick. A huge iron beak was placed on the bow two feet below the water line. The armament consisted of two VII-inch Brooke rifles, one at each end, and six IX-inch Dahlgrens and two 32-pounder Brooke rifles for broadside guns. Thus rebuilt, the vessel was named the *Virginia* and placed under the command of Capt. Tatnall, whose first lieutenant was Catesby Ap R. Jones. Capt. Tatnall becoming ill he was succeeded by Capt. Franklin Buchanan. A crew of 320 men, mostly volunteers from the army was gathered, and when all was ready, she went out from Norfolk at 11 o'clock on the morning of March 8th, 1862. The story of her success in sinking the frigate *Cumberland* and forcing the surrender of the frigate *Congress* and her defeat the following day by the *Monitor* is, of course, familiar to everyone. When the Union forces took Norfolk on the 10th of the following month, the *Merrimac* was blown up by the Confederates, completing the destruction the *Monitor* had begun.

The *Monitor* was built at Greenpoint, Long Island, in the shipyard of Thomas F. Rowland, the keel being laid October 25th, 1861, and the vessel launched January 30th, 1862. 1245 tons displacement, 174' x 41' x 11' 6". Draft 10'. Armament: Two XI-inch smoothbore Dahlgren guns in a turret 20 feet in diameter of iron plates 9 inches thick. Commander: Lieutenant John L. Warden. Chief Engineer: Alban C. Stimers.

The *Monitor* with her crew of forty-three men left New York March 6th, 1862, in tow, bound for Hampton Roads. A storm came up and increased so much by the seventh that if it had not ceased on the eighth the *Monitor* would inevitably have foundered. As she passed in by Cape Henry on the afternoon of the eighth the men could hear the sound of the *Merrimac's* guns destroying the Federal ships at the Roads. The following morning she engaged the *Merrimac* forcing her to withdraw so badly damaged that she was compelled to go into dry dock and was never again fit to engage in battle. On December 29th, 1862, the *Monitor* sailed for Beaufort, North Carolina, under command of Commander John P. Bankhead, in tow of the steamer *Rhode Island*. Two days later she foundered at sea in moderate weather carrying down with her four officers and nine men as well as eight men of *Rhode Island* who were taking off the crew.

[331] *MISSOURI.*—Colored lithograph by Day & Hague after E. Duncan of the United States Sidewheel Steam Frigate *Missouri*. 11¾" x 15⅞". Port view in distance, H.B.M. Ship *Malabar* in the foreground. Published by Ackerman, London. Inscribed: "The Explosion of the U. S. Steam Frigate *Missouri*, at Gibraltar, Aug. 26th, 1843."

[332] Companion to the above print showing the burning of the ship following the explosion. Starboard view, in flames. 11¾" x 15⅞".

The frigate *Missouri* was built in New York, at the United States Navy Yard, in 1839. 3220 tons, displacement; 1700 tons, register, 229' x 40'. Three masts. Bark-rigged. Machinery by the West Point Foundry Association, New York. Armament: two X-inch and eight VIII-inch guns.

As the fifth steam man-of-war in the United States Navy, the *Missouri* was regarded

by many as the most effective fighting machine afloat when completed. Her weakness was in her exposed paddle wheels of flimsy material which could quickly be shot away in a close conflict—a weakness which was later remedied in the steam screw frigate *Princeton* which had all its propelling machinery below the water line. The *Missouri* was totally destroyed by fire while lying at anchor off Gibraltar, on August 6th, 1843, having been set on fire when an engineer's yeoman accidentally broke a demijohn of turpentine in the store-room. In the court martial which followed the Commander, Capt. J. T. Morton, and the chief engineer were suspended from the service for two years and one year, respectively.

[333] *MONADNOCK*.—Colored lithograph by Endicott & Company of the United States Monitor *Monadnock*. 11¾" x 24½".

The *Monadnock*, a wooden double turret, "turtleback" monitor, was built in 1862, at the Boston Navy Yard. 3295 tons, displacement, 1564 tons, register, 259' x 52' 6". Machinery by Morris, Towne & Company, Philadelphia. Twin screws. Cost: $981,439.45. Armament: 4 XV-inch shell guns.

The *Monadnock* belongs to the class of heavier and more powerful monitors which followed the *Weekhawken* (q.v.) type, but she does not appear to have participated in any major engagements during the remainder of the Civil War. After the war she was laid up for many years at the League Island Navy Yard where, in the course of time, she was completely rebuilt coming out eventually as the *Monadnock II*.

When the development of modern armor piercing guns made ships of her type obsolete for coast defense, she was scrapped.

[334] *MONONGAHELA*.—Colored drawing of United States Steam Sloop-of-War *Monongahela*. 16⅞" x 24⅜".

The *Monongahela*, a steam screw sloop, was built in 1861, at the United States Navy Yard in Kittery, Maine. 2078 tons, displacement, 1387 tons, register, 225' x 37' 9". Ship-rigged. Engines by Merrick & Sons, Philadelphia. Armament: 2 XI-inch smoothbores; 5 32-pounders; 1 150-pounder, rifled.

The most important service seen by the *Monongahela* was in Southern waters under Farragut. She was second in line in the attack on Port Hudson in the Mississippi on the 14th of March, 1863, on which occasion the old paddle wheel frigate *Mississippi* which followed her was destroyed. She also took part in the battle of Mobile Bay on August 5th, 1846, under the command of Commander James H. Strong, after which she assisted in the capture of the powerful Confederate ram *Tennessee*. The *Monongahela* was one of ten Sloops-of-War, similar to the *Kearsarge*, but much larger, all of which were built late in 1861. By 1896 she was the only ship of her class left in the Navy. About that time her engines were removed and for some years she was used as a training ship for Naval Apprentices on the Newport station.

[335] *MONTANA*.—Colored lithograph of Pacific Mail Steamship *Montana*. 17½" x 34¾".

Red Jacket

[60]

The paddle wheel steamship *Montana* was built at New York, by William H. Webb, in 1866. 2676.82 tons, 318′ x 42.5′ x 27′. Three decks (also reported four decks). Two masts. Brig-rigged. Three bulkheads. One vertical beam engine. Cylinder: 105″ diameter. Piston stroke: 12′. Owner: The Pacific Mail Steam Ship Company. Commander. Capt. George H. Bradbury. Designed for and operated in the coastwise trade out of San Francisco.

[336] *MORNING STAR*.—Colored lithograph by Endicott & Company of the Missionary packet brig *Morning Star*, of Boston. 14⅜″ x 19⅞″. Under sail leaving port.

The *Morning Star* was built at Boston, in 1866, by Curtis, Smith & Company. 172.44 tons, 94.6′ x 26′ x 9.1′. One deck. Elliptical stern. Figure-head. Owner: American Board of Commissioners for Foreign Missions; Langdon S. Ward, Treasurer. Commander: Rev. Hiram Bingham.

The print shows the second of a series of five *Morning Stars* which were built or purchased for the American Boards' missionary work in the Pacific, the list including three brigantines, a barkentine and a steamer. The cost of these vessels was largely contributed by the children of American Sunday Schools. Capt. Bingham took the *Morning Star* out to Honolulu on her first voyage around Cape Horn in 122 days, arriving at his destination early in 1867. The vessel was lost March 8th, 1869, leaving the port of Kusaie, and a third and slightly larger *Morning Star* was immediately built to take her place.

[337] *MORRO CASTLE*.—Lithograph of American paddle Steamship *Morro Castle*. 17¼″ x 32¼″. Starboard view under steam entering Havana harbor. Inscribed: "Endicott & Co., Lith., 59 Beekman St., N. Y.... Wm. Minns & Co., 159 Pearl St., N. Y.... Steamship *Morro Castle*, R. Adams, Commander. Built for Spofford Tileston & Co., 1864."

The *Morro Castle* was built at New York, in 1864, by J. A. & Daniel D. Westervelt. 1680.96 tons, 262.2′ x 40′ x 23.1′. Two decks. Two masts. Brig-rigged. Round stern, no figure-head. One cylinder: 70″ diameter. Piston stroke: 12′. Owner: Paul Spofford of New York. Commander: Capt. Richard Adams.

Originally designed to run in Spofford & Tilestons' Line of steamships as a mail steamer to Havana, the *Morro Castle* was sold late in 1866 to the West India Mail Steamship Company (Mortimer Ward, secretary) when the firm of Spofford & Tileston was dissolved by the death of Thomas Tileston. In addition to the *Morro Castle*, the new firm also operated the steamships *Columbia* and *Eagle* on the southern routes. Thereafter the *Morro Castle* passed rapidly from one owner to another. Early in 1869 she was sold to the Atlantic Mail Steam Ship Company of which Samuel G. Wheeler was president. Capt. Adams still retaining command. In 1873 she was purchased by Edward A. Price of New York. Later in the same year she was passed to Frederick Butterfield of New York, who placed her under the command of Capt. Thomas H. Menton.

In 1879, the New York and Havana Steam Ship Company owned her, Capt. Edward G. Reed then being in command. William P. Clyde of Brooklyn and Thomas Clyde of Philadelphia, bought her in 1881 and, as she was considered a fast and able boat of good model, they rebuilt her as a screw steamship. Thus rejuvenated, she was put into the Clyde

Line on the run between New York and Charleston, South Carolina, proceeding occasionally to Havana. She was destroyed by fire at her wharf in Charleston, in 1883.

[338] *MOSES TAYLOR*.—Colored lithograph by Endicott & Company of paddle Steamship, *Moses Taylor*. 17⅞" x 32". Published by L. R. Menger, New York, for M. L. Roberts.

The steamship *Moses Taylor* was built at New York, in 1855, by William H. Webb. 1372 tons, 244' x 34' x 20' 5". Draft: 13'. Two decks. Two masts, Brig-rigged. Five bulkheads. Two beam engines. Two cylinders: 50" diameter. Piston stroke: 10'. Owner: Marshall A. Roberts, of New York. Commander: Capt. John McGowan.

After running for a time in the United States Mail Steam Ship Company line, part of the time under the command of Capt. Alfred G. Gray, the *Moses Taylor* passed in 1860 into the hands of Cornelius Vanderbilt who operated her in his California & New York, United States Mail Steam Ship Company. After the Civil War she was sold and her registry transferred to San Francisco. In 1869 she was running on the Pacific, commanded by Capt. J. H. Blethen.

[339] *NESHANNOCK*.—Lithograph of the wooden screw steamship *Neshannock*. 17" x 31⅞". Starboard view at sea under steam and sail. Inscribed: "Endicott & Co., Lith., 59 Beekman St., N. Y. . . . Steamship *Neshannock* of Philadelphia. Jas. H. Winchester, Commander. E. A. Sander & Company, owners." (Dimensions flank each side of the title.)

The *Neshannock* was built at Philadelphia, in 1865, by John W. Lynn. 1443.89 tons, 215.5' x 37.6' x 16.6'. Three decks. Two masts. Brig-rigged. Round stern. Eagle head. Vertical direct acting engine by Neafe & Phinney, of Philadelphia. Cylinder: 55" diameter. Piston stroke: 50". Owners: Edward G. Lowder, Stephen T. Lowder and Archibald Getty. Copartners: John W. Lynn and Charles Knecht of Philadelphia. Commander: Capt. James H. Winchester, of Brooklyn, who also owned a sixteenth in the vessel.

E. G. Lowden & Company managed the *Neshannock* during her entire existence, running her between Philadelphia and Southern ports. She foundered at sea.

[340] *NEW IRONSIDES*.—Colored lithograph of the United States Ironclad Steamship *New Ironsides*. 13½" x 20½". Shown attacking Fort Sumter. Published by H. Rease, Philadelphia. 1863.

The *New Ironsides* was built at Philadelphia, in 1861-2, by William Cramp, of wood with iron side armor, under a subcontract from Merrick & Sons of Philadelphia. 4120 tons, displacement, 3486 tons, register, 232' x 57.6' x 23'. Machinery by Merrick & Sons, developing a maximum speed of eight knots in smooth water. Armored on the sides with 4½" iron plates and 1" iron over the spar deck. Armament: 14 XI-inch Dahlgren smooth bores; 2 150-pounder Parrott rifles; 2 50-pounder Dahlgren rifles.

When the *Ironsides* was completed in the autumn of 1862 she was sent to Newport News under command of Commodore Thomas Turner, and in January, 1863, was sent on to the

The Royal Sovereign

[159]

Lithographs, Etchings, Woodcuts and Drawings

assistance of the fleet under Admiral Dupont which was blockading Charleston and which had been seriously threatened by the Confederate rams *Chicora* and *Palmetto State*. When Forts Sumter and Moultrie were attacked on the 7th of April, Admiral Dupont used her as his flagship, having decided that the attack should be made by the ironclads only. These were all monitors with the exception of the *New Ironsides*, the *Weehawken* (q.v.) being among the number. A fleet of fine wooden ships consisting of the *Wissahickon* (q.v.), *Canandaigna*, *Housatonic*, *Huron* and *Unadilla* was held in reserve to support the attack. The fleet was met by a heavy fire and several of the monitors sustained considerable damage, although the *New Ironsides* was practically untouched. After an engagement of one hour and forty minutes, Dupont withdrew and decided not to go in again. Subsequently Dupont was relieved by Admiral Dahlgren who used the ironclads in connection with land forces and eventually reduced the city, although not without great difficulty. The *New Ironsides* played an important part in silencing Fort Fisher in the attacks of December 24th, 1864, and January 13th, 1865, she then being under the command of Commodore William Radford. Admiral Porter was of the opinion that the work of the *Ironsides* was more effective than that of any of the other forty-four ships in the attacking squadron. On the 17th of January, after the successful termination of the Cape Fear River operations, the *Ironsides* was ordered back to Norfolk. Early in the following autumn she was sent to Philadelphia and laid up at the League Island Navy Yard in company with a fleet of the old monitors. She was totally destroyed by fire of accidental origin, on December 16th, 1865.

[341] *NIAGARA*.—Lithograph by Vincent Brooks, after Josiah Taylor, of the United States Steam Frigate *Niagara*. 17⅛" x 33½". Shown with the United States Steam Frigate *Susquehanna* and H. B. M. Ships *Leopard* and *Agamemnon* laying the first American transatlantic cable in 1857. Published by W. Foster, London, 1857.

The *Niagara* was built at the New York Navy Yard in 1854-7. 5540 tons, displacement, 4580 tons, register, 328' 10½" x 55'. Machinery by Pease & Murphy, of New York. Total cost: $1,057,210.14.

When completed, the *Niagara* was the largest, fastest and most powerful steam warship in the United States Navy, if not in the world. She was designed especially for speed and Henry Steers who had modeled and built several fast ocean steamships was consulted with reference to her lines and equipment. In proportion to her size she was given about fifty per cent more power than was the usual practice at the time, and she developed a steaming speed of 10.9 knots in smooth water. She was placed in commission in the Spring of 1857 and was first sent to England to assist in laying the Atlantic cable, under the command of Capt. Hudson. Half the cable was placed in the *Niagara* and half in the *Agamemnon* the two ships and their consorts leaving Valencia, Ireland, August 7th, 1857. The cable broke after a considerable part of it had been laid and the attempt was abandoned until the following year. In 1858 the ships met in mid-ocean and each started home from there and the cable was laid successfully. After two weeks it failed, due to defective insulation and was not replaced until 1866 when a new more effectively insulated cable was laid by the *Great Eastern*. The next service of the *Niagara* was to return nearly 300 slaves, captured in the slaver *Echo*, to Africa.

102 *The Marine Collection at India House*

In 1860 she carried the Japanese embassy back to Japan returning in 1861. Owing to her great size she was thought to be impractical for operations on the Atlantic coast in the Civil War, and was sent to Europe on special service. In August, 1864, she captured the Confederate privateer *Georgia*. After the end of the war she returned to Boston where she was laid up until 1885, when she was sold to be broken up.

The paddle wheel Steam Frigate *Susquehanna* also shown in the print, was built at the Philadelphia Navy Yard in 1847-50, after the design of Naval Constructor Denthall. 3824 tons, displacement, 2450 tons, register, 250' x 45'. Three masts. Bark-rigged. Total cost: $697,215.00. Armament: 23 guns, originally. Changed during the Civil War to 15 VIII-inch shell guns, and later in the war to 2 150-pounders, rifled, and 12 VIII-shell guns.

The *Susquehanna* was regarded as a sister ship to the *Powaton*, designed by Naval Constructor Grice, the two vessels being similar in dimensions, model and armament. In accordance with the recommendation of the Secretary of the Navy during the Mexican War, Congress passed an Act, March 3rd, 1847, authorizing the construction of four steam frigates to cost half a million dollars each. The same act authorized the Secretary of the Navy to contract with Capt. Edward K. Collins and his associates for the transportation of the mails to Liverpool on condition they would build four steamships suitable for conversion into warships, the steamers to be about the same size as the *Susquehanna*. The famous but ill fated Collins line was a direct result of this legislation. The act also gave the Secretary authority to make similar contracts for a line to carry the mails between New York, Havana and New Orleans and a third to transport mails from Panama to Oregon Territory, resulting eventually in the formation of the Law Line and the Pacific Mail Steam Ship Company. The *Susquehanna* was launched in April, 1850. She was sent to the Asiatic station in 1851 under the command of Capt. Aulick. Returning, she took part in the laying of the first Atlantic cables. During the Civil War she assisted in several major operations, the most important being the reduction of Hatteras Inlet on August 27th and 28th, 1861, and the capture of Port Royal on the 7th of November, following. At this time she was commanded by Capt. A. J. Lardner.

When the war ended she was laid up in ordinary at the New York Navy Yard, being finally sold and broken up. See No. 52.

[342] *NORTH CAROLINA*.—Colored lithograph by Ensign & Thayer of the United States Line-of-Battle-Ship *North Carolina*. 8⅞" x 12⅝". Published by Ridges & Comstock, New York.

The *North Carolina*, 74, was built at the Philadelphia Navy Yard, under the supervision of United States Naval Constructor, Samuel Humphreys, her keel being laid in 1818, and the launching taking place September 7th, 1820. 2633 tons, 196' 3" x 53' x 22' (hold). Armament: 12 VIII-inch guns, 72 32-pounders.

Like her sister ships, laid down about the same time, the *Vermont*, *New Hampshire* and *Ohio*, the *North Carolina* was rated as a 74, although fully equal to the 84's of her time.

When the Civil War broke out the *North Carolina* was, of course, obsolete, and took no active part in naval operations. She was sold and broken up in 1867.

Lithographs, Etchings, Woodcuts and Drawings

[343] *NYACK*.—Colored lithograph by Endicott & Company of the United States Screw Sloop-of-War *Nyack*. 15¾" x 29¾".

The *Nyack* was built at the Brooklyn Navy Yard, by B. F. Delano, in 1862-3. 410 tons, 179' x 29' 4" x 12' 3". Three masts. Ship-rigged. Single cylinder, direct acting engines, by D. McLeod. Armament: 3 guns. Classed as a fourth rater.

There were eight vessels of the *Nyack* class built in all. They were about one hundred tons larger than the "ninety day gunboats" and proved to be useful ships on blockade duty.

The *Nyack* was attached to the North Atlantic Squadron under Lieutenant Commander L. H. Newman, and among other engagements, was present at the reduction of Wilmington, N. C., in 1864. After rendering sundry services following the close of the war, she was laid up, and is on the Navy lists as being in ordinary at the Mare Island Navy Yard during the late seventies.

[344] *OCEAN EXPRESS*.—Lithograph of the medium clipper ship *Ocean Express*. 16.3" x 24.4". View leaving New York. Inscribed: "Clipper Ship *Ocean Express* . . . Outward bound, discharging the Pilot. . . . Sketched by J. Smith & Son, Brooklyn, L. I. . . . On Stone by C. Parsons. . . . N. Currier, 1856." H. T. P. 1224.

The *Ocean Express* was built at Medford, Massachusetts, by James O. Curtis and launched July 10th, 1854. 1937.39 tons (1495.22 tons, new measurement), 228' 6" x 42' 7" x 24' 6". Two decks. Round stern. Billet-head. Owners: Reuben S. Wade and Samuel G. Reed, of Boston. Commander: Capt. Thomas Cunningham.

Of easy medium clipper lines, the *Ocean Express* was, nevertheless heavily sparred and presented a very handsome appearance. She is popularly described as having a gilded eagle figure-head, but the official descriptions agree in crediting her with a billet-head. Capt. Levi J. Hotchkiss succeeded to the command in 1858. He was followed, successively, by Capt. G. H. Willis and Edward R. Warsaw, and, finally, by Leonard W. Horton, who had her when she was sold in 1871 to Peruvian owners. In 1876 she was again sold to go under the German colors, and later was registered under the Norwegian flag. She was abandoned in a sinking condition in the North Atlantic in 1890. While a good sailer and a popular cargo carrier she made no notable records, and her career under American ownership was marked with mishaps which proved quite costly to the underwriters.

[345] *OCEAN MONARCH*.—Colored lithograph by N. Currier of packet ship *Ocean Monarch*. 7.8" x 12.8". Inscribed: "Burning of the '*Ocean Monarch*' of Boston in the English Channel, Aug. 24, 1848. . . . N. Currier, 1848." H.T.P. 1225.

The *Ocean Monarch* was built at East Boston, by Donald McKay, and launched June 12th, 1847. 1301.5 tons, 178' 6" x 40' x 25' 10". Three decks. Square stern. Figure-head. Owners: Enoch Train & Frederick W. Thayer, copartners; Robert G. Shaw, G. Howland Shaw, Robert G. Shaw, Jr., William Appleton, Samuel Hooper and Abbott Lawrence, of Boston. Commander: Capt. James Murdock.

When the *Ocean Monarch* was launched she was described as "one of the finest and largest ships ever built in the United States." She was put at once into Trains' "White Dia-

mond Line" of Liverpool packets and was on her fourth voyage when the disaster, above referred to, occurred. It was stated that she left Liverpool on the 24th of August, 1848, (but see Captain's letter published in the New York Herald for September 10th, which gives the date as the 21st), and was about six miles off Orme's Head in the Irish (not English) Channel, when first was discovered. The ship was at once headed for the land and every attempt made to subdue the flames, but the fire spread with great rapidity and the ship was totally destroyed. Passing vessels including the packet *New World* hastened to her assistance but in spite of every exertion and many acts of individual heroism, 178 lives were lost. 218 of the passengers and crew being saved. The value of ship and cargo was estimated to be $200,000.00.

A second and larger *Ocean Monarch* was built in 1856, at New York, by William H. Webb. She was 240 feet in length, measuring 2145.59 tons, and she was reported as clearing from New Orleans in 1858 with the largest cargo of cotton—6900 bales—that had ever been loaded at the Levee.

[346] *OHIO*.—Colored lithograph by J. C. Sharp of the United States Line-of-Battle-Ship, *Ohio*. 10¼" x 14¾".

The *Ohio*, 74, was built at the New York Navy Yard, under the supervision of her designer, United States Naval Constructor, Henry Eckford. Keel laid in 1817. Launched May 30th, 1820. Commissioned in 1830. 2757 tons, 197' x 22' 2" (hold). Original armament: 34 long 32-pounders, and 34 42-pounder carronades. Armament, January 1st, 1850: 12 VIII-inch guns, and 72 32-pounders.

When completed, the *Ohio* was regarded as the finest ship of the American Navy. She spread nearly two acres of canvas and carried a crew of 1000 men. Most of her active service was spent on the European station and in the Pacific, her best known commander being Commodore Isaac Hull who cruised with her to Europe in 1840. His second lieutenant at that time was the late Rear Admiral Samuel F. Dupont. As in the case of all the old ships-of-the-line, when the Civil War broke out, the *Ohio* was considered unsuitable for offensive warfare in competition with the more mobile steamships. After the war her armament was reduced to five guns and she served as a receiving ship at Boston for many years. She was eventually broken up.

[347] *ONONDAGA*.—Tinted lithograph by Endicott & Company of United States Iron Clad Battery *Onondaga*. 11¾" x 25¾".

The double turret monitor *Onondaga* was built at Greenpoint, Long Island, in 1862, by the Continental Iron Works, under the supervision of T. F. Rowland, for Mr. George W. Quintard of New York. 1250 tons, 228' x 50' x 13'. Machinery by the Morgan Iron Works, of New York. Cost: $759,673.08.

In a general way the *Onondaga* belonged to the *Monadnock* class of "Turtleback" disappearing turret monitors, although the fine ships of this class differed slightly from each other in dimensions and minor details.

The *Onondaga* was in service during the last eighteen months of the Civil War. After

Sovereign of the Seas

[68]

Lithographs, Etchings, Woodcuts and Drawings

the close of the war, Congress passed an Act releasing her to Mr. Quintard on the same day the ram *Dunderberg* (q.v.) was released to William H. Webb. Mr. Quintard sold her to the French Government and she was on the French navy list at the close of the last century.

[348] *OZARK*.—Colored lithograph of the United States gunboat *Ozark*. 13" x 25¾". Published by Endicott & Company.

The *Ozark* was built at St. Louis, Missouri, in 1862, by James B. Eads. 523 tons. Machinery by James B. Eads, driving a single stern wheel recessed in the hull of the vessel and protected by ¾" iron plate. Armament: 2 XI-inch smooth bores in a 6" armored turret. Cost: $207,071.50.

Eads, who had already distinguished himself in '61 by constructing seven "90 day gunboats" of the *Carondelet* class, built three gunboats of the *Ozark* class, the others being the *Neosha* and the *Osage*. Owing to the fact that their decks were protected from rifle fire by ¾" iron plates, they were popularly known as "tin clads." All three were very light draft and rendered excellent service in the work of keeping the Mississippi open. The *Ozark* under Lieutenant G. W. Browne was with Admiral Porter's fleet of eighteen gunboats in the operations on the Red River early in 1864 which had for their object the defeat of the French scheme to detach Texas from the Confederacy. The French, as is well known, had taken advantage of the difficulties of the United States to seize Mexico and hoped to set up Texas as an independent sovereignty, as a buffer state between Mexico and the United States. With her sister ships, the *Ozark* was sold shortly after the close of the war and dismantled.

[349] *PACIFIC*.—Lithograph of paddle steamship *Pacific*. 15⅝" x 23⅞". Port view hove to in a rough sea, a dismasted bark on her beam ends in the background. Inscribed: "S. Walters, Del. . . . T. G. Dutton, Lith. . . . Published, Nov. 14, 1853, by S. Walters, 97 Bold St., Liverpool and Ackerman & Co., 96 Strand, London. . . Day & Son, Lithographers. . . . United States Mail Steam Ship *Pacific*, Capt. F. Nye, rescuing the crew of the Barque *Jessie Stevens* by means of Francis Metallic Life Boat During a Heavy Gale, Dec. 1st, 1852, in Lat. 48, Long. 40. . . . To E. K. Collins, Esq., this print is most respectfully dedicated by his obedient servant Saml. Walters."

The *Pacific* was built at New York, in 1848-9, by Jacob Bell. 2707.10 tons, 281' x 45' x 32' 3". Three decks. Three masts. Bark-rigged. Round stern. Sea goddess figure-head. Machinery by Allaire & Company. Two side lever engines. Cylinders: 95" diameter. Piston stroke: 9'. Paddle wheels: 35' x 12' 6". Owner: New York & Liverpool, United States Mail Steamship Company, of New York (Collins Line). Commander: Capt. Ezra Nye, late of the Liverpool packet *Independence* and other Liverpool packet ships.

The first steamers of the Collins Line, the *Atlantic* and *Pacific* were launched on the afternoon of the same day, the *Atlantic* from William H. Brown's yard and the *Pacific* from Jacob Bell's yard. The two vessels were quite similar in appearance although designed by different builders and were nearly the same size, although the *Atlantic* was slightly larger and had a flatter floor than the *Pacific*. They were the largest and most strongly built wooden ships in the world, when launched, their frames being constructed of 21-inch oak timbers,

with other material in proportion. They were built to beat the world, and did, in fact, make somewhat better passages on the average than the Cunarders of their time, the *Pacific* actually breaking the ten year record to the eastward which had been held by the *Acadia*. This was in 1851, her average speed for the voyage being 13 knots. Both ships were equipped to carry 200 passengers and their cabin accommodations were up to the best standards of the day. Each had four tubular boilers designed to work on a pressure of 10 to 15 pounds of steam and to develop 800 horse power, according to the British method of computation. They carried 1000 tons of coal on a draft of 19' 6". They were at once the pride and wonder of New York and when they were launched the newspapers predicted the speedy recapture of foreign steamship traffic just as a few years before, America had captured the sailing packet business. Ezra Nye, who had been one of the hardest driving packet masters twenty years earlier, was succeeded after a few years by another "Cape Codder," Capt. Asa Eldridge, who had also made a reputation as the first commander of Seccomb & Taylors' huge clippers, *Red Jacket* (q.v.) and *King Lear*. Both Nye and Eldridge were very popular Commanders and the *Pacific* became a favorite ship with the travelling public during her brief existence. In January, 1856, she left Liverpool with Eldridge still in command and 186 people on board, determined to beat the *Persia*, which had just been put into service by the Cunard Line. She was never again seen. What happened will always be one of the mysteries of the sea, but the *Persia* collided with an iceberg and it has been presumed that the *Pacific* did the same with fatal results.

Note: There was another steamship *Pacific* of 1100 tons built for the New York-Havana-New Orleans trade about this time which proved very fast. In October, 1850, she ran from New York to Havana in 3 days and 22 hours, her best day's run being 360 miles, or 27 miles better than the best run then reported by her namesake of the Collins Line. As many conflicting statements regarding the speed of early ocean steamships are current, it is also worthy of remark that Capt. Stoddard of the *Crescent City* reported a day's run of 376 miles on August 20th, 1848, while proceeding from Havana towards New York.

[350] *PENNSYLVANIA*.—Colored lithograph by N. Currier of the United States Ship-of-the-Line *Pennsylvania*. 140 guns. 8¾" x 12¾". Dated, 1846. H.T.P. 1161.

[351] The same; process print, after W. A. K. Martin. 17" x 20½". Dated 1858. Published by Gibbs & Company.

[352] The same; lithograph. 10" x 15⅜".
Inscribed: "*View of the Launch of the U. S. Ship of War Pennsylvania*....From the Navy Yard at Philadelphia, July 18th, 1837. Philadelphia. Lithog & Published by Lehman & Duval. Geo. Lehman del. Entered according to Act of Congress in the year 1837, by Lehman & Duval in the Clerk's Office of the District Court of the Eastern District of Pennsylvania."

The *Pennsylvania* was built at the Philadelphia Navy Yard, and launched July 18th, 1837. 3241 tons, 210' x 58' 1½". Four decks. Round stern. Figure-head.

Sonora

[369]

When the *Pennsylvania* was launched it was said that she was the largest ship in the world. She was, in fact, the largest sailing ship ever built for the American Navy The height of her hull from the bottom of the keel to the top of the main rail was 54 feet 9 inches. Her main yard was 110 feet long. Although rated as a hundred and twenty gun ship, she actually mounted one hundred and forty guns. As she was too valuable a fighting unit to be subjected to unnecessary risks, most of her existence was passed at anchor in harbor, with occasional short cruises. She was burned to prevent her falling into the hands of the Confederates when Norfolk was abandoned in 1861.

[353] *PLANTER.*—Colored lithograph of armed paddle steamer *Planter*. 10¼" x 18¼".

The *Planter*, a small, antiquated vessel of small importance and less value, had the fortune to figure in one of those humorous incidents which served occasionally to relieve the grim tension of the Civil War. She had been impressed into the Confederate service at Charleston, South Carolina, and was engaged in transporting ordnance and army stores. On the morning of May 13th, 1862, her captain tied her up to the wharf at Charleston and went ashore, leaving her in charge of her negro pilot Robert Small, a slave of rather unusual intelligence. When the captain was out of sight, Small cast off from the wharf and with the Confederate flag flying, steamed down past the forts, saluting each of them with his whistle in the customary manner. After he had passed their line of fire, he hauled down the Confederate flag and ran up a white one just in time to avoid the fire of the Union blockading fleet. The *Planter* was armed with one 32-pounder pivot gun and one 24-pounder howitzer and, in addition, had on board four heavy guns, one a VII-inch rifle, intended for a new fort in Charleston Harbor. She brought off with her eight men, five women and three children. Small was able to give Admiral Dupont much valuable information about the Charleston defenses. He was taken into the service and served as a pilot on the Southern coast throughout the war. Afterwards he was a member of Congress from South Carolina for several sessions.

[354] *PORPOISE.*—Colored lithograph by J. Baillie and J. Sowle, New Bedford, of the United States Brig *Porpoise*. 8½" x 12¼".

The *Porpoise* was built at the Boston Navy Yard, under the supervision of United States Naval Constructor, Josiah Barker, and launched May 31st, 1836. 224 tons, 88' x 15' x 11'. Hermaphrodite rig. Armament: ten light guns.

In 1843 the *Porpoise*, commanded by Lieutenant Stellwagen, was attached to Capt. Matthew C. Perry's fleet and sent to the African coast to assist in the suppression of the slave trade.

During the Mexican War she formed part of the blockading fleet off the Mexican coast, being then commanded by Lieutenant Somers. Later she was attached to Commodore Perry's expedition to Japan as a tender, her armament on that occasion being reduced to one 24-pounder brass howitzer and two 12-pounder brass howitzers.

[355] *QUAKER CITY.*—Lithograph of paddle steamship *Quaker City*. 17" x 30⅜". Starboard view at sea under steam, approaching Charleston, South Carolina. Inscribed:

"Drawn by J. L. Giles & Co., New York ... Lith by Macay & Herwig, New York ... Steam-Ship *Quaker City* 1800 tons. Regular U. S. Mail Line Between New York and Charleston. W. H. West, Commander."

The *Quaker City* was built at Philadelphia, in 1854, by Vaughan & Lynn. (Also given Vaughn & Lynn.) 1428.60 tons, 234.4' x 35.7' x 17.5'. Two decks. Two masts. Schooner-rigged. Round stern. Scroll-head. Machinery by Merrick & Sons, Philadelphia. One side lever engine. Cylinder: 85". Piston stroke: 8'. Owner and Commander: Capt. Robert W. Shufeldt.

Although built for the express purpose of running between Philadelphia and Charleston, the *Quaker City* also made trips to Havana and the Gulf ports during the early part of her career. She was very well designed and strongly built and was always a popular vessel. In 1857 she was running out of New York in the American Steam Ship Company's coastwise line. The following year she was purchased by Samuel G. Reed of Roxbury, John Codman, of Dorchester, Edward M. Robinson, of New Bedford, M. P. Pierce and Albert A. Frazer, of Boston, and William I. Forbes of New York. They appear to have sold her almost immediately to Paul Hargous, of New York.

After the Collins Line had lost the *Pacific*, she was chartered for a voyage or two for the transatlantic service, and at the outbreak of the Civil War was taken up by the U. S. Navy as a man-of-war for blockading service. In the late sixties, she was chartered to the North American Lloyd Co., and in 1867 carried a large excursion party to the Mediterranean and Holy Land, one of the first examples of an ocean mail steamer being employed on a yachting cruise of the kind that has since become so popular. One of her passengers on this cruise was Mark Twain, and he wrote the greater part of "Innocents Abroad" on board her. In 1869, she was owned by John S. Innes, of New York.

[356] *QUEEN OF CLIPPERS*.—Colored lithograph by N. Currier of the clipper ship *Queen of Clippers*. 10" x 12½". Paintings of her are reproduced as Nos. 483, 713 and 714 in "Sailing Ships of New England."

The *Queen of Clippers* was built at East Boston, by Robert E. Jackson, and launched March 26th, 1853. 2360.58 tons, 248' 6" x 45' x 24'. Draft: 23'. Three decks. Semi-elliptical stern. Figure-head. Dead rise: 18". Sheer: 4'. Owners: Isaac Taylor and Edward R. Taylor of Boston. Commander: Capt. Reuben Snow.

The lines of the *Queen of Clippers* were slightly concave below and convex above the water. Her entrance was quite long and sharp and her run easy but her model was not the extreme clipper type. Her figure-head was a queen, and her stern, which had a semi-elliptical turn at the monkey rail, was particularly neat. Her cabin accommodation was the best of her day. She was not so heavily sparred as the other clippers of her class, nor as graceful to look at. Her fore and main masts were built sticks; the lower main mast was 92' long; the top mast 54'; the topgallant, 30'; the royal, 29'; the skysail mast, 14'. The corresponding yards were 90', 70', 53', 44', and 31' long.

Her original owners, Seccomb & Taylor of Boston, sold her soon after she was launched to Augustus Zerega, De. Grasse B. Fowler, Francis D. Fowler and James W. Bingham, of

Union

[667]

New York, for $135,000, and Capt. Reuben Snow, who was to have commanded her, relinquished the position to Capt. John Augustus Zerega, formerly of the packet ship *Arctic*. Her ability to make 18 to 20 knots under favorable conditions was not questioned by admirers, but she appears to have had an unfortunate record under American ownership. Her first voyage to San Francisco was made in the very fair time, considering the season of the year, of 118 days, but before she arrived back from San Francisco, in 1854, she had met with several costly misadventures.

She subsequently crossed to Liverpool from whence she went to the Mediterranean and during the Crimean War was used as a transport by the French Government. In 1856 she was reported as having been sold at Marseilles, on French account, the consideration being 150,000 francs. She was renamed *Reine des Clippers*, hailed from Marseilles, and was registered as owned by Aquarora & Company. Her name disappears from the registers shortly after 1860.

[357] *RACER*.—Colored lithograph of clipper packet ship *Racer* by N. Currier and C. Parsons. 22" x 27". Published by N. Currier, 1854.

The *Racer* was built at Newburyport, Massachusetts, by Currier & Townsend and launched June 18th, 1851. 1669 tons, 207' x 42' 6" x 28'. Three decks. Round stern. Racehorse figure-head. Dead rise: 10". Owners: Elisha E. Morgan, David Ogden, Francis B. Cutting. Commander: Capt. W. H. Steele.

Several so-called clippers had been built for the packet trade, but the *Racer* was said to be the first true clipper, designed expressly for the Liverpool run and although the *Typhoon* and *Staffordshire* built in the same year, were actually put into the service for a time. She was also the largest ship that had ever been built on the Merrimac up to that time. She was very strongly constructed, being 26 inches through the sides. She carried no skysails but her yards were very square. Her foremast was 84 feet in length and she spread 8152 yards of canvas in a single suit of sails. Her passenger accommodations were regarded as equal to the best. She had a deck house 47' x 18', containing cooking galleys, hospital, and icehouse, and her first cabin was richly finished in mahogany, rosewood and gilt. The ceiling was white, decorated with handsome mouldings and beads. The second cabin extended forward to the main mast and was grained to imitate oak. Her bow was ornamented with the gilded figure of a race-horse and her stern with a carved spread-eagle finished in gold. Altogether, she was adjudged to compare favorably in strength, design and finish with any craft afloat. Her cost was reported as over $120,000.00. When she went to Liverpool on her maiden voyage in the summer of 1851, the English papers had nothing but praise for her. The Illustrated London News for October 18th, 1851, printed a picture of her accompanied by a long description. Her reputation as a fast ship was soon established and it was not long before she offered a charter of £10,000 from London to Sydney and £8,000 for the return from Calcutta to London, one of the heaviest charters recorded up to that time. In 1852 she ran 394 miles in one day. On May 5th, 1856, she left Liverpool bound for New York with Capt. James Ainsworth in command. On the night of the 6th she struck on the Arklow Bank off the coast of Ireland, and, there being no prospect of her getting off, she was abandoned. The pas-

sengers and crew were returned to Liverpool and arrangements made to salvage the cargo. When the wreckers came to engage in this work, the ship was found to be in possession of a horde of people from the neighborhood who were so intent on plundering that it was necessary to fire on them before they would leave. The loss of the *Racer* left the *Dreadnought* as the only ship of the Red Cross Line.

The *Highflyer* had sailed from San Francisco for Hong Kong in 1855 and was never seen again. Others of the line which had already met their fate within a short time were the *St. George*, burned; the *St. Patrick*, wrecked; the *Andrew Foster*, sunk in a collision, and the *Driver* missing with all hands.

[358] RED JACKET.—Colored lithograph of clipper ship *Red Jacket*. 16.4" x 23.12". Inscribed: "Clipper Ship *Red Jacket*.... In the ice off Cape Horn, on her passage from Australia to Liverpool, August 1854 ... Drawn by J. B. Smith & Son, Brooklyn, L. I.... On stone by C. Parsons.... N. Currier, 1855." H.T.P. 1236. (See oil painting of same.)

[359] REGENT.—Colored lithograph by Pringle, Endicott & Company of the paddle steam ship-of-war *Regent*. 19" x 30⅛". Published by Ward, Stillman & Company, New York, 1841.

The *Regent* was built at New York, in 1840-1, by Jacob Bell. 700 tons, 154' x 30' x 14' 6". Two decks. Three masts. Bark-rigged. Square stern. Machinery by the Novelty Works, of New York. Side lever engine. Cylinder: 42". Piston stroke: 4' 7". Boilers of heavy copper. Armament: 1 50-pounder pivot gun, and 4 24-pounders. Owner: The Spanish Government.

About the time the *Regent* was built, this country was witnessing a remarkable spurt of activity in the production of steam War vessels. Bell constructed a sister ship of the *Regent*, called the *Congress*, also for Spain. The Russian steam frigate *Kamschatka* was completed in 1840, and the United States was having the *Missouri* and *Mississippi*, two much larger steam frigates, built at the New York and Philadelphia Navy Yards. The agitation over the Ericsson propeller was on to be settled shortly by the construction of the Sloop-of-War *Princeton*, the first screw propelled warship in the world, and E. K. Collins, of the Dramatic Line of packets was already advocating the construction of a line of 2500 ton ocean steamers capable of conversion into warships, a suggestion which later bore fruit in the ill-fated Collins Line.

[360] RISING STAR.—Lithograph of steamship *Rising Star*. 13½" x 24½". Published by Endicott & Son, New York.

The *Rising Star* was built at New York, in 1865, by Roosevelt, Joyce & Waturbury. 2726.66 tons, 303.54' x 43.66' x 23' x 7.5'. Three decks. Three masts. Topsail schooner-rig. Round stern. Plain head. Machinery by Etna Iron Works, John Roach, New York. One vertical beam engine. Cylinder: 100". Piston stroke: 12'. Owner: New York Mail Steam Ship Company, John A. Raynor, President.

The New York Mail Steam Ship Company, usually referred to as the "Star Line" had

Lithographs, Etchings, Woodcuts and Drawings

three large wooden paddle steamers in addition to the above vessel: the *Morning Star*, *Evening Star* and *Guiding Star*, all of which ran between New York and New Orleans, and all of which were very lavishly equipped. The Line was started in 1863 and like many others founded during and just after the Civil War, did not long survive. Early in 1866, the *Rising Star* was sold to William S. Williams of New York. A couple of years later she was registered in the name of William N. Webb, who sold her to the Pacific Mail Steam Ship Company. She sailed for several years in the Pacific Mail Line under the command of Captain S. P. Griffin. Finally she became too small and antiquated for the Pacific Mail and was purchased by Vernon H. Brown, of New York, in 1873. Shortly thereafter her name disappears from the registers.

[361] *ROANOKE.*—Colored lithograph by T. Bonar, New York, of the United States Steam Frigate *Roanoke*. 15¾" x 28¼".

The *Roanoke* was built at the Norfolk Navy Yard, in 1854. 4772.2 tons, displacement, 3400 tons, register, 263' 8¾" x 52' 6". Machinery by the Tredegar Iron Works, of Richmond, Virginia. Rated as a 40-gun frigate. Cost: $836,752.36. Armament: 28 IX-inch smoothbores, 14 VIII-inch smoothbores, 2 X-inch pivots.

During the Civil War the *Roanoke* was razeed and converted into a three-turret monitor. She was laid up in 1874 at the New York Navy Yard.

[362] *ROBERT E. LEE.*—Lithograph in colors of the steamboat *Robert E. Lee*. 18¼" x 28¼". Starboard view, under steam. Further upstream is a stern wheel steamer and at the extreme right a grocery store on a raft. On the levee negroes are dancing. Inscribed: "F. F. Palmer, del. . . . Entered . . . 1868 . . . Currier & Ives . . . S. D. of New York . . . Lith. Currier & Ives, New York . . . Low Water on the Mississippi . . . New York, Published by Currier & Ives, 115 Nassau St." See No. 62 for water-color of same steamer.

[363] *ST. LAWRENCE.*—Colored lithograph after T. G. Dutton by Day & Sons of the United States Frigate *St. Lawrence*. 16" x 23½". Shown saluting, off Osborne, Isle of Wight. Published by Ackerman, London, 1851.

The *St. Lawrence* was laid down in 1826, at Norfolk, Va., but was not completed and launched until 1847. 1726 tons, 175' x 45' x 14' 4" (hold). Armament January 1st, 1850: 8 VIII-inch guns; 42 32-pounders. Rated as a 50-gun frigate.

The career of the *St. Lawrence* was limited to the usual round of service on foreign stations alternating with home squadron duties. In the Civil War she was used for a time as an ordnance store ship in the South Atlantic Squadron, being then unfitted for active warfare in competition with steamships.

During the latter part of her existence the *St. Lawrence* was used as a Marine barracks at Norfolk, Virginia.

She was sold in 1875 and broken up.

[364] *ST. LOUIS.*—Colored lithograph by A. Pomsett of the United States Sloop-of-War *St. Louis*. 18¾" x 30¼". Showing her in the harbor of Smyrna, July 2nd, 1853.

The *St. Louis* was built at the Washington Navy Yard, under the supervision of United States Naval Constructor, William Doughty. Keel laid in 1827. Launched in August, 1828. 700 tons, 127' x 33' 9" x 15' 3" (hold). Original armament: 24 long 24-pounders. Armament, January 1st, 1850: 4 VIII-inch guns, 16 32-pounders. Rated an 18-gun sloop. Used as a receiving ship at the League Island Navy Yard in 1874.

[365] *SAN FRANCISCO*.—Colored lithograph of paddle steamship *San Francisco*, after a painting by J. E. Buttersworth. 17.3" x 25.11". Published by N. Currier, 1854. H. T. P. 1391. The caption reads: "The Ships *Antarctic* of New York, Capt. Stouffer, and *Three Bells* of Glasgow, Capt. Creighton, Rescuing the Passengers And Crew From the Wreck of The Steamship *San Francisco*. Disabled on her voyage from New York to San Francisco, Dec. 24th, 1853 and in a sinking condition. The bark, *Kilby*, of Boston, Capt. Low, had previously fallen in with the wreck and taken off a part of the passengers, but during a gale in the night was separated and could not regain it."

The *San Francisco* was built at New York, in 1853, by William H. Webb. 2272.14 tons, 281' 5" x 41' x 24' 10". Three decks. Two masts. Brig-rigged. Round stern. No figure-head. Two oscillating engines by the Morgan Iron Works, of New York. Cylinders: 65" diameter. Piston stroke: 8'. Feathering paddle wheels: 28' x 8'. Owner: Pacific Mail Steamship Company, William A. Aspinwall, President. Commander: Capt. James Watkins, late of the China Trader *Akbar*, and other notable ships.

This lithograph commemorates one of the most heroic and spectacular rescues at sea ever recorded. The *San Francisco* left New York on her maiden voyage early in December, 1853, bound around Cape Horn for San Francisco with a very large passenger list, including 500 United States troops. She ran into a series of heavy gales and her machinery became disabled and for two weeks, she drifted at the mercy of the sea, swept by one furious gale after another. The bark *Kilby* hove in sight and as the steamer was gradually filling with water it was decided to abandon her. Only a few passengers had been taken off when the *Kilby* became separated from her in the night and was unable to find her again. Shortly thereafter the San Francisco was boarded by a huge sea which stripped her spar deck sweeping her deck cabin completely away with about 150 of its occupants. All hopes of rescue seemed futile when, on the 31st of December, the little iron ship "*Three Bells*" appeared and Captain Creighton signalled that he would stand by. And stand by he did for one solid week, marked by gale after gale, until the last survivor had been taken off. In the meantime the ship *Antarctic* appeared and assisted in the work, but the great majority—over 500—were taken off by the "*Three Bells*." It was estimated that over 170 perished in this disaster. It was this incident that inspired the familiar poem, "The Good Three Bells of Glasgow." Eventually the "*Three Bells*" arrived safely in England with her freight of survivors, and the landing of the large force of United States troops on foreign soil is said to have given rise to a situation which was destined to affect adversely for many years the destinies of the American merchant marine. It was, of course, desirable that the troops should be removed from England as soon as possible and Buchanan, who was then the diplomatic representative of the United States in Great Britain requested the agent of the Collins Line to furnish a steamship at once

William H. Connor

[76]

Lithographs, Etchings, Woodcuts and Drawings

to carry the men back to America. This, the agent was unable or unwilling to do, to the chagrin of Buchanan. As a sequel, whether because of this incident, or for other reasons, when Buchanan became President in 1857 the mail contract of the Collins Line was not renewed, and the line was forced into bankruptcy, a circumstance which marked the end of America's aspirations in the ocean steamship field.

[366] *SARATOGA*.—Colored lithograph by J. H. Bufford, of Boston, after Lieutenant P. Crosby, of the United States Ship *Saratoga*. 12″ x 17¼″.

The *Saratoga* was built at Vergennes, Vermont, in 1814, by Adam & Noah Brown, of New York. 734 tons, other dimensions not given in naval records. Armament: 8 long 24-pounders; 6 42-pounders; 12 32-pounders. Rated as a 26-gun frigate.

Adam and Noah Brown built the *Saratoga* from their own designs and launched her on April 11th, 1814, forty days after her timber had been cut in the forest. Altogether, they built fourteen vessels with a total tonnage of 2244 tons, manned by 882 men and mounting 86 guns. With this force Master-Commandant Thomas Macdonough met the British fleet, consisting of sixteen vessels, aggregating 2402 tons, manned by 937 men and carrying 92 guns, on Sunday morning, September 11th, 1814. In the engagement which followed Macdonough defeated and captured or sunk the entire British fleet.

The *Saratoga* was sold at Whitehall in 1824.

[367] *SAVANNAH*.—Colored lithograph of the United States Frigate *Savannah*. 7.8″ x 12.8″. Published by N. Currier in 1843. H. T. P. 1174.

The *Savannah* was laid down in the New York Navy Yard, in 1820, but was not completed and launched until 1842. 1726 tons, 175′ x 45′ x 14′ 4″ (hold). Armament, January 1st, 1850. 8 VIII-inch guns, 42 32-pounders. Like the *St. Lawrence* (q.v.) rated as a 50-gun frigate, but virtually equivalent to the 60-gun ships of her time.

The most noteworthy incident in the career of the *Savannah* occurred in 1846 when she was the flag ship of the Pacific squadron under Commodore John D. Sloat. The *Savannah* was lying at Mazatlan on the west coast of Mexico when by a fortunate accident Sloat received advance information of the outbreak of the Mexican War. He sailed at once for Monterey with the ships *Cyane* and *Levant* and took possession of California for the United States, forestalling a British squadron which was lying at Mazatlan with the same object in mind. When the Civil War broke out the *Savannah* was razeed with the idea of making her a more effective fighting unit. After the war she lay at Norfolk for some years, in ordinary, and was finally broken up.

[368] *SOMERS*.—Colored lithograph by N. Currier of the United States Brig-of-War *Somers*. 8.2″ x 12.8″. Undated but probably published in 1843. Shown with the bodies of two "mutineers" hanging from the starboard main yard arm. H.T.P. 1175.

The *Somers*, the second brig-of-war of that name, was built in 1842, under the supervision of Captain Sands. 266 tons (also given 259 tons), 103′ x 25′. Height of berth deck:

4' 10" between the beams. Armament: 10 light guns. Commander: Capt. Alexander Slidell McKenzie.

The first cruise of the *Somers* was to the coast of Africa in the summer of 1842, with the usual complement of officers and midshipmen and about 80 apprentice boys and 18 able and ordinary seamen. Few events in American naval history ever stirred more profoundly the feelings of the general public than the announcement upon the return of the *Somers* to New York on the 14th of December, 1842, that Capt. McKenzie had hung three men for attempted mutiny two weeks before, viz., Philip Spencer, aged 17, acting-midshipman, Elijah Small, aged 24, seaman, and Samuel Cromwell, aged 35, boatswain's mate. A court of inquiry was held which exonerated Capt. McKenzie of all blame in the matter. This was followed early in 1843 by a court martial, with a similar result, and the affair has gone down in history as a most villainous piece of treachery suppressed only by the coolness and bravery of McKenzie and his officers. The facts, however, established by the testimony taken, reveal a remarkable state of affairs. During the six months' cruise the log of the *Somers* recorded a total of 2313 lashes administered as punishment, most of which were meted out to boys of from 12 to 17 years of age. Capt. Jones, one of the officers of the court martial, commented that this was "ten-fold more punishment than ordinarily necessary." The evidence produced of the existence of a plot was of the flimsiest sort, in spite of the fact that it was wholly furnished by the defense, the alleged mutineers and their relatives being allowed no representation or counsel whatever; while the contention of Capt. McKenzie that his action was occasioned only by the sternest necessity must be judged in the light of his own testimony that the youths were hanged on ten minutes' notice after having been kept in irons several days, and his further evidence that the supposed plot involved at most not more than fifteen or sixteen out of a crew of more than one hundred, and it was not considered necessary to put but seven of these in irons, including the three who were executed. As Spencer came from an excellent New York family, being, in fact a son of the Secretary of War, the affair excited intense feeling both here and abroad. The English papers, especially, were bitter in their denunciation of Capt. McKenzie, who, in their opinion, had seized upon reports of idle romancing by a few irresponsible boys as a pretext for the execution. The matter had one good result, however. More than any other incident it became a factor in the wave of public sentiment which swept the country and led directly to the abolition of flogging at sea. The end of the *Somers* was as tragic as the inception of her career. On the 8th of December, 1846, she capsized and sank while chasing a Mexican blockade runner off Vera Cruz, carrying down with her half her crew, including Acting-Master Clemson, Passed-Midshipman Hynson and nearly forty men.

[369] *SONORA*.—Colored lithograph of wooden paddle steamship *Sonora*. 18¼" x 30¾". Published by Endicott & Company.

The *Sonora* was built at New York, in 1853-4, by Jacob A. Westervelt. 1616.77 tons, 269' 6" x 35' 2" x 25'. Three decks. Two masts. Topsail schooner-rig. Round stern. No figure-head. Two vertical engines. Cylinders: 50" diameter. Piston stroke: 10'. Owner: The Pacific Mail Steam Ship Company, William H. Aspinwall, President. Commander: Capt.

Wide Awake

[74]

Lithographs, Etchings, Woodcuts and Drawings

Richard L. Whiting. Other Commanders of the *Sonora* were Captains Lapidge and Baby.

The *Sonora* was sent around to the Pacific coast and spent most of her existence on the run between San Francisco and Panama. Her name disappeared from the registers prior to 1869.

[370] *SOUTH AMERICA.*—Lithograph of the wooden paddle steamship *South America*. 16¾" x 32½". Inscribed: "The United States and Brazil Mail Steamship *South America* 2150 tons... Endicott & Co. Lith. 59 Beekman St., New York... Agents for the Steamship Line... Garrison & Allen Agents No. 5 Bowling Green, New York."

The *South America* was built at New York, in 1860, by William H. Webb and launched as the steamship *Connecticut*. 2150.53 tons, 256' x 38' 5" x 24' 1". Three decks. Two masts. Round stern. Billet-head. One beam engine. Cylinder: 80" diameter. Piston stroke: 11'.

At the outbreak of the Civil War the *South America* was purchased by the United States Navy Department. In 1865 she was purchased by Samuel G. Wheeler, of New York, who sold her within a few weeks to the United States & Brazil Mail Steam Ship Company. She was immediately placed on the run between New York and Rio de Janeiro under the command of Capt. Edward L. Tinklepaugh. Other steamers operated by the Company were the *Havana* and *North America*, both of which were vessels of 2000 tons and upwards. Later, the *South America* was commanded by Capt. George F. Carpenter. She was still running in the line as late as 1887 under the management of William R. Garrison, President of the company, but during the eighties she had been altered to a propeller.

[371] *STATE OF CALIFORNIA.*—Colored lithograph of steamship *State of California*, after C. H. Parsons. 17½" x 27". Published by Currier & Ives, 1879. H. T. P. 1397.

The *State of California* was built at Philadelphia, in 1878-9, by William Cramp & Sons. 2266.03 tons, gross; 1260.06 tons, net. 300' x 38' 6" x 24' 4". Three decks. Two masts. Nominal horse power: 1800. Owner: Charles Goodall, of San Francisco. Commander: Capt. J. M. Lechlan.

Designed for the coastwise trade in the Pacific, the *State of California* was operated for many years in the Pacific Coast Steamship Company's line.

She was one of the earlier iron propellers which were turned out in considerable numbers during the late seventies and afterwards by the ship-builders of Philadelphia, Chester and Wilmington, and which marked the close of the era of wooden steamships.

[372] *SWEEPSTAKES.*—Lithograph of the clipper ship *Sweepstakes*. 16⅛" x 23⅝". Inscribed: "Clipper ship 'Sweepstakes'... W. A. McGill, Comdr.... F. F. Palmer after the painting by J. E. Buttersworth... N. Currier. 1853." H.T.P. 1241.

The *Sweepstakes* was built at New York, by Daniel and Aaron Westervelt, and launched June 18th, 1853. 1435.23 tons. 216' 4" x 41' 6" x 22' 3½". Two decks. Square stern. Man bust figure-head. Owners: Chambers & Heiser of New York. Commander: Capt. George E. Lane.

The vogue for extreme clippers was at its height when the *Sweepstakes* was laid down, and she, accordingly, ranks among the sharpest and most heavily sparred of the fleet. Her

bottom was so sharp, in fact, that when she was launched she took the ground and was not floated for three days. Although she was about the same tonnage as the *Flying Cloud*, her spars were much heavier, and she proved to be an exceptionally fast and able vessel throughout her career. Her logs show that she had many contests with fast medium and extreme clippers but was always able to pass those with which she happened to be in company. Her best work over a long course was her run from New York to Bombay in 1857. Her time was 74 days for the passage out and 81 days for the return trip. From late in 1860 until her end she was in the Pacific. In March, 1862, while under command of Capt. W. A. McGill, she was on a reef for ten hours in Sunda Straits. Although she got off and reached Batavia, she was so badly injured that Capt. McGill decided to sell her for the owner's account to avoid expensive repairs. She was then owned by R. L. Taylor, of New York.

[373] THREE BROTHERS.—Lithograph in colors of the ship *Three Brothers*, formerly the steamship *Vanderbilt*. 18¼" x 28". Inscribed: "Clipper ship *Three Brothers*. The largest Sailing Ship in the World ... Currier & Ives. 1875."

The wooden paddle steamship *Vanderbilt* was built at New York, in 1855, by Jeremiah Simonson. 3360.59 tons, 331' x 47' 6" x 32' 6". Three decks. Two masts. Brig-rigged. Round stern. Plain head. Two vertical beam engines by the Allaire Works of New York. Cylinders: 90" diameter. Piston stroke: 12'. Paddle wheels: 41' x 10'. Owner: Cornelius Vanderbilt. Commander: Capt. David L. Wilcox.

At the time the *Vanderbilt* was launched she was the largest and fastest American transatlantic steamship afloat, although she was eclipsed in size the following year by the *Adriatic* of the Collins Line. Cornelius Vanderbilt ran her for a time in his New York-Havre Line. When the Civil War broke out he presented her to the United States Government and she was armed and in 1863 was sent in pursuit of the *Alabama*. She was present at the attack on Fort Fisher as a part of Admiral Porter's fleet and altogether, proved herself to be a most useful vessel. After the war she was sold to George Howes & Company of San Francisco by whom she was converted in 1873 into a sailing ship. The work of alteration was supervised by Capt. Cummings who later commanded her for many years.

[374] TORY.—Colored lithograph of the British bark *Tory*. 11½" x 18". Inscribed: "800 tons Burthen. G. E. Langford, Commander. To the Directors of the Australian Cordillera Gold Mining Company, this Print of their Chartered Ship leaving the Downs with their first expedition to Australia."

The bark *Tory* was built at Sunderland, England, in 1842. 402 tons, register. Owners: Row & Company, London. Commander: Capt. J. Row.

The *Tory* was built for the trade between London and Adelaide, Australia, and appears to have spent her entire existence in the Australian service. Her name does not appear in the registers after 1855.

[375] UNITED STATES.—Engraving, colored by hand, of the United States Frigate, *United States*. 29" x 22". By C. Tibout, after T. Birch. Published by Jas. Webster. Inscribed:

Wild Ranger

[75]

Lithographs, Etchings, Woodcuts and Drawings 117

"U. S. Frigate *United States* Stephen Decatur, Comm.... John S. Carden... Capt. H. B. M. Frigate *Macedonian*." In battle with the *Macedonian*.

The *United States*, 44, designed by Joshua Humphreys, was built at Philadelphia, under the supervision of John Barry, senior officer of the Navy, and launched July 10th, 1797. 1576 tons, 175' x 43' 6". Armament: 32 24-pounders, 22 42-pounder carronades. Weight of metal, 787 pounds. Cost: $299,336.00.

Capt. John Barry was the first commander of the *United States*, sailing in July, 1798, for the West Indies in company with the Sloop-of-War *Delaware* to destroy the French and Spanish picaroons which then infested the waters. They captured several privateers and early in 1801 returned to the Washington Navy Yard where the *United States* was laid up until 1809.

In May, 1810, Capt. Stephen Decatur was assigned to the command of the *United States*, in which ship he had been a midshipman on her first cruise eleven years before—the most rapid promotion in the history of the American Navy. He was still in command when the War of 1812 opened. On October 25th that year, he fell in with the British Frigate *Macedonian*, Capt. John S. Carden, and took her after a sharp engagement of one hour and thirty minutes, losing twelve men out of his crew of 478 men; the *Macedonian* losing 104 out of a crew of 555 men. Decatur towed the *Macedonian* to New London where he was greeted with a great public banquet and ball. Shortly thereafter the *United States* was driven into New London with the rest of Commodore Jones' fleet by a heavy British squadron and kept bottled up there for the rest of the war. After the war the *United States* was sent over to the Mediterranean, under the command of Capt. John Shaw, with Commodore Bainbridge's squadron. Bainbridge joined forces with Decatur and with a fleet of ten vessels and 210 guns, soundly thrashed the fleet of the Dey of Algiers, consisting of twelve ships, mounting 360 guns. In January, 1824, the *United States* went to the Pacific as the flagship of Commodore Isaac Hull, being credited with the very fast passage of 62 days from Norfolk to Valparaiso. Returning, she was in active service much of the time until 1840, mostly in the Mediterranean. In 1842 she was again in the Pacific as Commodore T. Ap Catesby Jones' flagship, under whom she was involved in a premature attempt to seize California. Jones' action was disavowed and he and the *United States* were sent home. After a round on the African coast under Commodore George C. Read, she was laid up at Norfolk in 1859. She was still there when the Civil War broke out and was one of the historic ships burned by order of Commodore Paulding on April 20th, 1861, to prevent her falling into the hands of the Confederates.

[376] *VINCENNES*.—United States Sloop-of-War. (See lithograph of United States Ship-of-the-Line *Columbus*.)

[377] *WABASH*.—Colored lithograph by Endicott & Company, after John Collins, of the United States Steam Frigate *Wabash*. 11⅞" x 17⅛".

The *Wabash* was built at the Philadelphia Navy Yard, in 1854. 4774.3 tons, displacement. 3200 tons, register. 262' 4" x 51' 4". Machinery by Merrick & Sons, Philadelphia.

Rated as a 40-gun frigate. Cost: $892,373.46. Armament: 28 IX-inch smoothbores; 14 VIII smoothbores; 2 X-inch pivots.

In appearance, the *Wabash* and her sister ships, the *Roanoke*, *Colorado* and *Minnesota*, were very handsome, powerful looking vessels, and at the time they were launched they were believed to outclass the best fighting ships afloat.

The *Wabash* was commissioned in August, 1856, and commanded by Commodore Hiram Paulding on the home station for two years, after which she was sent to the Mediterranean under Commodore Lavallette. She returned in 1859. When the Civil War started she took part in the attack of August 27th and 28th on the defences of Hatteras Inlet, cooperating with land forces under Major General Benjamin F. Butler. At that time she was commanded by Capt. Samuel Mercer. Later in the year, with the *Minnesota*, *Cumberland*, *Susquehanna* and a number of smaller ships, she participated in the capture of Port Royal. Throughout the war she was engaged in operations along the Atlantic coast, her last important service being to assist in the attack on Fort Fisher in the Cape Fear River operations in December, 1864, and January, 1865.

Her powerful battery made her one of the strongest fighting units in the Northern Navy during the early part of the War, until the advent of the improved ironclads.

After the close of the war, the *Wabash* was sent to Boston, eventually becoming the receiving ship at the Charlestown Navy Yard, where she was a familiar sight for many years.

[378] *WILLIAM LE LACHEUR*.—Colored lithograph with monogram "T. C. '92" of the British ship *William Le Lacheur*, of Guernsey. 12¼" x 18½".

The *William Le Lacheur* was built at Guernsey, England, in 1864 by Sebire. 573 tons, 165' 8" x 30' 5" x 17' 7". Two decks. Round stern. Sharp model. Owner: J. Le Lacheur, of Guernsey. Commander: Capt. Lucas, followed by Capt. Le Visconte. Built for the London and Puntas Arenas trade. House flag: Blue St. Andrews cross on white field.

[379] *YORKSHIRE*.—Lithograph of the packet ship *Yorkshire*. 17" x 23½". Published by Day & Haghe, Lithographers to the Queen. From a painting by W. R. McMinn. Inscribed: "Dedicated to the Friends of Capt. D. G. Bailey."

The *Yorkshire* was built at New York, by William H. Webb, and launched October 25th, 1843. 996.81 tons, 166' 6" x 36' 2" x 21'. Two decks. Square stern. Billet-head. Owners: Charles N. Marshall, Nathan Cobb, Gabriel Mead, George Bell, William H. Webb and David G. Bailey, of New York, and Benjamin L. Waite, of Westport, Connecticut. Commander: Capt. David G. Bailey.

Although a full-built ship, the *Yorkshire* was regarded as very sharp for a Liverpool packet, and she proved to be the fastest ship ever built on true packet lines. She was designed expressly for the Black Ball Line and soon became one of the most popular of the "Canvas back Liners." Her record voyage, which was never equalled by a regular packet ship, is thus described in the New York Herald for November 19th, 1846:

"Arrival of the Packet Ship *Yorkshire*—Most Extraordinary Passage. We were not a little astonished yesterday morning when the telegraph announced that the packet

De Lesseps Medal

[671]

Lithographs, Etchings, Woodcuts and Drawings 119

> ship *Yorkshire*, Captain D. G. Bailey, had arrived from Liverpool. Although Capt. B. has always made remarkably quick passages, the public could hardly believe the telegraphic report. It was all correct however. This fine ship, under the guidance of Capt. B., has actually arrived in the *short run of sixteen days over the Atlantic*. She left Liverpool on 2nd inst., in the afternoon, and arrived off this port on Tuesday "(the 17th)" and was up to the city yesterday at dinner time. This, we believe, is the shortest passage on record. It is shorter than those of many of the steamships in the last year."...

The *Yorkshire* had, it later developed, made the Banks of Newfoundland in the then record time of 7 days from Liverpool and arrived off Sandy Hook a few hours more than 15 days out. Even before this she had made several exceptionally fast passages. On the 18th of January, 1846, she sailed from New York and arrived at Liverpool the 2nd day of February at 10.00 A. M., making the passage in less than 15 days. The New York Herald said on this occasion:

> "We are informed that the *Yorkshire* was as deep as a sand barge. Had she gone out with her usual draft, the passage would, no doubt, have been made in less than fourteen days from port to port."

The *Yorkshire* continued in the Liverpool trade throughout her existence. In 1848 Capt. Furber succeeded Capt. Bailey. On February 2nd, 1862, she sailed for Liverpool from New York with Capt. Edward R. Fairbanks in command and was never again reported. Twenty-six, including three passengers, were lost with her. It was stated at the time that "probably no ship in the Liverpool trade has realized a larger amount of net earnings."

[380] Colored lithograph of United States single turret river and harbor monitor of the "Tippecanoe Class." 12¼" x 23¾". Circa 1862.

✿ ✿ ✿

MISCELLANEOUS PRINTS

[381] View of Homeward bound American ship taking her departure from Land's End. Engraving by W. Elmes, published by J. Fairburn, London, 1797.

[382] Strangling of the American Seamen at Canton, October, 1821. Colored engraving from the Calcutta Journal.

[383] Loading a U. S. Frigate. Japanese woodblock print in color.

[384] Paquebots Americains a Volie et a Vapeur. Colored lithograph by Louis Lebagton.

[385] Voyage of American Clipper. Woodcut illustrations.

[386] Bombardment of Forts Hatteras and Clark by the U. S. Fleet. (Names of ships below.) Tinted lithograph by J. H. Bufford, Boston, after F. Garland, seaman on the *U. S. S. Cumberland*.

[387] Homeward Bound. (Sailing ship.) Colored lithograph by N. Currier, 1846. Small. H. T. P. 1213.

[388] The Chinese Junk *Keying*, Capt. Kellet as she appeared in New York harbour July 13th, 1847, 212 days from Canton. 720 tons burthen. N. Currier. 1847. Colored lithograph. 7.13" x 12.15". H. T. P. 1218.

[389] American Sailors. A series of five lithographs (the first being colored) published by N. Currier, N. Y., 1847-49. *The Sailor's Adieu*. H.T.P. 1256. *The Sailor's Return*. H.T.P. 1259. *The Young Sailor*. H.T.P. 1263. *The Sailor's Bride* Pair. (On shore and at sea.)

[390] Maria. Ship *Maria* of New Bedford, oldest ship in the U. S. Woodcut from Gleason's Companion, 1854.

[391] The First Battle between Iron Ships of War. Colored lithograph. Published by Henry Bill, 1862 (Conn.).

[392] Bombardment and Capture of Island "Number Ten" on the Mississippi River, April 7th, 1862. . . . Com. A. H. Foote. Colored lithograph by Currier & Ives, N. Y., 1862. 15.10" x 22.2". H. T. P. 1156.

[393] The Storming of Fort Donelson, Tenn., February 15th, 1862. Colored lithograph by Currier & Ives. 22.8" x 16". H. T. P. 832a.

[394] An American Ship Rescuing the Officers and Crew of a British Man of War. Colored lithograph by Currier & Ives, N. Y., 1863. 11.12" x 16.5". H. T. P. 1187.

[395] The Great Naval Victory in Mobile Bay, August 5th, 1864. Colored lithograph by Currier & Ives. 8" x 12.8". H. T. P. 1147.

[396] U. S. Mail Steamship in a Storm. Colored lithograph by Hatch & Co. after J. A. Shearman.

[397] The Repeal or the funereal procession of Miss Americ-Stamp. Engraving.

[398] Mort de Marquis de Montcalm Gazon. Engraving by G. Chevillet after Vateau.

[399] The Ironclad at Firing Practice. Tinted lithograph, proof.

Glory of the Seas Figurehead

[156]

Lithographs, Etchings, Woodcuts and Drawings

[400] The Battle of the Wilderness, Va. Colored lithograph by Currier & Ives. Large. H. T. P. 888.

[401] The Battle of Fair Oaks, Va. Colored lithograph by Currier & Ives. Large. H. T. P. 834.

[402] The Fall of Richmond, Va. On the Night of April 2nd, 1865. Colored lithograph by Currier & Ives. 16" x 22.4". H. T. P. 871.

[403] Sperm whaling with its varieties. Colored lithograph after Benj. Russell by J. H. Bufford, Boston, 1870.

[404] Right Whaling . . . with its varieties. Colored lithograph after Benj. Russell by J. H. Bufford, Boston, 1871.

[405] Destruction of the Whaling Fleet in the Arctic Ocean. Woodcut in four panels. Published by Edwin Dows, New Bedford, Mass.

[406] Battleship Fight with Farragut in the Rigging. Lithograph by W. H. Overend, artist's remarque proof. Published by the Fine Arts Society, 1884.

[407] Off the Port. (Clipper ship under sail.) Colored lithograph by Currier & Ives. Small. H. T. P. 1194.

[408] Clipper Ship Advertising Cards, pictorial. A collection of 55 mounted on six panels. Lithographed in color. A unique, rare and interesting collection of lithographed advertising cards of the period.

[409] The Collins Fleet of New York and Liverpool. Woodcut by G. H. Hayes.

[410] Yacht Races. A series of fourteen colored prints after the paintings by Fred. S. Cozzens.

* * *

VIEWS OF AMERICAN CITIES AND PORTS

[411] La Déstruction de la statue royale à Nouvelle York. Colored engraving by Francois & Habermann.

[412] The City of New York in the State of New York, North America. Colored engraving by Samuel Seymour after William Birch. Published 1803 by William Birch, Springfield, Penn.

[413] New York, from Governor's Island. Colored aquatint engraving by I. Hill after W. G. Wall, circa 1815.

[414] New York from Weehawk. Colored aquatint engraving by I. Hill. Published by Bourne, Depository of Arts, N. Y., 1828.

[415] Hanover Building, 1850, Hanover Square, N. Y. Colored lithograph by J. P. Newell. Published by J. H. Bufford, Boston.

[416] New York. Aquatint engraving by Himly after J. W. Hill. Published by F. & G. W. Smith, N. Y., 1855.

[417] Vue Génèrale de New York. Colored lithograph by Asselineau after Bachmann. Published by Wild, Paris, circa, 1860.

[418] The Great East River Bridge to connect the cities of New York and Brooklyn. Colored lithograph. Published by Currier & Ives, 1872. 8.8" x 12.7". H. T. P. 4019.

[419] The Port of New York—bird's-eye view from the Battery looking south. Colored lithograph by Parsons & Atwater. Published by Currier & Ives, 1872. 20.6" x 32.15".

[420] A Brisk Gale—Bay of New York. Mezzotint by W. J. Bennett.

[421] Vue de New York. Die Anlandung der Englischen Trouppen zu New York. Colored engraving by F. K. Haberman.

[422] The Government House. Colored lithograph by W. Ells after W. J. Condit. Published by H. R. Robinson, 1847, N. Y.

[423] Prince's Bay, N. J. Woodcut from *New York Clipper*, January 24th, 1857.

[424] Bangor, Me. Lithograph by Chas. Parsons after Dan'l Glasgow. Published by Smith Bros. & Co., N. Y., 1854.

[425] The Pepperell Mansion, Kittery Point, Me. Engraving.

[426] Portland, Me. Lithograph by Chas. Parsons after J. W. Hill and Dan'l Glasgow. Published by Endicott & Co., N. Y., 1855.

[427] Vue de Salem. Colored engraving by Leizelt.

[428] Vue de Boston. Prospect der Konig Strasse gegen das Land thor zu Boston. Colored engraving by F. K. Haberman.

Leviathan Bell

[669]

Lithographs, Etchings, Woodcuts and Drawings

[429] View of the town of Marblehead, Mass. Woodcut from *Gleason's Pictorial.*

[430] View of Gloucester, Mass. Colored lithograph after F. H. Lane. Published by J. H. Bradford & Co.

[431] New Bedford from Fair Haven, 1853. Steel engraving by W. Wellstood after J. W. Hill. Published by Smith Bros. & Co., N. Y.

[432] View of New London from Fort Griswold. Colored lithograph by E. C. Kellogg after J. Ropes. Published by Holmes & Co.

[433] View of New London, Conn.

[434] A View of New London from Mainwaring's Hill.

[435] The Town of Sherburne in the Island of Nantucket.

[436] Amerique Septentrionale, Etat de Rhode Island—North View of Providence. Lithograph by Deroy after Milbert, circa, 1825.

[437] Philadelphia from the River.

[438] Mobile. Taken from the Marsh opposite the City near Pinto's residence. Colored aquatint engraving by W. J. Bennett after William Todd. Published by H. I. Megarey, N. Y., 1842.

[439] San Francisco, 1849. Lithograph by Ibbotson after Henry Firks. Published by T. Sinclair, Philadelphia, 1849.

[440] City of San Francisco from Ricon Point. Colored lithograph by C. Parsons after F. H. Otis. Published by Endicott & Co.

[441] Post Office, San Francisco, Cal. Colored lithograph by H. F. Cox. Published by Endicott & Co., 1849.

[442] A View of Sutter's Mill and Calloma Valley. Lithograph by Sarony & Major after John T. Little.

[443] Across the Continent—Pacific Bhan nach Californien. Passing the Humboldt River, Central Pacific R. R. Colored lithograph published by H. Schile & Co., N. Y., 1870.

VIEWS OF INDIA HOUSE, LONDON

[444] The East India House. Engraving published by T. Malton, 1799.

[445] East India House. Engraving by S. Rawle.

[446] East India Co. Engraving from *European Magazine*.

[447] India House. Engraving published by Wyatt, 1809.

[448] Directors of English East India Merchants. 1722.

[449] Panel of four engraved views of East India House, Leadenhall St. Early 19th century.

[450] East India House. Colored engraving by W. Wallace after T. H. Shepherd. Published by Read & Co., London.

[451] India House, Leadenhall St. Colored engraving by J. C. Stadler after T. H. Shepherd.

[452] Panel of three engraved views of East India House.

[453] Panel of three engraved views of East India House.

[454] Panel of three engraved views of East India House.

[455] India House, the Sale Room. Colored aquatint engraving by Stadler after Rowlandson and Pugin. Published by Ackermann, London, 1808.

[456] East India Company's Stud at Chatterpore. Colored aquatint engraving by Dubourg after S. Howitt. Published by E. Orme, London, 1813.

[457] West India Company's House, Amsterdam. Engraving. 1783.

[458] The West India Company's Warehouse. Built 1641; meetings held here from 1647-1674. Line engraving.

[459] View of the Outside of the Royal Exchange, London. Engraving by Bartolozzi after J. Chapman & Luthenberg. Published by Chapman, London, 1788.

[460] View of the Inside of the Royal Exchange, London. Engraving by Bartolozzi after J. Chapman & Luthenberg. Published by Chapman, London, 1788.

Pair of Cannon

[619]

Lithographs, Etchings, Woodcuts and Drawings

[461] Royal Exchange. London.

[462] Destruction of the Royal Exchange by Fire, 1838. Lithograph by J. Graf after Wm. Heath. Published by R. Ackerman, London,

✿ ✿ ✿

VIEWS OF EAST INDIA DOCKS, NEW YORK
DRAWINGS AND ETCHINGS BY F. LEO HUNTER

[463] East India Wharf, 1880. Original pencil drawing. 16" x 14".

[464] Old Houses near East India Docks, 1882. Orig. p. d. 12" x 16".

[465] East India Wharf, South St., 1882. Orig. p. d. 9" x 12½".

[466] India Wharf, South St., 1885. Etching, artist's proof.

[467] Old East India Wharf, South St., 1885. Etching.

✿ ✿ ✿

VIEWS OF FOREIGN CITIES, PORTS AND SCENES

[468] A View of the Island of Jamaica. Engraving by Thos. Vivares after Geo. Robinson. Published by Boydell, London, 1778.

[469] City of Kingston from the Commercial Rooms. Lithograph by J. B. Clerk, London, after J. B. Kidd.

[470] City of Kingston from the Commercial Rooms, South & East.

[471] View of Port Royal and Kingston.

[472] The Parade and Upper Kingston from the Church.

[473] Kingston, Panama, etc. Panel of 6 lithographs by G. V. Cooper.

[474] Port Royal. Colored lithograph by W. Clark, London, after J. B. Kidd.

[475] View of the City of Rio de Janeiro. Colored aquatint engraving by Chamberlain, London, 1821, after John Clark.

[476] View of Rio de Janeiro. Tinted lithograph by Gosseln, Paris.

[477] View of the Harbour and Town, Valparaiso. Engraving after J. Searle.

[478] View of Aspinwall, New Granada. Colored lithograph by F. N. Otis, N. Y., 1853.

[479] Funchal—Madeira. Colored lithograph after Heine & Brown. Published by Ackerman, N. Y.

[480] View of the Banks of the River Douro, approaching the City of Oporto. Colored lithograph.

[481] Sierra Leone—View of Freetown, Sierra Leone. Pair of colored engravings after E. Duncan. Published by W. J. Huggins, London, 1837.

[482] The Chincha Islands. Distance, 5 miles North West by W. Lithograph by Currier & Ives. Sketches by Mr. H. Herryman, June 21, 1860. Published by Wm. B. Colville, Callao. 7.13" x 13.14".

[483] View of Canton. Engraving. Published by J. Archer, Boston, circa, 1830.

[484] Macao from Renha Hill. Colored lithograph by J. Queen after W. Heine. Published by P. S. Duval & Co., Philadelphia.

[485] A View of the Harbour, City of Alexandria, from the Pharo's Tower. Colored aquatint engraving after H. Merke. Published by E. Orme, London, 1804.

[486] Cast Iron Bridge across the Weir at Sunderland. Lithograph by P. Gauci, printed by Engleman & Co., published by Reed & Son, 1837.

[487] Nova Totius, Terrarum Orbis. Engraved map, colored. Amsterdam, circa 1700.

[488] Broom Road, Tahiti.

[489] View of Monument Mountain.

[490] Ficus or Banyan Tree.

[491] Observatory Peak, Fiji Islands.

[492] Four engravings after A. T. Agate.

Main Staircase

Lithographs, Etchings, Woodcuts and Drawings

[493] Scenes from Travel in the East. A series of ten engravings by J. N. Gimbrede after C. Wilkes.

[494] The Process of Planting, Growing, and Curing Tea. A series of four colored aquatint engravings by J. Clark after E. Orme.

[495] Vue... d'un Arc de Triomphe... de Canton. Colored engraving by Brainais.

[496] City of Pekin—Emperor's Palace—and other Chinese views. A series of twelve colored engravings by J. June.

[497] Chinese Battle and Procession Scenes. A series of twenty engravings by Helman, 1786.

[498] Palm and Banana Trees. Colored lithograph after J. B. Kidd. Published by W. Clerk, London.

[499] City of Manilla. Napa from Bamboo Village. View of Uraga Yedo Bay. Bay of Wodowara. River Jurono, Singapore. Hokodadi from Telegraph Hill. A Collection of six colored lithographs by Sinclair & Sarony.

[500] Vue de Cederhall dans l'Isle d'Antigon. Colored aquatint engraving by Hurlimann after L. Strobwasser.

[501] Views on Prince of Wales Island: The Great Tree. The Convalescent Bungalow. Chinese Mills, Penang. From Strawberry Hill. From Halliburton Hill. Mt. Erskine and Pulo Ticoose Bay. Glugor House and Spice Plantations. Suffolk House. North Beach from the Council House. Colored aquatint engravings by Wm. Daniell after Capt. Robt. Smith. Published by Wm. Daniell, London, 1821.

[502] Views of Honolulu. A series of three lithographs (each with two views) by Britton & Ray, San Francisco, after Paul Emmet.

[503] View of Hilo. View of Waimea. Mission Seminary at Lahainaluna. Village of Kealakekua. A series of four engravings by Herrick.

[504] A collection of 44 copperplate engravings after drawings by J. Webber portraying the lives and customs of the savage races of the South Seas and Alaska. From the Asiatic Society.

[505] A collection of views in Western North America. Colored lithographs mainly from the U.S.P.R.R. Expd. & Survey, comprising 50 in all.

[506] Capture of Monterey. Colored lithograph by Bagot after C. Nebel.

[507] Battle of Buena Vista. Colored lithograph by Bagot after C. Nebel.

[508] Monterey. A collection of five views after D. P. Whiting. Colored lithographs. Published by Endicott & Co., N. Y.

[509] Bombardment of Vera Cruz. Colored lithograph by Bagot after C. Nebel.

[510] Attack on Havannah, 1762. A series of four engravings by Canot after Serres.

❊ ❊ ❊

ENGLISH AND AMERICAN NAVAL BATTLES

[511] Perry's Victory on Lake Erie. Colored engraving by A. Lawson after T. Birch. Published by W. Smith, Philadelphia.

[512] MacDonough's Victory on Lake Champlain. Engraving by B. Tanner after Reinagle.

[513] A View of the Thames. East Indiamen stranded at East Bourne. Engraving by Robert Have & Son, after C. Ade.

[514] Action of Quallah Battoo as seen from the *Potomac* at anchor in the Offing. J. Downes, Esq., Commander, February 5th, 1832. Aquatint engraving. Published by G. C. Smith, Boston.

[515] View of the Capture of Amoy on the Coast of China, 1841. Colored engraving by H. Papprill after R. B. Crawford. Published by Ackerman, London, 1842.

[516] A series of three colored aquatint engravings.

❊ ❊ ❊

FRENCH NAVAL ENGAGEMENTS

[517] La Valeur recompensee à la Prise de la Grenade, le 4 juillet, 1779. Engraving by Demarne.

[518] The Serapis and the Bon Homme Richard. Engraving. Published by Nonahere et Brauvais, Paris.

Lithographs, Etchings, Woodcuts and Drawings

[519] The Serapis and Bon Homme Richard. Engraving by Lempiere & Fittler after R. Paton. Published by Boydell, London, 1780.

[520] Combat Serapis and Paul Jones on the Bon Homme Richard. Colored engraving by Loizel.

[521] A series of eight tinted lithographs by Lemercier after Ford. Published by Anaglylic, London, 1844.

* * *

JAPAN

[522] Passing the *Rubicon, Japan*, 1853. First landing of Americans in Japan, 1853. Pair of colored lithographs by Sarony & Co., after W. Heine. Published by E. Browne, Jr.

[523] Landing of Commodore Perry, Japan, 1854. Colored lithograph by Sarony & Co., after W. Heine. Published by E. Browne, Jr., N. Y.

[524] Dinner given the Japanese Commission on board the U. S. Frigate *Powhatan*. Tinted lithograph by P. S. Duval & Co. of Philadelphia after Heine.

[525] Boat on River. Japanese woodblock print in color. 14″ x 10″.

* * *

[526] *HON. ELIHU YALE, GOVERNOR OF EAST INDIA COMPANY, LONDON.* Colored lithograph.

[527] *COMMODORE HOPKINS.* Mezzotint by Thomas Hart, 1776.

[528] *ROBERT LORD CLIVE.* Mezzotint by J. McArdell after Gainsborough.

[529] *DONALD McKAY.* Lithograph by L. Grozelier. Published by Southworth & Harves, 1854.

[530] *WARREN HASTINGS.* Proof engraving by W. Skelton after W. Bleecher.

[531] *JOHN PAUL JONES.* Mezzotint.

[532] *GENERAL ANDREW JACKSON.* Three colored lithographs.

[533] *BENJAMIN FRANKLIN.* Panel of four pieces including document signed by him in 1785 and three portraits including a colored mezzotint by Alix and two others of French origin.

[534] *PORTRAIT OF A CHINESE MANDARIN.* Lithograph.

[535] *ISIAH CROMWELL.* Engraving.

[536] *J. R. POINSETT.* Photograph.

[537] *STEPHEN GIRARD.* Engraving by Williams.

[538] *W. A. GRAHAM.* Engraving by Halpin.

[539] *COLLECTION OF SIXTY-FIVE PORTRAITS OF AMERICAN STATESMEN AND MERCHANTS.* Engraved or lithographed.

Lounge

MISCELLANEOUS OBJECTS OF IMPORTANCE

MISCELLANEOUS OBJECTS
OF IMPORTANCE

[600] *CHARLOTTE DUNDAS.*—Fragment of ship's knee from the steamboat *Charlotte Dundas*, in mahogany case in vestibule. 33" x 5" x 41".

The *Charlotte Dundas* was built at Grangemouth, Scotland, by A. Hart, in 1801, under the direction of William Symington, the inventor. Dimensions: 56' x 18' x 9'. Engines by Symington. The first horizontal, direct acting engine used in England.

The *Dundas* was intended for use by Lord Dundas as a towboat on the Forth and Clyde Canal. Symington originally designed her with side paddle wheels, but in order to avoid damage to the banks of the Canal he was induced to fit her with a single stern wheel placed within the hull and two stern rudders. In 1802 she was given a trial and towed two loaded 70 ton barges 20 miles at the rate of $3\frac{1}{4}$ miles an hour—an excellent performance. However, the owners of the Canal objected violently to her use on the ground that she would wash away the banks of the Canal, so she was laid up for many years and was eventually removed and sunk in Grangemouth harbor. Her cost was £3000, defrayed by Lord Dundas. While in England gathering the data which enabled him to design his first steamboat, Robert Fulton examined the *Dundas* and met her inventor, Symington, and also talked with the inventor Rumsey.

[601] *JOSEPH CONRAD.*—One time master of the *Torrens* and one of the greatest writers of the turn of the century. The *Torrens* was a composite ship, Scotch built in 1875, and was used in the Australian passenger trade. It was as a passenger going to the South Seas to see Robert Louis Stevenson that John Galsworthy first met Conrad and began a life-long friendship. The latter left the ship in 1896.

On view in the Library is one of the finest letters on the sea that the late Mr. Conrad ever wrote. It is in two-page, octavo, in full autograph, written at Oyster Bay, L. I., June 2, 1923. We quote in full:

134 *The Marine Collection at India House*

2ᵈ June. 1923.

<div style="text-align:right">Effendi Hill
Oyster Bay, Long Island
New York</div>

On leaving this hospitable country where the cream is excellent and the milk of human kindness apparently never ceases to flow I assume an ancient mariner's privilege of sending to the Owners and the Ship's-company of the Tusitala my brotherly good wishes for fair winds and clear skies on all their voyages. And may they be many!

And I would recommend to them to watch the weather, to keep the halliards clear for running, to remember that "any fool can carry on but only the wise man knows how to shorten sail in time" ... and so on, in the manner of ancient mariners all the world over. But the vital truth of sea-life is to be found in the ancient saying that it is "the stout hearts that make the ship safe."

Having been brought up on it I pass it on to them in all confidence and affection.

<div style="text-align:right">Joseph Conrad.</div>

Presented by Mr. James Farrell.

[602] Schooner *Elizabethport* expense sheet of port charges in Philadelphia, 1770.

[603] New York Whaling Company receipt for subscription made out to Hugh Gaine, circa 1774 (and) Tontine Coffee House receipt for subscription made out to Anthony A. Rutgers, 1792. Two pieces framed together.

[604] Order of Sailing signed by Horatio Nelson. Written to Capt. Samuel Hood, April 10th, 1797.

[605] Ship *Perseverance* clearance papers to Capt. Thomas W. Morman of Baltimore, signed by John Adams, 1798.

[606] Certificate of the American Seaman's Friend Society made out to the Rev. Leander Thompson, 1848. With engraved vignette by Pollock after W. Wade showing Sailor's Home on Waterfront. Steel engraving.

[607] The Great Ship Company Certificate for one share, 1858.

[608] U. S. Consul at Rio de Janeiro, 1822. Printed notice signed by him soliciting commissions from Philadelphians.

[609] Ship's Clearance Papers signed by Napoleon Bonaparte.

Marine Room

Miscellaneous Objects of Importance

HOUSE FLAGS

[610] Marine Signals of Baltimore. A series of four panels of colored house flags.

[611] Private Signals of the Merchants of Boston. Respectfully dedicated to the Merchants and Underwriters of Boston by their Obedient Servant, John T. Smith. Colored lithograph by Kramer & Co. of Boston. Showing 112 house flags of Boston Merchants.

[612] Private Signals of Modern New York Shippers. Printed in color. Published by Baker, Carvill & Morell, 1921.

❂ ❂ ❂

[613] Charter of the Marine Society of the City of New York. By-laws, etc. Sm. 4to, marbled boards. New York: Francis Childs, 1788. Presented by Mr. James A. Farrell.

[614] Old Sextant

[615] Pair of globes, terrestial and celestial, each mounted in walnut stand, with compass. London: Cary, 1800.

[616] Brass ship's bell from a U. S. Naval boat. 10" in diameter; 11½" high.

[617] Barometer made by Cox of London. Mahogany banjo-shaped wall-case. 41" long, 14" wide.

[618] Pair of Ship Lanterns. Brass with walnut wall brackets. Port and starboard lights from the Cunard S. S. *Saxonia*. Presented by D. W. Cooke. Marine room, flanking fireplace.

[619] Pair of cannon. Bronze, three inch bore, six-pounders, complete with carriages and tools. Cast by G. D. Sherwood at Fort William, 1820, probably from captured English models.

[620] Pair of antique swivel guns. Bronze, ornamented with sea horses. Spanish 16th century.
　Guns of this type were mounted on the quarterdeck railings and used only at close quarters or when the enemy boarding parties were in the waist of the ship.

[621] Ship's chronometer, made by Arnold (his number 2014) and originally purchased from Charles Frodsham, Strand, London. In mahogany case.

[622] Japanese armor. Complete suit of dress armor on manequin.

[623] A collection of eight Chinese musical instruments.

[624] Laughing Buddha. Antique Chinese carved teakwood statue. 24″ high. On panelled oak stand (46″).

[625] Buddha. Chinese gold bronze statue. On lotus stand with brown patine. 21″ high.

[626] Hindu sacred cup, made from human skull, elaborately mounted. With gold bronze coronet, mask finial and figures in relief supporting and on covers. On pierced and carved teakwood base. 15″ high.

[627] Set of twelve Indo-Chinese gold bronze statuettes, dignitaries in robes with characteristic bas-relief motifs. Fine and rare specimens with rich patine. 9″ high.

[628] Antique gold bronze statuette of a dignitary. Rich patine. 4″ high.

[629] Set of three antique Hindu gold bronze statuettes of deities. Rich patine. 4¾″, 5¼″ and 4″ respectively.

[630] Antique Hindu gold bronze casket with pictured deities and ornamentation pierced and in relief. Scrolled legs and splayed-top cover, ornamented. 11½″ high, 8½″ long.

[631] Antique Hindu bronze statuette, dignitary standing on chimera. Dark patine, on octagonal base.

[632] Antique Hindu bronze statuette of deity. Aged gilt patine. With plaquette and stand. 11½″ high.

[633] Antique brass statuette—Heron on tortoise. 11½″ high.

[634] Antique Hindu carved marble Buddhistic statuette. 7½″ high.

[635] Antique Hindu carved marble statuette. 7½″ high.

[636] Antique Hindu metal shrine with repousse motifs on front. Gilt. 5″ x 2½″ x 7″.

[637] Set of four antique Hindu bronze Buddhistic statuettes, with natural dark patine. 4½″ (two), 5″ (two).

[638] Antique Hindu bronze statuette "The Holy Man." Light gilt patine. 5″ high.

[639] Antique Indo-Chinese bronze Buddhistic statuette on lotus base. Natural aged patine. Rare specimen. 12″ high.

Library

Miscellaneous Objects of Importance

[640] Pair of old carved teakwood group statuettes. Indo-Chinese with silver line inlay. Equestrian figures. 21" high.

[641] Three old bronze Indo-Chinese trays with etched decoration. 15" diameter.

[642] Trumeau (pier-glass): carved wood decoration with ship. "Rect Doot Zee." With mirror background. 27" x 44".

[643] Antique massive bronze statuette. Indo-Chinese Buddha.

[644] Four antique Indo-Chinese statuettes. Companion to the set of twelve.

[645] Antique Hindu Buddhistic statuette with gold bronze features. Dark patine on robes and red enamel detail. 6½" high.

[646] Antique Indo-Chinese Buddhistic statuette, all gilt patine. 5½" high.

[647] Antique Indo-Chinese statuette. Natural bronze. Lotus base. 6" high.

[648] Antique Indo-Chinese statuette of goddess. Natural patine. Lotus base. 7" high.

[649] Antique Hindu bronze group. Deity on horse. Rich gold patine. 12" high, 10" wide.

[650] Antique bronze Buddhistic statuette. Natural patine. Lotus base. 7" high.

[651] Antique bronze Buddhistic statuette. All gilt patine. Lotus base. 7½" high.

[652] Antique bronze Buddhistic statuette. Lotus base. Dull gilding. 7½" high.

[653] Old Chinese bronze vase, with incised decoration and dragon handles. 9½" high.

[654] Antique bronze Hindu Buddhistic statuette. All gilt patine. 10" high.

[655] Antique bronze Buddhistic statuette of goddess Siva. Natural patine. 10½" high.

[656] Sculptured statuette of Buddha in marble. 10" high.

[657] Hindu gold-bronze casket. Ornamented in relief and pierced; depicting deities. Scrolled legs and splayed-top cover. 11½" high, 8½" long.

[658] Pair of nautilus shells richly mounted in gold bronze with decoration in relief and jeweled.

ACQUISITIONS SINCE 1935

ACQUISITIONS SINCE 1935

For purposes of continuity the numbering system used in the 1935 edition has been followed in this second edition. A careful search of the records of acquisition and a study of the minutes of each meeting of the Board of Governors have shown that the following new art works have been given to India House during the past thirty-eight years. Restrictions of space have severely limited the acquisition of new paintings, models and artifacts.

The largest number of acquisitions since 1935 and the most valuable came from the late John J. Farrell and James A. Farrell, Jr., sons of the cofounder of India House. This section will be divided, therefore, into two parts, the first listing the Farrell gifts to India House and the second listing other acquisitions since 1935.

FARRELL ACQUISITIONS

[659] Bronze bust.—A bust of James A. Farrell, by Massey Rhind, signed, dated 1924, 28½" high.

[660] Bronze figure.—*Deep-Sea Fisherman Casting a Line,* by E. Lorner, signed, 28½" high.

[661] Bronze gift mantel clock.—The top of the clock is decorated with various ship models, and it is a beautiful work.

[662] Collection of nineteenth-century Liverpool pottery.—Five large pitchers with illustrations of various late eighteenth-century ships and of people and scenic views of the same era. The five pieces are on display in the main bar of the club.

[663] *DELIGENTE.*—Slave brig model, typical of the small sailing craft so common in the colonies before the American Revolution. Great Britain transported about half the slaves brought to America until the Revolution. In 1792 Denmark became the first nation to outlaw

the slave trade. In 1808 the United States prohibited further importation of slaves, but, as a type, the slave ship continued in use for another half century.

[664] Farrell Rare Marine Book Collection.—Some 250 books, housed in a pair of eighteenth-century walnut bookcases, each fitted with glass doors.

[665] *GLORY OF THE SEAS.*—A photograph of the figurehead of *Glory of the Seas* taken shortly before the famous clipper was burned for her metal in May of 1923. The photograph shows the forward portion of the grand old craft with the forested shore-line of the state of Washington behind her. She was burned near Seattle, and her passing corresponded with the delivery voyage of the rebuilt *Leviathan,* pride of the American Merchant Marine. The salvaged figurehead is now one of India House's prized pieces of memorabilia.

[666] *TUSITALA.*—A display model, made to scale. This model is the work of Captain James P. Barker, last master and sailing master of the *Tusitala,* the last commercially operated full-rigged sailing ship to fly the American flag in the offshore trades. An engraved silver plaque is attached, and reads: "In Memoriam—John Joseph Farrell, 1890–1966. Member of Board of Governors 1932–1966." Captain Barker was an author of note, among whose books was *The Cape Horn Breed.* The model is located beneath the portrait of James A. Farrell, the first president of India House.

[667] *UNION.*—A model of the *Union,* an early clipper built in Baltimore in 1851. The ship measured 184 feet in length, by 37 feet 7 inches, by 21 feet 8 inches. Her first master was Captain B. Vuxton. Her figurehead was a golden dragon. The vessel was sold to the French in 1863, and was condemned in 1871 and scrapped. The model is rich in detail, even including a working bell on the forecastle.

OTHER ACQUISITIONS

[668] *BAVARIA.*—An oil painting, by H. Stuck, dated 1847. The French flag is at the foremast. The owner's house flag is white with a blue U. The American ensign has its stars in a star-shaped pattern in the blue field. The imitation gun ports and the style of the vessel show that she was built considerably earlier than Stuck painted her, possibly as early as the late 1820s. She was a packet ship and probably was chiefly used to carry passengers across the North Atlantic.

[669] Bell from the *Leviathan.*—The *Leviathan* was the largest passenger liner by tonnage ever to fly the American flag. This 59,957-gross-ton vessel was built in 1914 as the *Vaterland* by the Blohm and Voss yard in Hamburg. She was interned in New York in 1914 and was seized by the U.S. Navy in 1917 for use as a troopship. During the 1920s and the early 1930s the United States Lines used her as its flagship. She was finally scrapped in Scotland in 1938.

Acquisitions Since 1935

[670] *CASA FUCA*.—A model, donated by Clifford Hemphill. Ordered by the Spanish Admiralty in 1650 for the Crown, the model is of a seventeenth-century galleon. It was made from the timbers of even older ships on a scale of ⅜ inch to the foot.

[671] De Lesseps Medal.—On the occasion of the 150th anniversary of the birth of the French diplomat and promoter of the Suez Canal Ferdinand, Count de Lesseps, the Suez Canal Company commissioned a commemorative bronze medal. Three silver medals were struck at the same time, one of which was presented to the Club in 1956 by the Suez Canal Company, through the courtesy of Claude E. Boillot. The medals were presented to those persons and organizations throughout the world for whom the Suez Canal had some particular significance. India House was felt to "constitute the best possible home in America for this testimonial to a man whose vision and drive did so much for the shipping community of the world."

[672] Eskimo Sailing Vessel.—A model, donated by Bernhard M. Schaefer, of a "bidarrshs" or small craft used by the Eskimos of the Pribilof Islands off Alaska. The frame is of bent wood, and the transparent skin is made from the membrane of seal throats. Four oars rest in the boat, and there is a tiller oar at the stern. She could accommodate about ten Eskimos.

[673] *GANGES*.—A painting of the brig by an unknown artist in 1862, presented to India House by David B. Dearborn. The *Ganges* sailed out of New York; her master was Captain Rufus G. Dearborn. Her owners' house flag is a red burgee with a white cross. The ship's name is shown on a port sternboard. The painting has its title legend across the bottom. The vessel is shown entering Leghorn. The style of painting is primitive.

[674] India House.—An ink and wash drawing by Dong Kingman, 17" by 22", donated by George V. Robbins. Done in browns and light orange, this delightful drawing shows India House in its early period, when it was a residence. In the foreground there are a large tree and people and carriages.

[675] *ISAAC WRIGHT*.—A painting of the American packet ship of the famous Black Ball Line, a company that started in 1818 with the *James Monroe*. Their packet ships instituted the custom of sailing on schedule even if the ship was not filled with cargo and passengers, a custom that revolutionized the shipping business. The *Isaac Wright* was a vessel of 1,300 tons, large for a packet, and was built in New York by William Webb, who later founded the famous Webb Institute, a school for naval architects now located in Glen Cove on Long Island.

[676] *JAMESTOWN*.—A painting of the packet ship by Samuel Walters, a noted artist of the pre-Civil War period. Of 1,300 tons, the *Jamestown* was a full-rigged ship built by

Perine, Patterson & Stack. Her figurehead was notable in that it was a woman's figure virtually erect with hands raised before her. The vessel's crew is shown on the foredeck, and a host of small sailing ships are nearby.

[677] *MONMOUTH*.—A brilliant painting depicting an episode in the Mexican War, signed by an artist named Evans. It shows the arrival of General Zachary Taylor and his staff at Balise on November 30, 1847. The steamboat flies the house flag of the United States Quartermaster Corps. The vessel is interesting as an excellent example of the earliest type of steamship. Both the foremast and the mainmast are rigged for sail. The large walking-beam engine can be seen rising between the twin paddle boxes on either side. Dark coal or wood smoke is shown coming from the tall stack. The boat was large enough to require a "hog" frame, a device to hold the bow and stern of a long, wooden-hulled vessel from sagging or "hogging" at either end. The hog frame was a heavy wooden truss that ran on either side of the amidship deckhouse, something like the trusswork of a bridge. This painting was used as a cover illustration by *The American Heritage* magazine.

[678] *L'OCÉAN*.—A model of the French warship, donated by Mrs. Elmer R. Jones in honor of her husband, a Governor of India House from 1843 to 1861. The model is made of bone and wood. *L'Océan* was a steamship with two low smokestacks. A number of delicately made bone lifeboats hang from davits on either side and at the stern. The deck equipment is also made of bone. A full-rigged ship, her heavy masts and sails are done considerably larger than to scale, indicating that the model was the work of a seaman. The vessel dates from the late nineteenth century.

[679] *SANTA MARIA*.—A model of the flagship of Columbus's fleet, presented by the Mariners Museum in Newport News, Virginia. Heavy-looking sails of leather dominate this scale model, which was built in carefully carved plank layers. The model stands on an ornamented gilt box, and a gilt plaque records that the original was a ship of 120 feet in length, with a beam of 20 feet and a depth of 10 feet, although none of these dimensions is actually known. The model is a superior piece of craftsmanship.

[680] *WASHINGTON*.—A painting by J. E. Buttersworth. The *Washington* was the first American-flag steamship to operate in the regular trans-Atlantic service. Built in 1847, she served between New York and Bremerhaven, having her cost of operation partly defrayed by an American subsidy and partly by a subsidy from the City of Bremen. After ten years the American subsidy was withdrawn, and the Bremen Line collapsed. The *Washington* went into the gold-rush service to California.

The first edition of this book was designed and published in an edition of one thousand copies by Melville E. Stone, at the Sign of the Gosden Head, New York, in the month of November, 1935, for the Board of Governors of India House, and was printed under the direction of John S. Fass at The Harbor Press.

*This second, revised edition
is limited to twelve hundred fifty copies
four hundred thirty-five of which are
special copies for India House members*
Photography: *Taylor & Dull*
Paper: *Monadnock Paper Mills*
Printing: *The Meriden Gravure Company*
Binding: *Tapley-Rutter Company*
December, 1973